FACES OF THE LIVING DEAD

The Belief in Spirit Photography

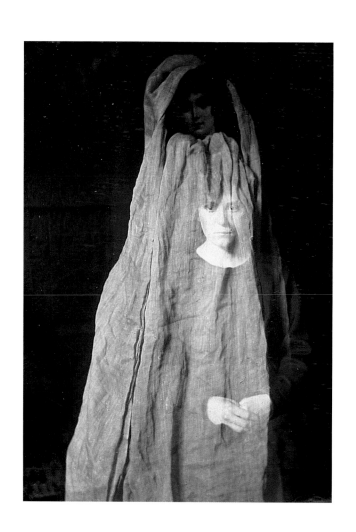

FACES OF THE LIVING DEAD

The Belief in Spirit Photography

Martyn Jolly

Mark Batty Publisher

LIST OF ABBREVIATIONS

ASPR American Society for Psychical Research
BCPS British College of Psychic Science
SPR Society for Psychical Research
SSSP Society for the Study of Supernormal Pictures

Photographs: front jacket illustration: WILLIAM HOPE *(attributed)*, *Unknown sitter, c. 1920* *composited with* WILLIAM HOPE, *Unidentified extra, 1921 (both Barlow Collection, British Library, London);* back jacket illustration: SOCIETY FOR PSYCHICAL RESEARCH, *Walter's hand in a cloud of ectoplasm, undated (Cambridge University Library) composited with* ADA DEANE, *Unidentified extra, c. 1922 (Barlow Collection, British Library, London); page 2* ADA DEANE, *Girl with extra and cascade of cloth, c. 1922; pages 6–7* ADA DEANE, *Two women, c. 1922 (detail). Both gelatin silver photographs, Cambridge University Library, Society for Psychical Research.*

Every effort has been made to trace accurate ownership of copyrighted text and visual materials used in this book. Errors or omissions will be corrected in subsequent editions, provided notification is sent to the publisher.

10 9 8 7 6 5 4 3 2 1 First Edition

This edition © 2006
Mark Batty Publisher
6050 Boulevard East, Suite 2H
West New York, NJ 07093

www.markbattypublisher.com

Library of Congress Control Number: 2006921050
ISBN: 0-9772827-3-2

First published 2006 by
The British Library
96 Euston Road
London NW1 2DB

Text © 2006 Martyn Jolly
Photographs © 2006 The British Library Board and other named copyright holders.

Designed and typeset in Requiem by DW Design, London
Colour reproduction by Dot Gradations Ltd, UK
Printed and bound in Hong Kong by
South Sea International Press

ACKNOWLEDGEMENTS

For help with sources and references I would like to thank: Caroline Greenaway, Canberra, and Jenny McFarlane, Helen Ennis and Erika Essau, Australian National University; Gael Newton, National Gallery of Australia; Karon Hepburn, Frith Street Gallery, London; Karl Schoonover, Brown University, Rhodes Island; Jennifer Tucker, Wesley College, Delaware; Pierre Apraxine, Gillman Collection, New York; Colleen Phaidon, American Society for Psychical Research, New York; Alison Ferris, Bowdoin Gallery, Maine; Josef Lebovic, Sydney; Erin Garcia, San Francisco Museum of Modern Art; and Michael Underwood, J. Paul Getty Museum, California. For feedback on the text I would like to thank Jane Goodall, University of Western Sydney, and Bronwyn Coupe, Canberra. For their friendship and support during the period of research I would like to thank: Neil Bromwich and Zoe Walker, London; Meegan Williams and Trevor Smith, New York; and most importantly Bronwyn Coupe. For their professional support during the production of the book I'd like to thank: Lara Speicher, Annie Gilbert, Kathleen Houghton, Charlotte Lochhead and Georgina Difford from the British Library and most importantly Denise Ferris, Professor David Williams and Doris Haltiner from the Australian National University School of Art.

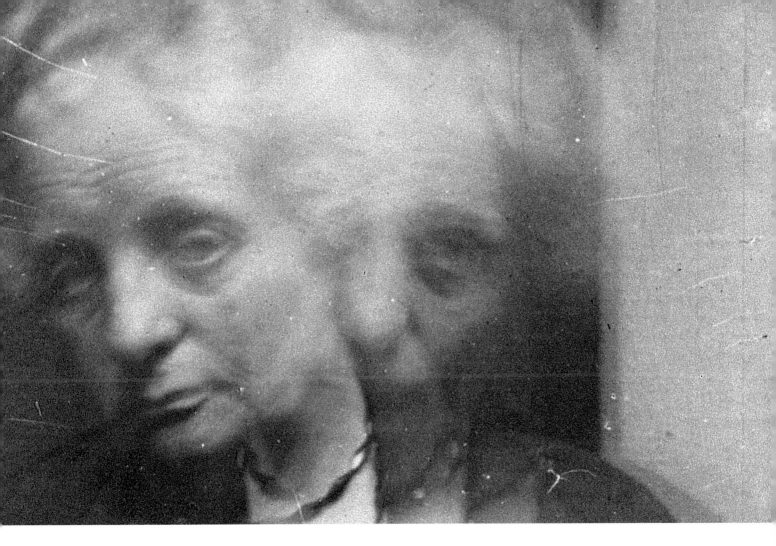

CONTENTS

Introduction: CREDULITY AND SUPERSTITION 8

Chapter One: THE INVENTION OF SPIRIT PHOTOGRAPHY 12

Chapter Two: SPIRIT MATERIALIZATIONS 28

Chapter Three: PSYCHIC PHOTOGRAPHIC IMPRESSIONS 44

Chapter Four: ECTOPLASM 62

Chapter Five: THE RETURN OF THE DEAD 88

Epilogue: THE SPIRITS' LEGACY 140

Bibliography 146

Notes 152

Index 158

Picture Credits 160

Introduction: Credulity and Superstition

> The time wasted on [spirit] photography, the money thrown away and the violent emotions that have been engendered render the subject of more than passing interest to the student of human stupidity, credulity and superstition.[1]

With this backhanded endorsement Dr Eric Dingwall damned the large collection of spirit photographs he had just carefully annotated for the British Library. He was writing in 1960, about a collection that had been assembled forty years earlier by his friend, Fred Barlow. Back then, in the 1920s, Dingwall had been the research officer for the Society for Psychical Research, a society (which exists to this day) that dedicated itself to the objective scientific investigation of paranormal phenomena. Barlow had been the honorary secretary of the Society for the Study of Supernormal Pictures, a group who were convinced that spirit photographs truly showed the spirits of the dead returning from the other side to be photographed with their loved ones. Eventually, by the 1930s, Dingwall had managed to convince Barlow that the pictures he had been collecting were fakes, and that he had been tricked by a series of very clever so-called 'spirit photographers'.

Dingwall spent a lifetime pursuing the evidence for psychic phenomena. To him, once he had exposed them as fakes, they could only be one thing: incontrovertible evidence not of spirit return, but of human stupidity. However, students of photographic culture, rather than psychic phenomena, have recently become interested in spirit photographs. Historians, curators and artists have realized that although 'fakes' on one level, they nonetheless remain powerful photographic evidence on another level. Forty years after Dingwall dismissed them, they now speak to us more strongly of faith, desire, loss and love, than gullibility. They raise new questions: not about whether they are fake or real, but how and why they came to be made, and what they meant, emotionally, to the people who once treasured them. Looking into these portraits now, their fakery seems crude and self-evident, but, if we keep on looking, another very real quality emerges from the faces of the people who were photographed – their ardent desire to see and touch a lost loved-one once more.

In the late nineteenth century and early twentieth century the marvellous technological advances of modernity, such as the telegraph, the wireless and X-rays, allowed people to communicate instantaneously over vast distances, or see previously invisible things for the first time. These technologies also seemed to offer to the people in these photographs, the incredible possibility that the eternal desire to communicate with the departed might finally be realizable. The belief in this possibility was called Spiritualism. Modern Spiritualism traced its origin back to one day in 1848, when two young sisters apparently heard mysterious rapping noises in their house in upstate New York. They supposedly worked out

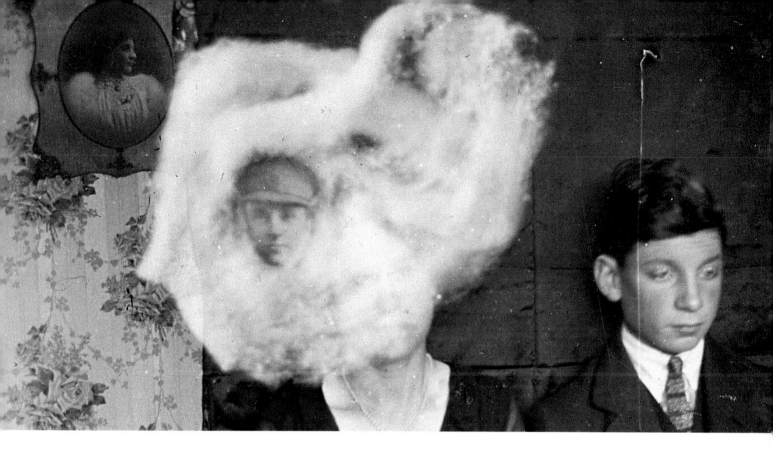

a simplified Morse code by which they could rap back questions to the ghost who they claimed haunted the house, and receive rapped answers. The two girls, Kate and Margaret Fox, went on to become Spiritualism's most famous mediums. They held séances, in which they apparently communicated with the dead, throughout the United States and the United Kingdom for the rest of the century. Many other mediums, professional and amateur, also began to hold private and public séances. At these séances the mediums would communicate with the dead through raps, or they would fall into a trance and, supposedly under the control of an intermediary spirit guide, speak in the voices of spirits who had messages for the living. As the ranks of believers in these phenomena swelled, they formed themselves into associations and churches, and Spiritualism became a widespread social movement.[2]

But it is not only the elaborate paraphernalia of Spiritualism that continues to make spirit photographs so compelling for us now, it is something about the essential nature of photography itself. Photography stops an image of a living person dead in its tracks, and peels that frozen image away from them. In this sense, all portrait photographs are spirit photographs because they all allow us to see, and almost touch, people as they lived in the past. The people in these images, once so desperate for an image of their deceased loved ones, are now themselves all dead also, but ironically revenant in their portraits. Perhaps we too can almost reconnect with them, in a way not dissimilar to their own attempts to reconnect with those on the other side of the veil.

ADA DEANE, *Spirit photograph in house, c. 1922 (detail). Gelatin silver photograph, Cambridge University Library, Society for Psychical Research.*

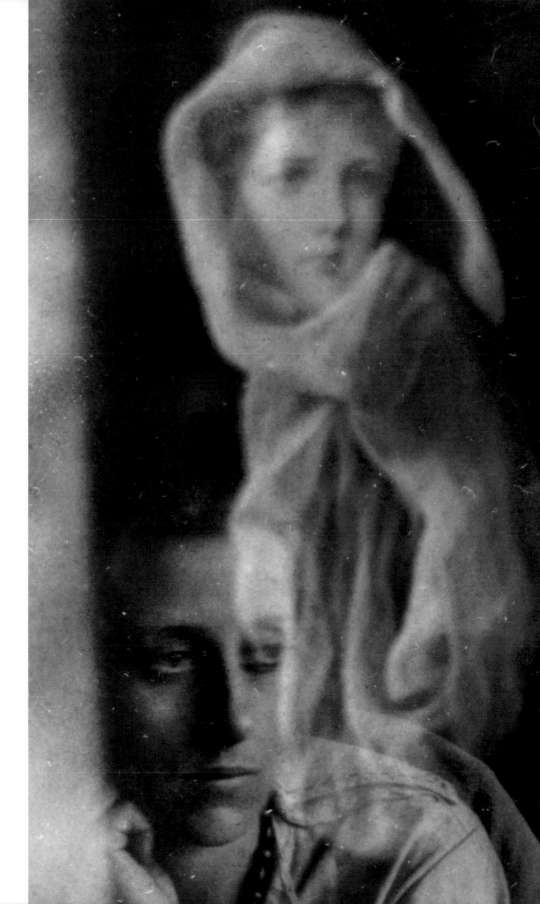

ADA DEANE, *Unidentified
sitters and extra, c. 1922 (detail).
Gelatin silver photograph,
Barlow Collection,
British Library, London.*

IO

II

THE INVENTION
OF SPIRIT
PHOTOGRAPHY

THE INVENTION OF SPIRIT PHOTOGRAPHY

In May 1869, at the end of a trial that had lasted for three weeks, the New York City Special Sessions judge finally brought down his decision. The judge himself was morally convinced that there may have been trickery and deception practised by the accused, the spirit photographer William Mumler, but after a thorough analysis of the extraordinary testimony of all the witnesses, he found himself compelled to discharge the prisoner because of lack of evidence. Mumler left the court surrounded by his elated supporters. Newspapers reported that he had borne the trial with the air of someone who, although he was acutely aware of being persecuted, was nonetheless willing to become a martyr for the cause.[3]

His cause was Spiritualism. During the trial his defence counsel had claimed that there were eleven million Spiritualists in the United States. But the newspapers derided the movement's representatives, who packed out the courtroom every day, as a motley array of believers with sickly sentimental eyes and cadaverous lantern-jawed physiognomies, who had the general appearance of having stretched their necks to the utmost tension by constant endeavours to peer into the shadowy world on the other side. Most of the crowd were women, described as staid matrons and elderly maidens with pale faces and eyes lacklustre from constant study and meditation. Before the trial, one of them, Amelia V. Brooks, had directly petitioned the judge to ensure that sufficient room was set aside for lady Spiritualists who wished to be present at this, the first time their belief was the subject of judicial determination. She went on to sombrely advise the judge that the spirits were anticipating his decision with more than ordinary anxiety, but she trusted that he was equal to the emergency.[4]

The testimony given to the court was extraordinary. Some of the strongest evidence for the defence came from another judge, John Worth Edmonds, who had publicly converted to Spiritualism in 1851, resigned his position on the New York Supreme Court, and begun to proselytise his conviction in the press. He testified that he had gone to Mumler's studio and had been photographed in profile against a blank wall. Upon development, the form of a lady was seen standing between him and the wall. He explained to the court that he believed that images such as these, which came to be known as 'extras', could only be spirits because everything had some form of materiality, even spirits, so there was no reason why they could not be photographed. He was certain that, in time, his reasoning would be proven correct as intercourse with the spirits developed.[5]

For their part the prosecution called upon expert witnesses from the photographic industry, who were able to describe nine different ways in which Mumler's so-called spirits could be photographically reproduced. In the 1860s, portrait photographers had to coat a cleaned glass-plate with a sticky collodion emulsion in a darkroom immediately before each sitting. The wet plate was then placed in a plate-holder before being brought out into the

studio and slid into the back of the camera. A protective dark-slide was pulled out from the plate-holder, the exposure made, and the dark-slide slid back. The plate-holder was taken back into the darkroom to be developed. Later, prints were made from the negatives for sale to the client. The expert witnesses concluded that, depending on the vigilance of the client, Mumler had most probably either exposed his portraits through a glass-plate with a positive image of an extra 'spirit' figure, which he had previously made and hidden in the front of his plate-holder; or he had pre-coated the glass-plate with a dry emulsion and pre-exposed an extra spirit figure onto it, before pouring on the wet-collodion emulsion for the client; or he had double-printed the final prints from two separate negatives, one of the sitter and one of a spirit. All of the witness testimony in the prisoner's defence, the prosecution therefore claimed, proved only the existence of a belief in the mediumistic powers the prisoner claimed, not the truth of those powers.

But, unfortunately for the prosecution, nobody had caught Mumler in the act. And the prosecutor went on to dangerously compromise his case by directly attacking Spiritualism as a belief, as well as the Spiritualists themselves. He quoted the Bible to claim that, even though Spiritualists saw themselves as being at the forefront of modern Christianity, Spiritualism was in fact antagonistic to Christianity, the very basis of United States law, because it believed that a gaggle of survived spirits competed for supernatural space with angels, the only officially sanctioned messengers of the Lord. And he quoted the French psychologist A. Brierre De Boismont, whose book *Hallucinations: or the Rational History of Apparitions, Visions, Dreams, Ecstasy, Magnetism, and Somnambulism* had been translated into English in 1853, to argue that the spirits they had seen may have been inside their heads, evidence of a transition from reason to insanity proceeding from a heat-oppressed brain and a derangement of the nervous and circulation systems.[6]

There was plenty more to muddy the waters of the trial. It was sensational enough to attract the master of humbug, P. T. Barnum, to the stand. Barnum was a showman, world famous for confounding fact with fantasy, and science with entertainment, in his popular sideshow attractions. He testified for the prosecution that Mumler had told him how he had created the spirit effects, and had sold him two spirit photographs for ten dollars each, which he had put on display in his famous American Museum on Broadway as *Spiritualistic Humbugs*.[7] The way in which the charges had first been brought also smacked of sensationalist entrapment. Mumler's spirit photographs, like most portrait photographs from this period, were *cartes-de-visite*, small portraits glued to visiting cards that were popularly exchanged between friends and family. *Cartes-de-visite* were described at the time as the social currency, the sentimental banknotes, of civilization.[8] New York's First Marshall, who had gone to Mumler's Broadway studio incognito, was outraged when he was charged ten dollars for a dozen *cartes-de-visite*, rather than the going rate of three dollars a dozen. But Mumler's assistant smoothly assured him that the high price was because the spirits didn't like a throng

of the vulgar multitude clamouring for their likenesses. Clients, who had already paid their ten dollars and received recognizable images of their lost relatives, now wouldn't part with them, even for thousands of dollars, he said.[9]

Mumler's New York trial was the high point of a precarious career he had maintained for many years, and when the heat had died down from the trial he wrote up his memoirs. Photographers had always been able to point to the momentous announcement of photography's invention by Louis Daguerre, in Paris in January 1839, as the starting point of their science. And it was well known among Spiritualists that their faith had been inaugurated on the night of 31 March 1848, when Kate and Margaret Fox first rapped back to the spirits. With a similar sense of historical significance Mumler dated the discovery of the science of spirit photography to one day in October 1861, when he was still just a humble engraver for a firm of Boston jewellers. In his account, a transparent form had quite unexpectedly appeared on the plate beside him, while he was tentatively experimenting with photography by taking self-portraits. The figure looked like his cousin who had died thirteen years previously, and he remembered a slight tingling in his arm during the exposure. He showed it to a Spiritualist friend, who immediately recognized the phenomenon as further evidence of spirit communication, and published the news in two Spiritualist newspapers, the *Herald of Progress* and the *Banner of Light*. Spiritualists came flocking to Mumler's Boston studio, and his fame spread throughout the Spiritualist world. (See Figures 1 and 2.) What may, perhaps, have initially been an accidental double exposure and an innocent over-interpretation, quickly became Mumler's deliberate profession. Spiritualists were able to order copies of his photographic proof that the dead lived, in packets of three, for three shillings and sixpence. And many spirit photographs, which also began to feature celebrity mediums, were mounted into their *carte-de-visite* albums around the world.[10]

Mumler had discovered his apparent gift for photographing the dead just after the outbreak of the American Civil War, an event which had profound effects on American photography. Two years later, as the war raged and the casualties mounted, the columnist Oliver Wendell Holmes, who was America's most cogent analyst of the social impact of the new medium of photography, wrote an article for the *Atlantic Monthly* in which he described the shock he, and by extension other Americans, felt at seeing photographs of the war dead for the first time. To Holmes, the photographs of the corpse-strewn battlefield at Antietam,

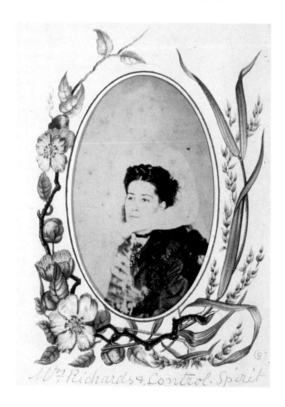

Figure 1. WILLIAM MUMLER, *Mrs Richards and control spirit, c. 1872.* Carte-de-visite albumen photograph in album page, National Gallery of Australia, Canberra, Photography Fund: Farrell Family Foundation donation.

16

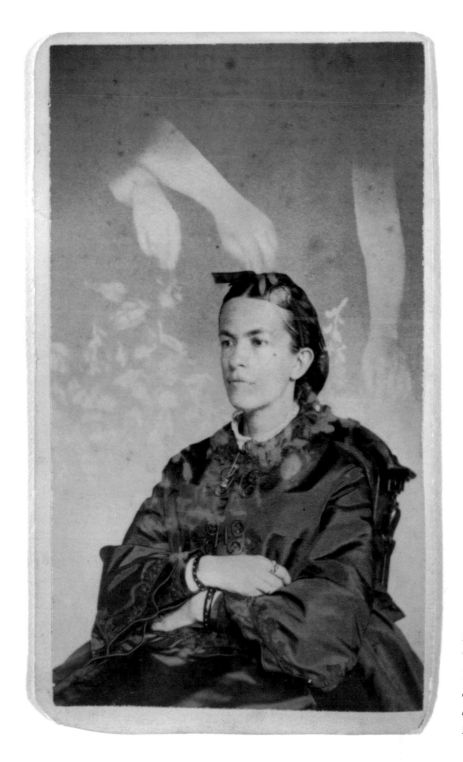

Figure 2. WILLIAM MUMLER, *The medium Mrs Conant of the* Banner of Light *with spirit arms, c. 1865.* Carte-de-visite *albumen photograph, J. Paul Getty Museum, Malibu, California.*

THE INVENTION OF SPIRIT PHOTOGRAPHY

the bloodiest battle of the war, which were published by the New York photographer Matthew Brady, were so realistic that they were almost like corpses themselves: 'we buried them in the recesses of our cabinet as we would have buried the mutilated remains of the dead they too vividly represented.' This new style of reportage photography bought the finality of death, via the corpse, right into the private parlour. Many soldiers departing for the war had had their photographs taken by the thousands of portrait photographers who were springing up across the country. Inevitably, these small *cartes-de-visite* were destined to become all that many grieving families had to remember their fallen soldiers by. Holmes had recognized that photography, which was just beginning to mature as a popular technology, was also becoming inextricably linked to death and mourning.

Later in his article, Holmes considered the connection between photography and death from another angle. He described the tenuous consolations for grief that Mumler's new aberrant breed of spirit photograph seemed to promise to Spiritualist believers.

> But it is enough for the poor mother, whose eyes are blinded with tears, that she sees a print of drapery like an infant's dress, and a rounded something, like a foggy dumpling, which will stand for a face: she accepts the spirit portrait as a revelation from the world of shadows. Those who have seen shapes in the clouds, or remember Hamlet and Polonious [...] will understand how easily the weak people who resort to these places are deluded.[11]

Mumler, himself, also recognized that such consolation was the key to his career as a professional spirit photographer. Unlike Holmes, however, he did not want his readers to think that the belief in spirit return was merely the psychological product of an extreme emotional need combined with the chimerical nature of the spirit photograph itself. He wanted them to remain convinced that their belief was a stable religious truth in an increasingly unstable world:

> ... as I look back upon my past experience, I feel that I have been the gainer, personally, for all the sacrifices I have made, and all the troubles I may have endured in the knowledge I have gained of a future existence, and in the soul-satisfaction of being a humble instrument in the hands of the invisible that surrounds us for disseminating this beautiful truth of spirit communion. Nevertheless it has been a difficult task to battle with the skeptical world, to bear persecution and poverty, to outlive slander, and to overcome the many obstacles that beset the path of ones whose mission it is to advance some new truth. ... After a man has passed the middle age he looks forward, at best, to but a few years of earthly existence, and naturally asks, 'Is this all of life? Is

there a hereafter? ... The anchor to which he has ever been clinging to for safety begins to drag; ... and where is he drifting? Spiritualism comes to him like a beacon light to the mariner; and thousands who were tossed wildly about upon the waves of doubt and skepticism are quietly resting under this protecting shelter of the beautiful truth.[12]

Mumler's memoirs were full of the testimony of grateful clients, which went on to circulate through the Spiritualist press. The most powerful testimony came from Moses A. Dow, the editor of Boston's *Waverley Magazine*. The faded, desiccated spirit we see in the *carte-de-visite* today (see Figure 3), gives the contemporary viewer little indication of the intense emotions and complex interactions that surrounded the production of the photograph. Dow had taken a talented young woman, Mabel Warren, under his wing and eventually came to regard her as a dearly beloved daughter. She was suddenly taken ill and quietly passed into spirit land, leaving Dow grief-stricken. Seven days after her death, Dow made contact with Mabel's spirit through a séance at his home. Later the spirit announced, through the trance-voice of a medium who was presumably colluding with Mumler, that she wished to give Dow her spirit picture. The spirit asked Dow to make the appointment with Mumler for the next week. At the studio, Mumler made several unsuccessful attempts to secure Mabel's image. On the final attempt Dow sat for five minutes before the camera, while Mumler stood with his back to him with his left hand resting on the camera. As the exposure was finishing, Mumler's wife, who was also a medium, came into the room and, immediately falling into a trance under the control of Mabel, said: 'Now I will give you my picture, it will be here in a few minutes. ... I put into it all the magnetism I possess.' As Mrs Mumler came to herself, Mumler re-entered the room with the developed plate. Dow took the plate and looked at it:

> The picture presents me as sitting upright in a chair with my legs crossed. My hands lie on my lap, with my fingers locked together. Mabel stands partially behind my right shoulder, dressed in a white well-fitting robe. Her hair is combed back, and her head is encircled by a wreath of white lilies. Her head inclines forward so as to lay her cheek on my right temple, from which my hair is always parted. Her right hand passes over my left arm and clasps my hand. Her left hand is seen on my left shoulder, and between the thumb and forefinger of this hand is held an opening rose bud, the exact counterpoint of the one I placed there while she lay in the casket at her funeral.[13]

All traces of that rose bud have now finally leached out of the photograph.

Spiritualists who were unable to visit Mumler in person could even send in a *carte-de-visite*

Figure 3. WILLIAM MUMLER, *Moses Dow, editor of* Waverley Magazine, *and spirit of his adopted daughter, Mabel Warren, c. 1871.* Carte-de-visite albumen photograph in album page, National Gallery of Australia, Canberra, Photography Fund: Farrell Family Foundation donation.

19

portrait as a substitute for themself and, allowing for time-zone differences, arrange with Mumler to photograph the photograph as they concentrated their mind on it. Mumler then returned both images, the copy now having spirit extras manifesting around it (see Figure 4).

Spiritualism arose in parallel to the explosion of scientific discovery and invention in the late nineteenth century, when advances in physics and chemistry were fundamentally reconfiguring accepted notions of energy, time, space and reality itself. Technologies such as photography, electricity and telegraphy were pushing back the boundaries of human perception and experience in all directions, and were proving that forces, signals and messages could be sent invisibly over vast distances. Like many other Spiritualist mediums, Mumler also drew on the authority of contemporary science to explain his apparent abilities. He mused in his memoirs that it had been known since photography's invention that the photographic plate was sensitive to ultraviolet light, a 'dark light' that lay beyond the range of the human eye. Perhaps spirits were able to reflect ultra-violet light? Alternatively, the London electrician Cromwell Fleetwood Varley had recently produced a faint glow by passing an electrical current through a vacuum tube. Perhaps, Mumler speculated for the benefit of his readers, he himself was like the vacuum tube, able to make invisible forces visible.[14]

✛

Figure 4. WILLIAM MUMLER, Female 'spirit' standing next to a table with a photograph propped against a vase of flowers, c. 1870. Carte-de-visite albumen photograph, J. Paul Getty Museum, Malibu, California.

In 1873, the spirit photographer Edouard Buguet emerged onto the Spiritualist scene, working from a studio on the Boulevard Montmartre in Paris. To explain his uncanny photographic powers, Buguet drew on the European tradition of mesmerism with its theory of animal magnetism. Mesmerists could supposedly affect a human body at a distance, with magnetic forces emitted from their hands and transmitted through an invisible universal fluid, which they believed connected all things. Buguet sometimes had himself, his plates and his camera magnetized by a mesmerist before a sitting. He claimed that spirit controls entranced him during the exposure of the plate, regulating the length of exposure for him. Buguet's main mentor was the dominant figure of French Spiritualism at the time, Pierre-Gattan Leymarie, who reproduced his photographs at high quality, and had them individually tipped into his magazine the *Revue spirite*. One of the photographs the magazine reproduced was of Leymarie with a friend (see Figure 5). Between the two men, enveloped in a fluidic veil,

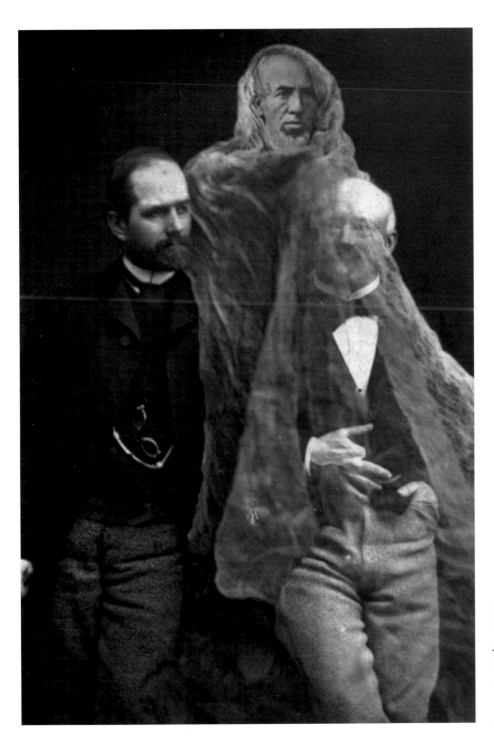

Figure 5. EDOUARD BUGUET,
*Pierre-Gattan Leymarie, with a
friend and the spirit of Edouard
Poiret, c. 1873. From an original
albumen silver photograph, Mary
Evans Picture Library and College
of Psychic Studies Archive.*

THE INVENTION OF SPIRIT PHOTOGRAPHY

appeared a spirit the pair recognized as an old friend who had died twelve years previously. To the English medium, Stainton Moses, this was the finest spirit photograph he had ever seen, because the face was the thoroughly developed face of a living man, with every feature distinct – more distinct, curiously, than the faces of the sitters.[15]

Buguet also took several photographs of the Spiritualist Lady Caithness and her son Count de Medina Pomar (see Figure 6). Among the thirteen spirits that appeared, they received recognizable likenesses of five departed ancestors. The spirit of Lady Caithness's late husband even brought along an emblem to seal the truth of his identity – an apple, from the family crest. As many other Spiritualists were to do, Lady Caithness mounted these photographs, alongside a large collection of William Mumler spirit photographs she had obtained in America the previous year, in an album, in which she was surrounded by loving friends and family, living and dead.[16]

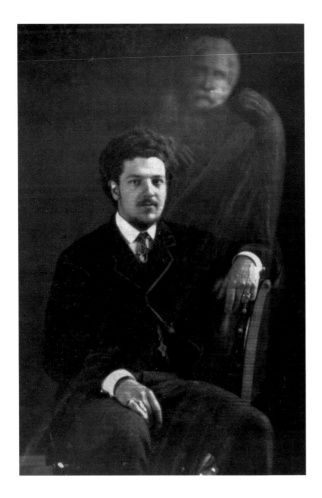

Figure 6. EDOUARD BUGUET, *The Count de Medina Pomar with the spirit of his father, c. 1874. From an original albumen silver photograph, Mary Evans Picture Library and College of Psychic Studies Archive.*

In June 1875, Buguet was tried for fraud. He quickly confessed to surreptitiously double-exposing his plates with images of dummies, or his studio assistants, dressed up in drapery. Police raided his studio and seized two dummies, shrouds, false beards, and almost 300 pictures of various heads glued onto card. These, it came out in the trial, would be used to construct an approximation of the particular deceased person the customer had said they wished to see once again, which would be photographed against a dark background shrouded in a 'fluidic veil' to hide the edges, while they continued to chat to the receptionist. Buguet showed a police officer one portrait that had served as the mother of one sitter, the sister of a second, and the friend of a third. Despite his confession, and the police discovery, witness after witness – journalist, photographic expert, musician, merchant, man of letters, optician, ex-professor of history, and colonel of artillery – came forward to testify in his defence. They each refused to accept the court's construction of them as simply Buguet's gullible dupes. One after another these witnesses were confronted with Buguet, and heard him explain how the trick had been done. One after another they left the witness box still protesting that they chose to believe the evidence of their own eyes, rather than Buguet's confession.

Witness: The portrait of my wife, which I had specially asked for, is so like her that when I showed it to one of my relatives he exclaimed, 'It's my cousin.'

Court: Was that chance, Buguet?

Buguet: Yes, pure chance. I had no photograph of Mme. Dessenon.

Witness: My children, like myself, thought the likeness perfect. When I showed them the picture, they cried 'It's mamma.' ... I am convinced it was my wife.

Court: You see this doll and all the rest of the things?

Witness: There is nothing there in the least like the photograph I obtained.

Court: You may stand down.[17]

For the Spiritualists, the experience of recognition became paramount, because it was what allowed them to short-circuit in their own minds the thought that the images might have been manufactured beforehand. Stainton Moses, who defended Buguet, statistically analysed the recognition rate for his extras and determined that, at forty out of 120, his was the highest of any spirit photographer. However, another witness testified that *he* recognized the sharply defined face, previously recognized by Leymarie as their deceased friend, as his own father-in-law, who was very much alive and reportedly very much annoyed at his premature introduction to the spirit world. Buguet was sentenced to one year's imprisonment and a fine of 500 francs.

Leymarie, the editor of *Revue spirite*, admitted that he was the one to first suggest that Buguet should emulate Mumler. But he maintained that he too had innocently believed in Buguet's powers. He had published so many testimonials from Buguet's satisfied clients, not in order to entice further gullible customers, but as a form of scientific proof: 'Only a crowd of testimonials makes it possible to recognize that a fact is true, that there is a strict and severe criteria,' he told the judge. Nonetheless, he was convicted as an accessory and received the same sentence as Buguet.[18]

During their imprisonment, Spiritualists suggested that the trial and confession were a set-up by the Catholic Church to discredit Spiritualism. And, in September 1875, after his release, Buguet publicly retracted his confession at the Spiritist Congress of Brussels. He declared that he had been persuaded to make it in exchange for a promised acquittal, and that the paraphernalia found in his studio had been used without his knowledge by his staff while he was away ill.[19]

✚

Like many accomplished upper-class women in Britain, Miss Georgiana Houghton had experimented with the new scientific pastime of photography. However, in 1859 she found her true passion – Spiritualism – and ebulliently developed her own amateur mediumship.

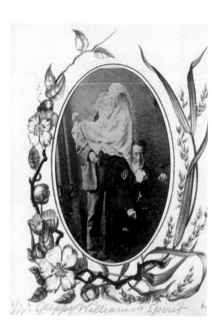

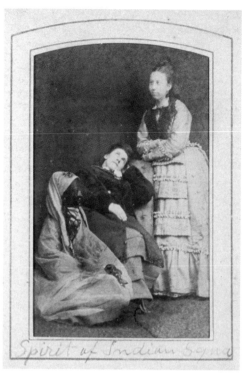

Left: Figure 7. FREDERICK HUDSON, *Samuel Guppy (left), the medium Charles Williams and a spirit, c. 1872.* Carte-de-visite *in album page, National Gallery of Australia, Canberra, Photography Fund: Farrell Family Foundation donation.*

Right: Figure 8. FREDERICK HUDSON, *Spirit of Indian Syna and Misses Wood and Fairlamb, c. 1874.* Carte-de-visite *albumen photograph in album page, National Gallery of Australia, Canberra, Photography Fund: Farrell Family Foundation donation.*

She not only had a large circle of family and friends, dead and living, whom she cared for dearly, but she also believed she had acquired a host of seventeen archangels who constantly attended her, giving her advice which she received as intimations felt within her 'in breaths'. She had read the first reports of William Mumler's spirit photographs in the *Spiritual Magazine* of December 1862. Believing at once, she purchased one of the packets of three Mumler photographs that the magazine offered to its readers.

Two years later she tried to produce her own spirit photographs with the assistance of a photographer friend, but they were unsuccessful. She had to wait another eight years, until 1872, when the husband of the celebrated London medium, Mrs Guppy, introduced her to the elderly and apparently doddery photographer, Frederick Hudson, before she was finally able to report to the *Spiritual Magazine* that for the first time a photograph of a spirit had been obtained in London. Working together, the psychics and the photographer had been able to produce apparent spirit phenomena for an immediately convinced Houghton.

Mr and Mrs Guppy were popular figures in London Spiritualism. Samuel Guppy was well known for his wealth, and his younger wife was famous for her power to produce 'apports', physical objects and animals that seemed to be instantaneously transported from other places into the middle of a séance. (Although, it was noted, she was a large woman,

and her voluminous skirts could have contained all manner of objects.) On 7 March 1872, Mr Guppy showed Houghton photographs Hudson had taken of him which showed a large, fully veiled spirit figure standing behind him (see Figure 7). He suggested that since the day was fine, and a good one for photography, they should all visit Hudson for a photographic séance. She didn't need any more persuasion.

Houghton breathlessly recounted her subsequent four years of experimentation in monthly letters to the *Spiritual Magazine,* which were eventually collected into a book illustrated with fifty-four miniaturised *cartes-de-visite,* called *Chronicles of the Photographs of Spiritual Beings and Phenomena Invisible to the Material Eye* (1882), which joined her previous work, *Evenings at Home in Spiritual Séance* (1881). She travelled across London every Thursday to Hudson's backyard glasshouse studio, meeting friends or fellow mediums for regular appointments at which Hudson would coat, sensitize and expose three plates of her. Hudson wholesaled his photographs, of Houghton herself as well as of other celebrity mediums, to her, and she retailed them to her Spiritualist correspondents around the world, thus increasing his clientele as well as making enough profit to cover her own costs.[20] (See Figure 8.)

Miss Houghton and Mrs Guppy took turns to be photographed after they had cast the other into a mesmeric trance in a 'cabinet' – a curtained-off part of a room that supposedly collected and concentrated the psychic energy of entranced mediums. The women's theory was that, once mesmerized, they acted as batteries of stored-up spirit-power which could be drawn upon by the spirits as they manifested themselves before the camera. Spirits, speaking through another medium, Mrs Tebb, told the lady experimenters to wear clothes that they had had about their person for a considerable time, and to avoid wearing clothes that had just been laundered. Now that the blessing of spirit photography had come, they reported, there was a great desire from many thousands of spirits on the other side to show their faces to their friends once more.

Every Thursday Houghton would also perform mesmeric hand-passes over different parts of the studio, as well as the plates and jars of collodion emulsion, and she would sit on different pieces of furniture, use different backdrops, pose with different friends and mediums, and assist the frequently flurried and out-of-sorts Hudson with applying, sensitizing and varnishing the fragile wet-collodion plates. She constructed her own dark-cloth out of one of her black satin petticoats, for Hudson to use to cover and uncover his lens. There were many failures when Hudson was unable to produce for her the results she desired. However, in the resultant extended series of successful photographs, many different spirits appeared alongside Houghton. She usually managed to successfully recognize them as either members of her now departed family, or figures from the Bible with whom, in Houghton's self-constructed psychic world, she was on equally familiar terms. The photographic sessions Houghton held with Hudson became a kind of collaborative, extemporized theatre, where the spirits communicated not just the fact of their existence to

26

her through her recognition of them, but also discoursed with her in a kind of moral pantomime. They held symbolic flowers or jewels out to her; were crowned with globes, crosses or rays of pure light; stood in particular poses; assumed particular countenances; or appeared to interact directly with her.

Throughout her experimentation Houghton was encouraged by her spirit friends, who conveniently controlled and spoke through the mediums she regularly consulted in order to guide and confirm her interpretations. For example, in a photograph taken in May 1872 a spirit appeared standing close behind Houghton. She thought she recognized who it was, but since she had passed away over thirty years previously she couldn't be sure. Her sister, however, confirmed her recognition. It was her Aunt Helen, who had died of heart disease brought on by grief at the loss of her husband. She had left half her fortune to Houghton, who had gratefully exhausted it all on her Spiritualist enthusiasms. In Houghton's hermeneutic interpretation of the image, her aunt had appeared standing right behind her to indicate that she continued to support her from beyond the grave. Images such as this made their way into the albums of spiritualists all over the world[21] (see Figure 9).

Hudson's fame as a spirit photographer grew, and his waiting room became filled with Spiritualists, most of whom incontrovertibly recognized the ensuing extras. However, more sceptical Spiritualists also began to accuse him of fraud, by using the trick of pre-coating and pre-exposing his plates before applying another coating of collodion onto what the sitter assumed was a clean plate, or by double-printing two negatives onto one print. In the September 1872 edition of Spiritualist magazine, it was claimed that many Hudson plates showed clear signs of double exposure, with the pattern of a background carpet being seen through the dress of a living sitter, and other distinctive marks in the background being duplicated. But Hudson's supporters reported that during séances the spirits had conveyed an explanation for this apparent double exposure. Their psychical aura had a different density to the earthly atmosphere, they said, and therefore caused a 'double defraction' when they materialized during the long period of the exposure. In a supposed message from the other side, the spirits reassured the wavering sceptics:

> The success of our manifestations in these cases is to bring ourselves within
> the sphere of the sitter, and to amalgamate that sphere with our own. When
> rays of light pass through this mixed aura they are refracted and often cause
> things to be apparent which you cannot account [for].[22]

Unconvinced Spiritualists even accused Hudson of altering his negatives by hand, and dressing collaborators up as ghosts. Houghton complemented the disingenuous explanations of the supposedly spirit-controlled mediums with her own, thoroughly ingenuous, theory of spirit photography. She explained the flat, draped appearance of her

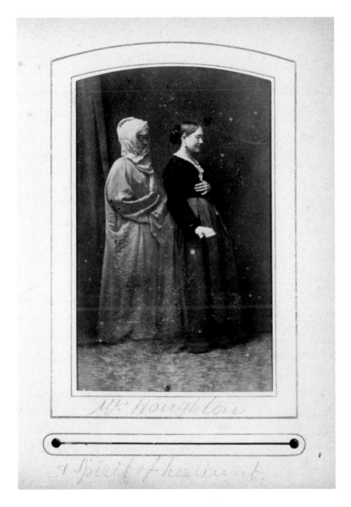

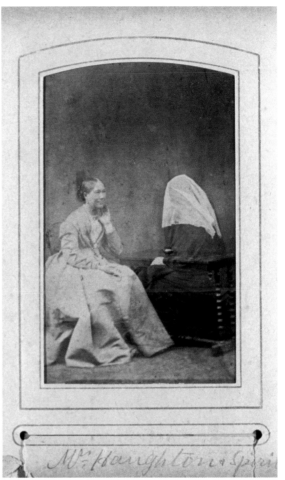

spirits as the result of them using their spiritual power with wise economy. What, for Houghton, was ultimately most convincing about the shrouded figures was not the unreal effect of their drapery, but the simple, unassuming modesty of their attitudes. Usually, she noted, people wanted their portraits taken in order to exhibit their ego, and they paid photographers to make the most of any good feature. For her, however, the air of peaceful repose of the spirits in Hudson's photographs (see Figure 10) was far more genuine than the hundreds of *cartes-de-visite* displayed in shop windows, where the sitters were full of self-consciousness and had an air of self-gratification.[23]

Chapter Two

SPIRIT
MATERIALIZATIONS

SPIRIT MATERIALIZATIONS

The studio glasshouses of Mumler, Buguet and Hudson were flooded with chaste daylight. But the world's most famous psychic scientist, Sir William Crookes, used the modern power of electrical lamps to throw both light and shadow onto his experiments with the young medium Florence Cook.

The chemist and physicist William Crookes had been made a Fellow of the Royal Society in 1863, for using the newly invented instrument, the spectroscope, to analyse light from mineral compounds and identify a previously unknown element, thallium. In 1867, he was devastated by the death of his much-loved youngest brother who, at the age of twenty-one, had caught yellow fever while laying a submarine telegraph cable in Cuba. At the time, Crookes was collaborating with a fellow electro-physicist Cromwell Fleetwood Varley, who was a pioneer of intercontinental telegraphy, as well as a clairvoyant. He persuaded Crookes to try to get in touch with his dead brother by Spiritualist means.[24] Over the next few years, Crookes was drawn deeply into the London Spiritualist scene and began to communicate with his brother. By the 1870s, Spiritualism had become a broad social movement. As a society fad and a popular enthusiasm, it was quickly dismissed and ridiculed by the press, but it also garnered many serious adherents from all social quarters.

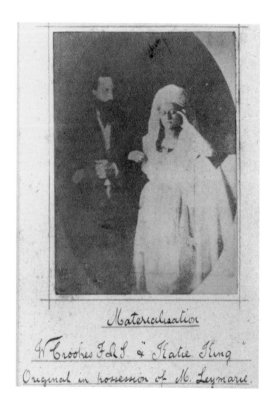

Figure 11. WILLIAM CROOKES, *William Crookes and Katie King, 1874. Albumen silver photograph, Barlow Collection, British Library, London.*

Crookes and Varley were part of an emerging group of psychic investigators who, at least initially, seemed to be very different from the passionate Spiritualist converts lampooned during Mumler's trial. They eschewed the occult mysticism of most so-called spiritual investigators for the experimental methods of modern science, with their basis in accuracy and observation. In 1870 Crookes reported to the *Quarterly Journal of Science*, which he edited, that he intended to use such methods to investigate the physical phenomena associated with Spiritualism. A year later he announced that he had found hard evidence of a 'psychic force' within the world's most powerful medium, D. D. Home. He had observed an accordion play tunes by itself within an electrified cage. He had measured the pressure of the psychic force on a set of weighing scales, and had directly recorded the force's action as it invisibly pulled down the end of a mahogany board, scratching a curve onto a smoked glass plate with its edge.[25]

In subsequent letters, Crookes not only vigorously defended himself against the virulent scoffing of his scientific colleagues, but also went on to enumerate the many

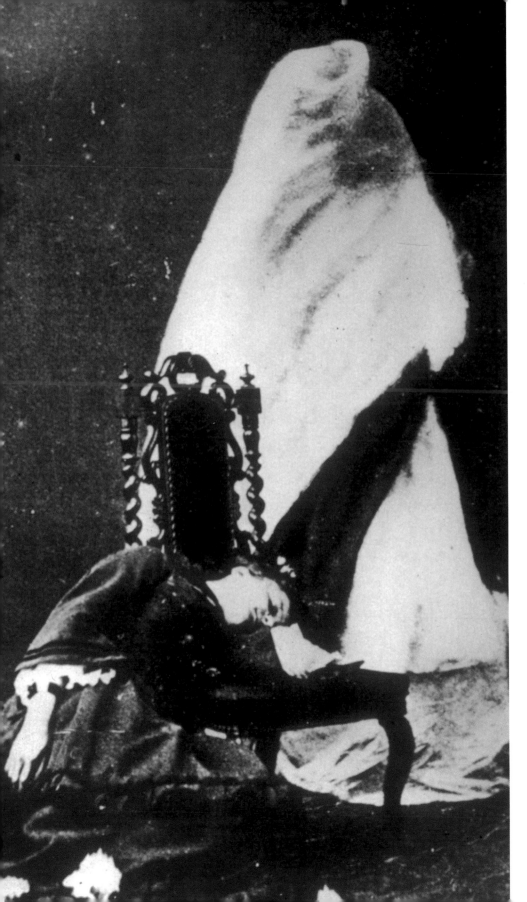

Figure 12. FREDERICK HUDSON, *Florence Cook lying in a trance, with a spirit form behind her, c. 1874. Albumen silver photograph, Mary Evans Picture Library.*

rappings, levitations, floating globes, luminous hands, phantom forms, and direct communication with 'invisible intelligences' he had witnessed at séances. The séances, he insisted, had been carried out under 'test conditions', where the medium was searched and obvious signs of fraud guarded against. Nonetheless, the Royal Society rejected Crookes' paper on D. D. Home.

Crookes' next sequence of experiments were reported, not in the scientific press, but to the more receptive Spiritualist press. In a letter to the *Spiritualist* of February 1874, he announced that he had begun an experimental campaign to establish the truth of the powers of Florence Cook. Cook was a 'materialization medium'. She not only communicated with the spirits through a code of raps, or by speaking in their voices, she was also supposedly able to physically materialize the spirits themselves. Cook had been operating as a medium for three years, since she was fifteen, from her parents' house in the respectable working-class London suburb of Hackney. At her séances sitters would usually gather round, 'like a party of grown-up children waiting for the magic lantern', according to one visitor, while Cook supposedly sat entranced in her cabinet.[26] Eventually, after some hymn singing, the curtains of the cabinet would part, and a fully materialized spirit called Katie King (see Figure 11) would step out, swathed in orientalist drapery. Katie was supposedly the daughter of John King, a sixteenth-century pirate. John King was Spiritualism's glamorous celebrity spirit. He was materialized by many different mediums, including Charles Williams, an American who while in London had mentored Cook. Frederick Hudson distributed a photograph of Williams and Samuel Guppy with a shrouded spirit-form superimposed on the plate (see Figure 7), and he had also photographed Cook swooning in a voluptuous trance, while a solid spirit-figure stood behind the chair[27] (see Figure 12).

In December 1873, Cook's mediumship became a popular scandal. At the behind-the-scenes instigation of Mrs Guppy, who was jealous of the younger medium's growing success, a sitter joined the séance circle in order to expose Cook as a fraud. At a séance, he suddenly gripped the spirit's hand when it was proffered to him to kiss. He grabbed the spirit around the waist, and exclaimed, 'It's the medium!' The low gaslight was immediately extinguished. Cook's fiancé, Elgie Corner, leapt up and wrestled the spirit free of the sitter's grasp and back into the medium's cabinet. When the gaslight came on again it was found that the spirit had somehow managed to tear off some of the sitter's beard and scratch his face. Some moments elapsed before the cabinet was opened. Cook was found moaning and unconscious, still apparently bound to her chair with knots sealed with wax, and still in her own black dress and boots. She was searched, but no trace of voluminous white drapery could be found.[28]

After this incident, Cook made the bold step of throwing herself at the mercy of Crookes' reputation, ambition and scientific methods. She invited him to establish the facts for himself. He willingly agreed, paying her for forty séances over the next five months,

32

publicly vouching for her, and making her the most famous medium of her era. At his home, he strung a curtain between his laboratory and his library, turning his library into an improvised cabinet. Like all sympathetic investigators, Crookes agreed to the condition that spirit and medium should not be touched without permission. However, he established 'test conditions' to his own satisfaction by sealing the doors and windows with wax and thread, and binding the medium's hands and feet.

Modern Spiritualism had begun just four years after Samuel Morse invented the electrical telegraph, and the extraordinary idea of telegraphy, where messages were turned into an immaterial code and invisibly transmitted over enormous distances, deeply structured Spiritualist thought. Crookes' collaborator, Varley, was a pioneer of intercontinental telegraphy, and he took the analogy between the Spiritualist medium and the electrical telegraph to its ultimate conclusion by submitting Cook to an electrical test. At one séance, Varley wired Cook up to a kind of polygraph machine, which he adapted from a patent of his that he normally used to test for faults in submarine telegraph cables. Treating the medium like a telegraph cable being tested, he constructed a circuit from a battery through platinum wire soldered to sovereigns pressed against Cook's wrists with elastic bands. Any movement the medium made would change the resistance in the circuit and be recorded by a galvanometer. During a materialization, the galvanometer recorded no sudden movements and Cook passed the test to Varley's satisfaction.[29]

At one of her appearances, the spirit Katie King had warned Crookes that if her material manifestation was exposed to the effects of more than one low gaslight she would be injured, so he constructed a lamp out of a jar of phosphorized oil, which gave him a source of light which was faint, but amenable to the spirit. At one séance, the spirit Katie invited Crookes into the cabinet itself so that he could establish that she and her medium were two separate entities. Kneeling, Crookes held one of the medium Cook's hands and passed the lamp along her entranced body as it lay in the cabinet, and then he turned and passed the lamp up and down the standing spirit's whole figure. He declared himself thoroughly satisfied that it was the veritable Katie King who stood before him, and not a phantasm of a disordered brain. Eventually, the desire to touch her became too much for Crookes and he respectfully asked her if he could clasp her in his arms. She agreed, and he was able to establish that, at least temporarily, she had become a material entity, and was not wearing corsets. In subsequent physical examinations of both spirit and medium, he established that the spirit materialization was taller and fairer, and had smoother skin and longer fingers than her medium, her ears were unpierced, her luxuriant tresses auburn not black, her pulse a rhythmic seventy-five not a skitting ninety, and her lungs sound and not afflicted with a cough.

Crookes had a long and deep involvement in photography and used it as an integral part of his scientific apparatus. The existence of Katie needed to be recorded. He had five cameras set up, five sets of coating, fixing and sensitizing baths, and electric lights rigged

to batteries. In all, he took forty-four successful exposures (see Figures 11 and 13). These were fundamentally different to the spirit photographs of Mumler, Buguet or Hudson, who were supposedly able to record unseen spirit forces on their plates. Crookes' images were conventional photographs of physical entities. To believers, the entities were spirits, fully materialized by the psychic power of the medium. To skeptics they were simply records of an imposture perpetrated by Cook alone, or Cook working with an accomplice.

Crookes had begun the test séances with a professed commitment to the objective scientific recording of observable phenomena. But within the crepuscular hush of the séance he was as beguiled by the spirit's ethereal, yet palpable, beauty as everyone else. It was clear that a strong current of seduction had begun to flow through the seances:

> Photography is as inadequate to depict the perfect beauty of Katie's face as words are powerless to describe her charms of manner. Photography may, indeed, give a map of her countenance; but how can it reproduce the brilliant purity of her complexion, or the ever-varying expression of her mobile features, now overshadowed with sadness when relating some of the bitter experiences of her past life, now smiling with all the innocence of happy girlhood when she had collected my children round her and was amusing them by recounting anecdotes of her adventures in India?[30]

Rumours started to flow that Crookes, whose wife was expecting their tenth child, was having an affair with Cook – described at the time as a 'trim little lady of sweet sixteen'.[31] Sitters also continued to remark on the dissimilarity between Katie and her medium at some séances, and their striking physical resemblance at others. Some started to ask why simpler and more explicit methods couldn't be used to establish that Katie was really a separate entity to Cook, such as marking Cook's forehead with indian ink. Others remarked that it would indeed be easy for the medium to smuggle a long white muslin veil into the cabinet secreted in her underwear, and under cover of the hymn singing remove her outer garments and arrange them over some cushions to look like a supine form, then drop the veil over her white underclothes ready to emerge from between the curtains.[32]

Amidst all this damaging speculation, Katie suddenly let it be known during a materialization that she only had energy to manifest on the material plane for three years, due to expire on 21 May 1874. The final séances in the week leading up to this date took place nightly at Cook's family home back in Hackney. Cook's bedroom was used as a cabinet. It had two doors, one leading to the séance room, and another leading to the kitchen stairs, which, significantly, Crookes himself took responsibility for locking. Once she had supposedly materialized behind the curtains, and before leaving the cabinet, the spirit wrapped her medium's entranced head in a shawl, in order, she said, to protect it from the light.

34

Figure 13. WILLIAM CROOKES, *Dr J. M. Gully and Katie King, 1874. Albumen silver photograph, Barlow Collection, British Library, London.*

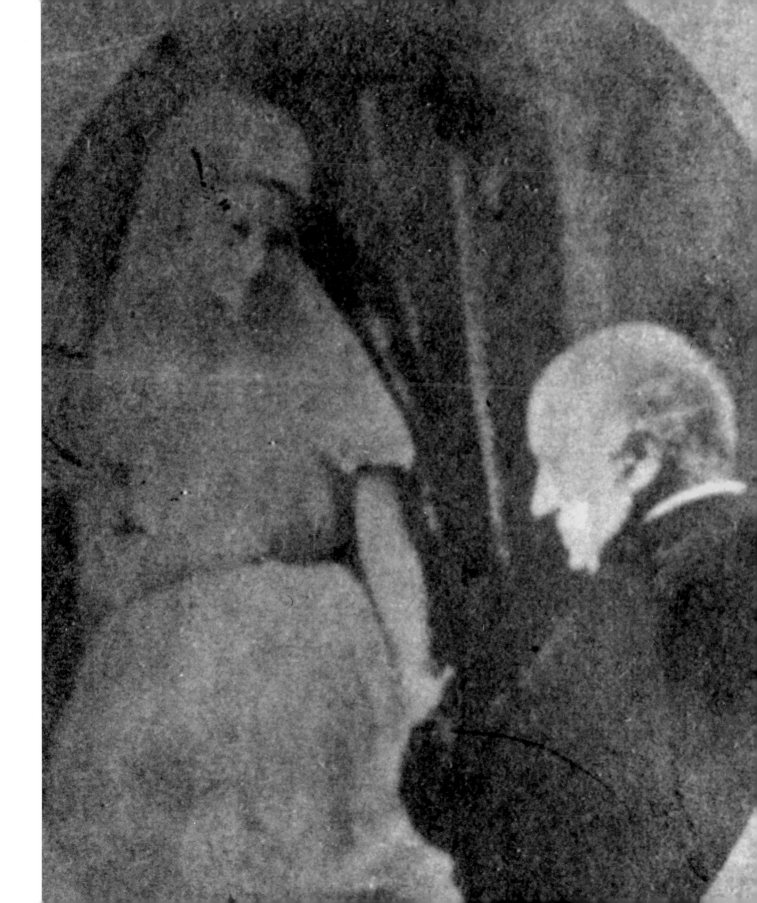

She then moved about under the full blaze of the light as freely as before, distributing flowers and locks of her hair to the sitters.

At last it was time for Katie's farewell. Crookes recounted for the readers of *The Spiritualist* how, at the end of her final séance, Katie had taken him back into the cabinet with her. Stooping over the medium, the spirit touched her and said: 'Wake up, Florrie, wake up! I must leave you now.' Cook woke and tearfully entreated Katie to stay a little time longer. 'My dear, I can't; my work is done. God bless you,' she replied. Crookes supported Cook, who had fallen on the floor, sobbing hysterically. He looked round, but the white-robed Katie, whoever she was, had gone. As soon as Miss Cook was sufficiently calmed, he led her out of the cabinet into the light.

After Katie's last farewell Crookes' experiments with Cook petered out, but he publicly acknowledged his debt to her:

> I do not believe she could carry on a deception if she were to try, and if she did she would certainly be found out very quickly, for such a line of action is altogether foreign to her nature. And to imagine that an innocent school-girl of fifteen should be able to conceive and then successfully carry out for three years so gigantic an imposture as this, and in that time should submit to any test which might be imposed upon her [and] should bear the strictest scrutiny ... to imagine, I say, the Katie King of the last three years to be the result of imposture does more violence to one's reason and common sense than to believe her to be what she herself affirms.[33]

He now channelled his energies into more orthodox researches, for which he received a knighthood in 1897, becoming president of the Royal Society in 1913. He and Varley began to experiment with the cathode-ray tube, a vacuum tube with an electrical terminal at one end. If an electrical current was run into the terminal, a faintly luminous ethereal glow resulted. (It was these experiments that Mumler cited in his memoirs as a scientific validation for his own mysterious powers of photographic mediumship.) In another experiment, a wheel suspended inside the tube slowly turned, although nothing visible touched it. Crookes concluded that these uncanny effects were produced by the cathode terminal emitting rays of electrified 'radiant matter', a fourth state of matter, neither solid, liquid or gaseous. In his report to the science journal *Nature* in 1879 he said, 'we have actually touched the borderland where matter and force seem to merge into one another, the shadowy realm between the Known and the Unknown which for me has always had peculiar temptations.'[34] It was up to later physicists to establish that the rays were not of material particles as Crookes had supposed, but of electrons ionising residual gas in the tube. But nonetheless their work eventually led to the discovery and use of X-rays, television picture tubes and fluorescent lighting.

In their research, physicists and electrical scientists, such as Crookes and Varley, were routinely thinking across different dimensions of space and time, where electrical impulses were transmitted thousands of miles instantaneously; and they were also thinking across different states of matter, where energy became matter. This made the supposed psychic phenomena they were also researching appear relatively familiar to them. Testifying in front of an 1871 Dialectical Society investigation of Spiritualism, Varley perfectly united his physics and his psychics by using a startling image drawn from practical nineteenth-century technology. Trying to explain how previously unknown psychic forces could penetrate our world from the other side via a medium, he used the scientific analogy: 'An iron wire is to an electrician simply a hole bored through a solid rock of air so that the electricity may pass freely'.[35]

Crookes never published or circulated the photographs from his final séances with Cook, and in 1887 told the Spiritualist writer Alexander Aksakov that all the negatives had been broken.[36] But neither did he resile from his statements of the early 1870s. In 1896 he became president of the Society for Psychical Research (SPR), a society dedicated to the clear-headed scientific investigation of psychic phenomena that had been formed by a group of Cambridge dons in 1882. Although the Spiritualists continued to celebrate him as their most distinguished advocate, his explanations for the phenomena he had recorded shifted, in keeping with the ideological focus of the SPR and in keeping with the direction of his own research with cathode-ray tubes, away from the conventional Spiritualistic ideas of invisible operators and the return of the dead, towards mental telepathy – a form of vibration continuous with other forms of electromagnetic vibration, such as radio or X-rays, which acted on the brain.

In 1922, after Cook had died in 1904, and Crookes in 1919, a man named Francis Anderson contacted the SPR in order to leave secret testimony. As a young man of twenty-three, he said, he had been seduced by Cook. At that stage she was living with her two teenage children in a country house supplied by her patron in Spiritualism Charles Blackburn. Her husband, Elgie Corner (the fiancé who had gallantly rescued the supposed spirit at the notorious séance of 1873) was a mariner away at sea at the time. In strictest confidence Anderson told the SPR research officer, Eric Dingwall, that although she was in her thirties she was still delicate and beautiful with fine flawless skin – and highly sexed. During their affair she had titillated Anderson with stories that indeed she had been Crookes' mistress during the period of the test séances, and he had been complicit in aiding the materializations so as to allow her to live in his house under his wife's nose, and to cover their trips together to Paris. For his part, during his life Crookes acknowledged to his friends the hurt the rumours had caused him and his wife, but he continued to deny them until his death.[37]

Whether the affair actually happened or not, it was clearly very present not only as a public rumour, but also as a private fantasy for the protagonists. Like so much else to do with

Spiritualist phenomena, the thought of the affair was a compelling, but elusive, idea inevitably produced by the sexual current that ran through the séances. The circuit of desire in Spiritualist investigation – to see, to know, to believe – was closed when the young *ingénue* medium gave the eminent investigator the phenomena he craved. This generated an intense emotional energy that suspended conventional scepticism, propriety and objectivity, and induced all kinds of extraordinary visions to appear. These visions shifted and slipped between the hermetic theatre of the darkened séance room and the minds and imaginations of the excited sitters. And, in a scientific period where entirely new and extraordinary physical phenomena seemed to be manifesting themselves everywhere, some of those visions even appeared to be able to slip themselves onto the photographic plates of the spirit photographer.

✠

In the decades following Cook's spectacular materializations, many other young female mediums acquired status, mobility and power within Victorian society by developing a range of psychic phenomena which they produced in the near-dark of the séance room, while apparently lying entranced in their cabinets.[38] Exotic objects were suddenly apported into the middle of the séance. Spirit hands materialized, were thrust into molten paraffin and then dematerialized, leaving a minutely detailed glove-shaped mould. Meaningful messages were received, and questions were correctly answered in the direct voice of spirit controls. To this list the full, or partial, materialization of spirit beings was added.

The Newcastle medium Elizabeth Hope, who conducted her mediumship under the name Madame d'Esperance, not only produced apports of exotically flowering plants six feet tall, but also produced full body manifestations. In her own account of her mediumship, *Shadow Land: or Light from the Other Side,* d'Esperance reproduced an 1890 picture of her most famous materialization, Yolande, a young Arab girl of fifteen, photographed peeping out from under her lifted veil by the brief flare of a lit magnesium ribbon (see Figure 14). While Cook's Katie King character was gentle and beneficent, d'Esperance's Yolande was a semi-barbaric girl, who did not even know what a chair was for, though she knew at once the use of jewels. But like Katie's, her body was real and carnally feminine.[39] In her book, d'Esperance added to the experience for her clients by confiding in them what it felt like being split in two as her body materialized the spirit for grateful clients:

> I begin to wonder which is I. Am I the white figure, or am I the one in the chair? ... It is my face which is being wet with the tears which these good women are shedding so plentifully, yet how can it be? It is a horrible feeling, thus losing hold of one's identity.[40]

Figure 14. Elizabeth
d'Esperance, *Yolande as she*
appeared when materialized,
photographed by magnesium light,
8 March 1890. Half-tone
reproduction, from d'Esperance's
book Shadow Land: or Light
from the Other Side, *1898,*
British Library, London.

Figure 15. ANNIE MELLON, *Mrs Mellon and 'Cissie', from a photograph taken at Edinburgh by Mr Stewart Smith on 3 September, 1890. Half-tone reproduction, from Thomas Shekleton Henry,* Spookland!, *1894, British Library, London.*

Opposite: Figure 16. ANNIE MELLON, *Mrs Mellon's control 'Josephine', from a photograph taken 16 March, 1894. Half-tone reproduction, from Thomas Shekleton Henry,* Spookland!, *1894, British Library, London.*

40

In the 1870s, Frederick Hudson had photographed two successful young mediums of the day, Miss Wood and Miss Annie Fairlamb (see Figure 8). By 1890, the two had quarrelled. Miss Fairlamb became Mrs Mellon, who was able to partially materialize Cissie, the spirit of a little African girl (see Figure 15). Shortly afterwards, after some embarrassing séance exposures, Mellon left Britain on a tour of New Zealand and Australia, and set up as a professional medium in Sydney, charging ten shillings a sitting. She not only materialized Cissie, but also Josephine, a beautiful young woman (see Figure 16) and Geordie, a gruff Scotsman.

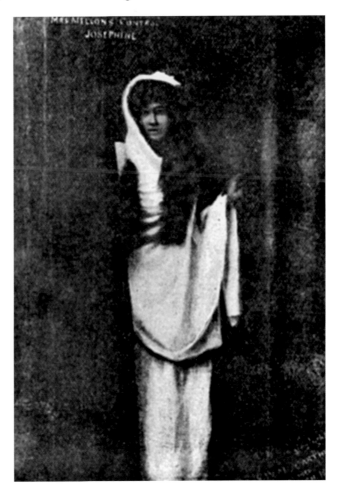

In Sydney, Mellon submitted herself to some photographic séances that were conducted under 'test conditions', which meant her clothing and hair were searched by two lady Spiritualists beforehand and, rather than wearing white underclothes, she wore coloured flannels which would remain recognizable under a thin drapery of muslin. Rather than the near-darkness usually required, the séances were conducted in daylight so the camera could record the materialization. However, the sitters were requested to sit with their back to the cabinet because Mellon claimed that in the daylight their direct gaze would bore holes into the spirits. Although the first test produced no usable photographs, two sitters did manage to obtain a clear view of a materialization by surreptitiously using hand mirrors to look over their shoulders. At the second test séance, all the sitters came equipped with mirrors. The spirits must have detected this subterfuge, because two whole hours of hymn singing failed to produce a single apparition, and only the gift of some valuable jewellery mollified the offended medium afterwards. Four days later, on 9 August 1894, while the sitters sat with their eyes tight shut, the camera photographed her standing in front of the cabinet curtains beside the partially materialized, flat form of Geordie (see Figure 17).

Like all materializing mediums, Mellon had to endure the constant threat of rude exposure. One of Mellon's most ardent devotees, T. S. Henry, recorded in a pamphlet he

wrote called *Spookland!*, how he had slowly become suspicious of the constrained movements the spirits made, the doll-like appearance of their faces, the sewn hems visible in their spirit drapery, and the fact that they could not leave footprints on the sooted slates he placed under them. At a darkened séance, he suddenly grabbed the spirit child Cissie and found that he actually had hold of Mellon, who was on her knees with muslin over her head and shoulders, black material over her face, and her skirt turned up over her stockingless legs.

After the fuss had died down, Mellon improvised an elaborate theory of materialization for the newspapers to explain away what had happened. She said that she always felt a numb chill as the 'psychoplasm', the stuff from which the spirit formed itself, poured out of her left side and her fingertips. The vapoury mass first fell to her feet in waves, then slowly formed a distinct human shape. As the form reached completion she became very weakened. When the delicate spirit form was suddenly interfered with during the séance, the science of materialization dictated that either the form had to be reabsorbed by the medium, or the medium reabsorbed by the form. As the form was held fast by Henry, the remaining matter of the medium had to be pulled forward off her chair to be reabsorbed by the spirit form. The spirit drapery had then rapidly dissolved off her like steam. And because the psychoplasmic spirit matter had come from her lower body, her legs had shrunk, causing her stockings and shoes to fall off. These explanations were accepted by at least one Sydney Spiritualist, who under the pen name 'Psyche' stoutly defended her reputation in his own pamphlet, *A Counterblast to Spookland, or Glimpses of the Marvellous.*[41]

42

Figure 17. ANNIE MELLON, *'Geordie' and Mrs Mellon, photographed by daylight 9 August, 1894. Half-tone reproduction, from Thomas Shekleton Henry,* Spookland!, *1894, British Library, London.*

43

SPIRIT MATERIALIZATIONS

PSYCHIC PHOTOGRAPHIC IMPRESSIONS

One of British Spiritualism's most energetic and public converts was the notorious reformist journalist and publisher William T. Stead. In 1893 Stead republished a report on spirit photography in his popular magazine, the *Review of Reviews*. The report was by J. Traill Taylor, the editor of the respected professional publication the *British Journal of Photography*. Taylor was also a Spiritualist who had been investigating spirit photography since the 1860s. Although he was convinced that the phenomenon was genuine, he had to admit to his more sceptical photographic colleagues that the spirit figures behaved badly before the camera. Some were in focus, others not. Some were lit from the right, while the living sitter was lit from the left. Some monopolized the entire plate, obliterating the sitter, while others looked distinctly haphazard and out of place, as though they had been cut out of another photograph by a can-opener and held up behind the sitter. When photographed with a stereoscopic camera, which required that two photographic plates be exposed simultaneously from two different angles, the spirit extras stayed flat, not three dimensional, and were out of alignment on the stereo plates. This led Taylor to the conclusion that the images were produced without the aid of the camera, at another stage in the process than the initial act of portraiture. 'But still the question obtrudes, how came these figures there? I again assert that the plates were not tampered with, by either myself or anyone present. Are they crystallizations of thought? Have lens and light really nothing to do with their formation?'[42]

An answer to this question quickly and conveniently came from the other side. Stead had developed automatic writing as his main way of communicating with the dead. Entrancing himself, he would begin to write, and then allow a spirit to control his arm, hand and pen, like a post-office clerk operating a telegraph machine. The spirit would continue with page after page of spirit communication, which Stead claimed he only comprehended when he read it for the first time at the end of each session. Through automatic writing he was in frequent contact with his spirit-guide Julia, an American journalist who had recently died. He published regular 'Letters from Julia' in a Spiritualist quarterly he had begun called *Borderland*. Desperate for a picture of Julia, in 1895 he sat for the London medium-photographer Richard Boursnell. He was delighted when he saw a beautiful female extra behind some ferns, but disappointed when Julia told him (through automatic writing) that it wasn't in fact, an image of herself he had been given, but her 'thought form' poured into the 'mould' of the unidentified lady in the picture. Thought itself could not be photographed, she told him, but spirit thoughts developed invisible memories into a materialized picture in the same way photographic chemicals developed a negative-plate.[43]

Whenever any spirits on our side manifest themselves, either by means of photography or by materialization, it is necessary for them to create what I

46

may call a mould, by which they can impress themselves upon the photographic plate ... we could, of course, make a fresh mould for every fresh sitting, but this would involve a great deal of trouble, and when you have got one good mould there is no necessity to take the trouble to make new moulds any more than there is to have a separate woodcut for every reproduction of a picture in a book, or taking a new negative for every portrait you desire to give away to your friends. You get the block and go on printing. We get the mould, and go on reproducing copies when they are wanted.[44]

This theory, that the photographic extra was really a reusable mould impressed onto photographic emulsion, was startling even by the audacious standards of the Spiritualists. But it consolidated all the various previous Spiritualist explanations of the phenomena. The spirit photograph was now a picture of a picture. Julia's explanation explained the flat cut-out appearance of many of the extras the Spiritualists revered, and why sometimes the same extras were seen on different plates, but it also meant that any spirit could present to the camera any thought picture of any person, living or dead, or even a copy of a photograph or a drawing.

47

This new theoretical possibility turned out to be a very convenient one for spirit photographers. For instance, in 1908 the deceased wife of F. C. Barnes told him, by speaking through a direct-voice trance-medium at a séance in Brisbane, Australia, to travel to London to visit Boursnell, where she would try to reflect herself. When Barnes arrived for the sitting Boursnell said: 'There is the spirit of a beautiful lady here, who seems in a very bright light, and suffered greatly on earth.' Barnes knew at once it was his wife, so he was greatly disappointed when the extra turned out to be the portrait frontispiece of a book called *The Martyrdom of an Empress*, about the assassination of the Empress of Austria, which Barnes remembered having read, and been greatly moved by, back in Brisbane (see Figures 18 and 19). However, it transpired that the appearance of this extra was only the 'intelligent operators of the invisible' reproducing a reproduction that was already strongly present to him, as a means of opening a channel between the two worlds. At his second sitting, when he brought along his two children with their additional psychic energy, his wife finally fulfilled her promise and an image of her appeared on the plate.[45]

Boursnell, although like Hudson before him, an elderly, seemingly doddery man, was

Figure 18. Elizabeth, the Empress of Austria, portrait photograph from the studio of Carl Pietzney, c. 1895. Half-tone reproduction, Barlow Collection, British Library, London.

48

 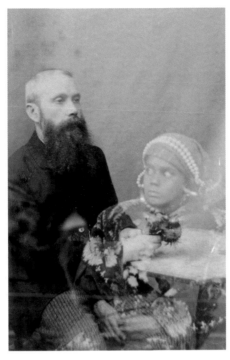

nonetheless Britain's busiest spirit photographer during the 1890s and 1900s. Because the same images appeared as extras on up to four different plates he was frequently accused of fraud, but in 1903 the Spiritualists endorsed him by presenting him with a purse of gold and a framed testimonial in a decorative border incorporating his own spirit extras. He appeared to many of his sitters to have clairvoyant powers, frequently declaring that he saw the spirit standing beside them during the exposure. To his sitters he was a genial old gentleman, a dear, old, simple, unpretentious mediumistic photographer who dried the tears and lifted sorrow from aching hearts. To sympathetic psychic investigators, who clustered around famous medium-photographers such as Boursnell, paying them for portrait sitting after portrait sitting supposedly conducted under 'test conditions', and excitedly writing up their results for the Spiritualist press, he was their classic image of the passive medium – a poor, illiterate man whom the spirit people nonetheless recognized was a great instrument with the highest virtues.[46] Like many other mediums, Boursnell photographed the materialised forms of many exotic spirits (see Figures 20 and 21). The British Spiritualist imagination, like the other alternatives to mainstream Christianity that developed at the same time, such as Theosophy, was Orientalist. It conjured an other side where colonial relations were reversed, and exotic Africans, Indians and Arabs, with their supposedly natural connection to vast mysterious reservoirs of spirituality, took precedence.

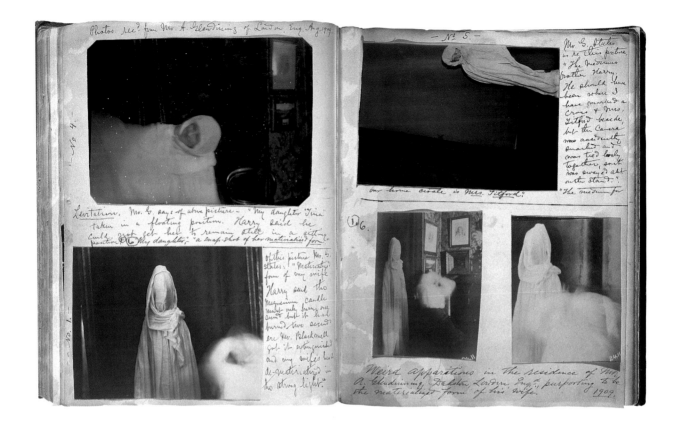

The handwritten annotations on the album pages include:

Photos. rec'd from Mr. A. Glendinning of London, Eng. Aug. 19—

– Nº 5. –

– Nº 4.

Levitation. Mr. G. says of above picture – "My daughter 'Tina' taken in a floating position. Harry said he could not get her to remain still in a sitting position." "My daughter," "a snap-shot of her materialised form."

– Nº 1.

1 & 6.

our home circle is Mrs. Titford."

Weird apparitions in the residence of Mr A. Glendinning, Dalston London Eng., purporting to be the materialised form of his wife. 1909.

50

Figure 22. Henry Blackwell, *The materialized forms of Andrew Glendinning's daughter, his wife, and the medium's brother, Harry, along with the medium Mrs Titford, 1909. Gelatin silver photographs in an album of spirit photographs assembled by W. J. Pierce, San Francisco Museum of Modern Art.*

With the activities of Taylor, Stead and Boursnell, London had become the centre of spirit photography. In 1903 the Californian Spiritualist W. J. Pierce made a pilgrimage to London, and met fellow spirit-photography investigators Andrew Glendinning and Henry Blackwell, who was eventually to amass a personal collection of over 2,000 spirit photographs. Pierce returned home with photographs by Boursnell as well as two other spirit photographers, David Duguid and C. Lacey, which he pasted into his album.

He kept in touch with developments in London, and in 1909 Andrew Glendinning sent him photographs taken by Blackwell of the spirit of Glendinning's departed wife. She had been materialized by the medium Mrs Titford, and had levitated herself around the parlour. When Blackwell lit a ribbon of magnesium to illuminate the scene for his camera, she instantaneously generated a shroud of drapery to protect herself from the flare[47] (see Figure 22).

Before leaving for his London trip, Pierce had conducted his own experiments with Edward Wyllie (see Figures 22–32 as examples of his work), who had set up as a spirit photographer in California. Pierce wanted to know who the spirits were who kept on

appearing as extras on Wyllie's portraits. He conceived of the idea of asking the invisible operators directly. He cut out some of Wyllie's extras and pasted them on a card with the question: 'Who are they?' Wyllie photographed the card and the disappointing reply appeared on the plate: 'You ask more than I can do' (see Figure 23).

As with all spirit photographers, Wyllie's sitters believed him to be a man without guile, modest, retiring, and too simple to be a fraud.[48] His extras came up close and intimate to the sitters, often appearing as large faces nestled across their vital organs. And, rather than the nobly pious or glamorously exotic spirits of the nineteenth century, deceased babies or aged relatives frequently appeared.

British Spiritualists began to send locks of hair to California, sealed into envelopes, which Wyllie photographed against a dark background, returning prints in which the envelopes were surrounded with extra faces, many of which were recognized by the grateful recipient. In 1909 the researcher James Coates, who was working on the first history of spirit photography, *Photographing the Invisible*, raised a subscription to bring Wyllie to Britain, where he practised until his death in 1911.

Like Boursnell, Wyllie was frequently accused of fraud. A writer for *The Progressive Thinker* found a negative of extras in a house which Wyllie had just left, and somebody else claimed that he had paid Wyllie to show him how to produce spirit photographs by holding a negative backed with luminous paint in his cupped hand against the plate during the process of magnetization. In reply, Coates cited the testimonies of professional photographers such as Robert Whiteford, his local photographer, whom he invited to visit Wyllie for a test sitting. In the darkroom, Whiteford loaded the plate-holders himself and withdrew the dark-slide to allow Wyllie to magnetize the plate with his hands, but detected no phosphorescence. However, he received an extra of an unidentified woman nestled in his lap (see Figure 24).

Under Wyllie's mediumship spirits seemed to take any opportunity to place their image on any of his plates, until at last they were finally recognized by a loved one. For instance, the wife of Wyllie's British patron, James Coates, had had a daughter by a previous marriage who had died as a young child decades before. An extra of a young girl appeared once in a Wyllie portrait of her surviving sister, and then again on the portrait of a stranger, a Mrs Shaw. In both instances the extra was recognized as her deceased daughter by her mother. To the mother, the extra looked just like a photograph of the surviving sister which had been taken at the same age the deceased daughter had reached before she had died, and she also recognized the familiar jewellery the spirit wore (see Figures 25 and 26).

Figure 23. EDWARD WYLLIE, *Arthur G. Krause and spirit extra; card of cut-out extras made up by W. J. Pierce, with the question 'Who are they?' and the reply 'You ask more than I can do', 1903. Gelatin silver photograhs in an album of spirit photographs assembled by W. J. Pierce, San Francisco Museum of Modern Art.*

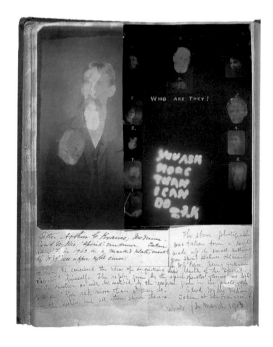

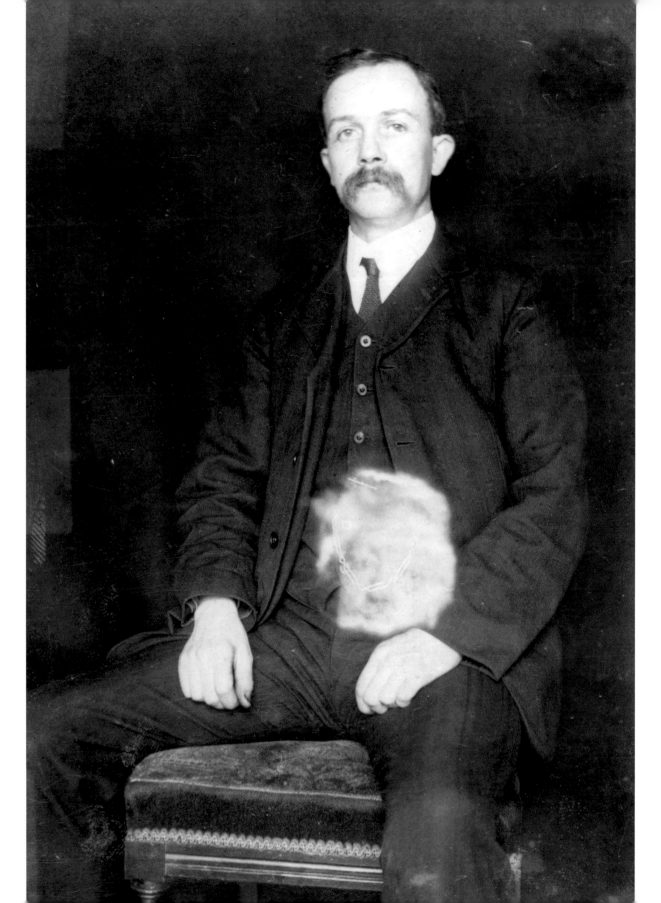

52

For the Spiritualists, one fact again and again dispelled all the doubts and ambiguities that surrounded spirit photographs – that fact was the incontrovertible thud of recognition they felt in their chests when the belief that they were seeing a familiar face once more hit home. During this period, big companies such as Kodak were marketing their cameras by heavily promoting the mnemonic value of amateur family snapshots, and more and more people were able to afford regularly updated professional portraits for their family albums. Amateur and professional photographs were gaining a ubiquitous authority as the prime bearers of family memory. The photographic portrait became an ever more intense arena for experiencing, nurturing, and sharing feelings of affection and connection. Photographs were intimately incorporated into people's lives as they were exchanged between dispersed family members to keep them in touch with each other. In this context, when the spirits revealed, through the voices of the mediums, that they had specific emotional and filial motivations for appearing within the family portrait, the act of recognition was sealed even more strongly onto the amorphous face of the extra.

Sitters closely entwined their personal and family memories into their experience of the photographic séance, and mediums were often able to pick up on their desires. For instance, a woman called Maria Payne sat for Wyllie, who during the exposure told her he saw a light beside her. At a subsequent séance Wyllie said, while entranced, 'I hear the name of Addy'. When Payne received the photograph, the extra's resemblance to a deceased cousin, Adeline, was so marked for her, and the likeness to the family so strong, that she was convinced it was Adeline returning to her. She wrote:

> This spirit photograph – so unexpectedly received, for I was hoping that I should get somebody else – has given me great pleasure. It is only recently that I have learnt that our loved ones are neither dead nor indifferent to the welfare of those left behind. I believe that she has given me this to comfort me and I prize it very highly.[49]

At a séance, James Coates' wife was controlled by the spirit of a woman who had returned to her husband as an extra on Wyllie's portrait of him. She tried to explain the process by which spirits such as herself established an ethereal connection back to our side of the veil through the force of spirit memory.

53

Opposite: Figure 24. EDWARD WYLLIE, *Mr. Robert Whiteford, professional photographer of Rothesay, with extra, c. 1909. Gelatin silver photograph, Barlow Collection, British Library, London.*

Above: Figure 25. EDWARD WYLLIE, *Woman with an extra of her baby sister, identified by the pattern of lace on her smock, c. 1910. Gelatin silver photograph, Barlow Collection, British Library, London.*

When we think of what we were like upon the earth, the ether condenses around us and encloses us like an envelope. ... our thoughts of what we were like, and what we would be better known by, produce not only the clothing, but the fashioning of the forms and features. It is here that the spirit-chemists step in ... using their own magnetic power over the etherealised matter [they] mould it so, and give to it the appearance such as we were in earth life.[50]

FACES OF THE LIVING DEAD

Opposite, top left: Figure 28.
EDWARD WYLLIE, *Woman with an extra of a baby in her lap, c. 1910. Gelatin silver photograph, Barlow Collection, British Library, London.*

Opposite, top right: Figure 29.
EDWARD WYLLIE, *Woman in black smock with spirits, c. 1910. Gelatin silver photograph, Barlow Collection, British Library, London.*

Opposite, bottom left: Figure 30.
EDWARD WYLLIE, *Woman with a boy extra over her heart and spirit, c. 1910. Gelatin silver photograph, Barlow Collection, British Library, London.*

57

Opposite, bottom right: Figure 31.
EDWARD WYLLIE, *Envelope and extra, c. 1910. Gelatin silver photograph, Barlow Collection, British Library, London.*

Figure 32. EDWARD WYLLIE, *Unidentified sitter and extra, c. 1910. Gelatin silver photograph, Barlow Collection, British Library, London.*

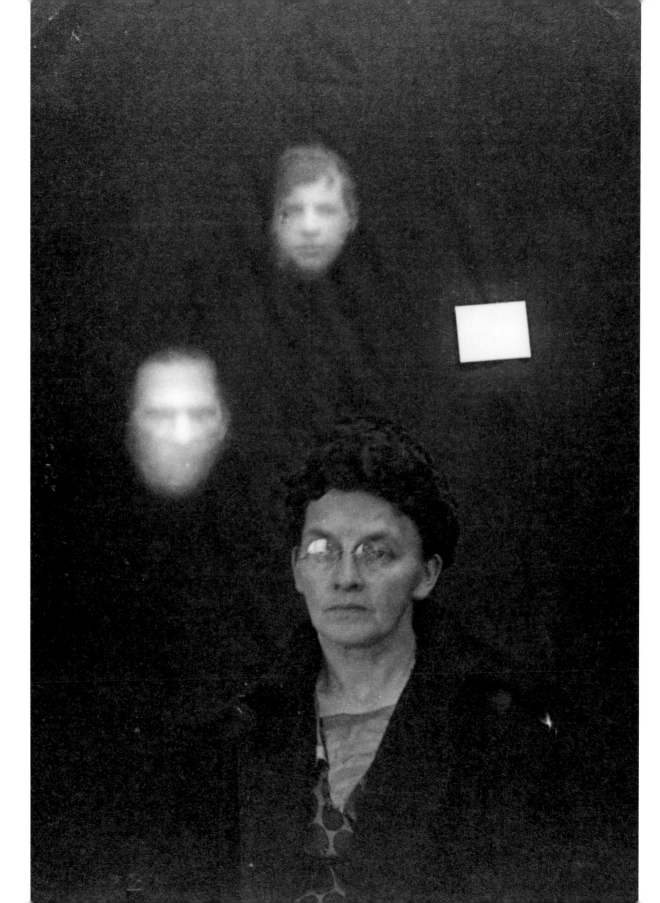

58

Spiritualists had always believed that psychic impressions could accumulate around objects that had become magnetically imbued with the presences of their owners. In 1920 the artist photographer M. J. Vearncombe, of Bridgewater, England, added spirit photography to his business. Like Wyllie, he invited people to send him a personal article belonging to someone who had crossed over, usually a letter, which he photographed, either by itself, or in tandem with the sitter. A Mrs Humphry received recognized extras in this way (see Figure 33), as did the keen psychic researcher Henry Blackwell (see Figure 34). The flying log-book of Lieutenant J. M. J. S., photographed sealed in a packet and secured by a clamp, managed to attract several unidentified extras all by itself (see Figure 35).

Opposite: Figure 33.
M. J. VEARNCOMBE,
*Mrs L. M. Humphry, two extras
and letter, 1921. Gelatin silver
photograph, Barlow Collection,
British Library, London.*

Vearncombe could be posted packets of plates, which he would keep close by him so they could be 'controlled' by spirits, before returning them supposedly unopened (see Figure 36). Upon development, various faces of spirits were found to be present. The Occult Committee of the Magic Circle, a group of stage magicians who exposed fraudulent mediums, sent him a package of plates which had had their top left-hand edges marked with red varnish, invisible in a darkroom. When the package was returned, complete with latent extras, it was found that the plates had been reversed in the package. The Magic Circle wrote to Vearncombe that that they were very pleased with the success of the experiment, but they needed reassurance that the packet had not been tampered with. Vearncombe replied that it had been 'controlled', but certainly not opened.[51] After sending a sealed packet of plates along with a guinea to Vearncombe, Miss Ina Jephson from the SPR also found that her package had been opened and the plates rearranged. She wrote ruefully to Eric Dingwall, 'I had hoped that the conventions of swindling and of psychic photography combined might have led Vearncombe to take a little more trouble – such laziness is really rather enraging.'[52]

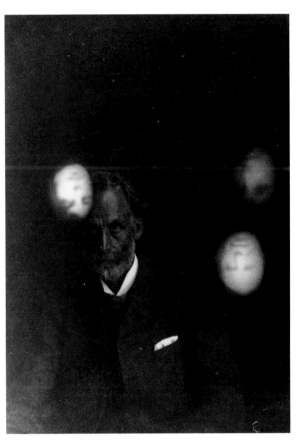

By this time a loose, but compelling, theory of spirit photography was firmly established. Extras were reusable images that had been moulded out of an etheric substance using spirit memory and impressed onto the photographic plate by the intelligent operators of the invisible. This theory either came ready made from helpful spirits, who supposedly gave long explanations in a medium's entranced voice, or it was developed slowly by Spiritualist investigators as they struggled to make their pre-established convictions fit around the evidence.

59

Figure 34. M. J. VEARNCOMBE, *Mr Blackwell and three extras, 1921. Gelatin silver photograph, Barlow Collection, British Library, London.*

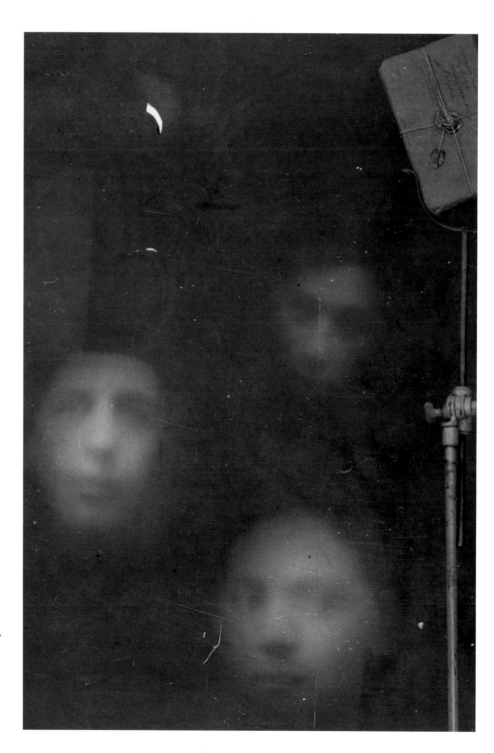

60

Figure 35. M. J. Vearncombe,
Flying log-book of Lieutenant
J. M. J. S., with unidentified
extras, 1920. Gelatin silver
photograph, Barlow Collection,
British Library, London.

But no matter which side of the veil it came from, the theory of spirit photography, like the Spiritualist imagination generally, was very much part of contemporary developments in technology and science. In the first years of the twentieth century Sir William Crookes, in his role as the scientific eminence of Spiritualism, was succeeded by another leading physicist, Sir Oliver Lodge, who worked on the development of electrolysis, X-rays and, most importantly, wireless telegraphy. Lodge constructed a huge machine, made of two massive discs spinning at high speed, between which he projected two beams of light in an attempt to record the existence of ether. Before Einstein's mathematics made it unnecessary, ether was assumed by all physicists to be the interstitial substance physically necessary to carry electromagnetic waves. The idea of ether structured Lodge's thought in both physics and psychics. In his presidential address to the Society for Psychical Research, Lodge proposed that spirits normally have a kind of etheric, or radiant body, but like the mollusk that can extract the material for its shell from water, they are able to temporarily utilize the terrestrial molecules that surround them for the purpose of building up a material body capable of manifesting itself to our senses.[53]

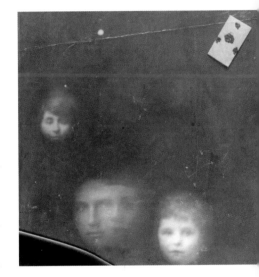

To other scientific Spiritualists this combination of biology and chemistry even provided a possible explanation for the elaborate classical drapery the spirits wore (which would at last substitute for the eschatological explanations of Georgiana Houghton, for whom spirit drapery was primarily a sign to a higher morality). Alfred Russell Wallace, the prominent Spiritualist, naturalist, and co-developer, along with Charles Darwin, of the theory of evolution, reflected on the appearance of Frederick Hudson's spirits. Wallace mused that drapery must be easier to materialize than the human form. The copious drapery in which spirits were almost always enveloped was there to show only just what was necessary for the recognition of the spirit's face and figure. 'The conventional "white-sheeted ghost" was not then all fancy, but had a foundation in fact — a fact, too, of deep significance, dependent on the laws of yet unknown chemistry.'[54]

At the cusp of the twentieth century, nobody could predict what was going to be a scientific dead-end and what wasn't. For Varley, Crookes, Wallace and Lodge it was impossible to disentangle their physical and psychical research. Identical analogies and metaphors structured their thought in both areas. And identical passions and lusts, for prestige, power and discovery, drove them. During this period of radical change in the fundamental underpinnings of physics, a certain amount of credulity was necessary for every scientist, to loosen the bounds of his presuppositions. And the inevitable incredulity of the public and their colleagues was to be expected, and had to be overcome, before any new idea was accepted, in either psychics or physics. The only clue to the future was that physics was progressing but psychics, which subscribed to the same modern ideology of progress, wasn't — although it did continue to pile up mountains of tantalizing evidence.

Figure 36. M. J. VEARNCOMBE, *Envelope with wax seals and four extras, c. 1921. Gelatin silver photograph, Barlow Collection, British Library, London.*

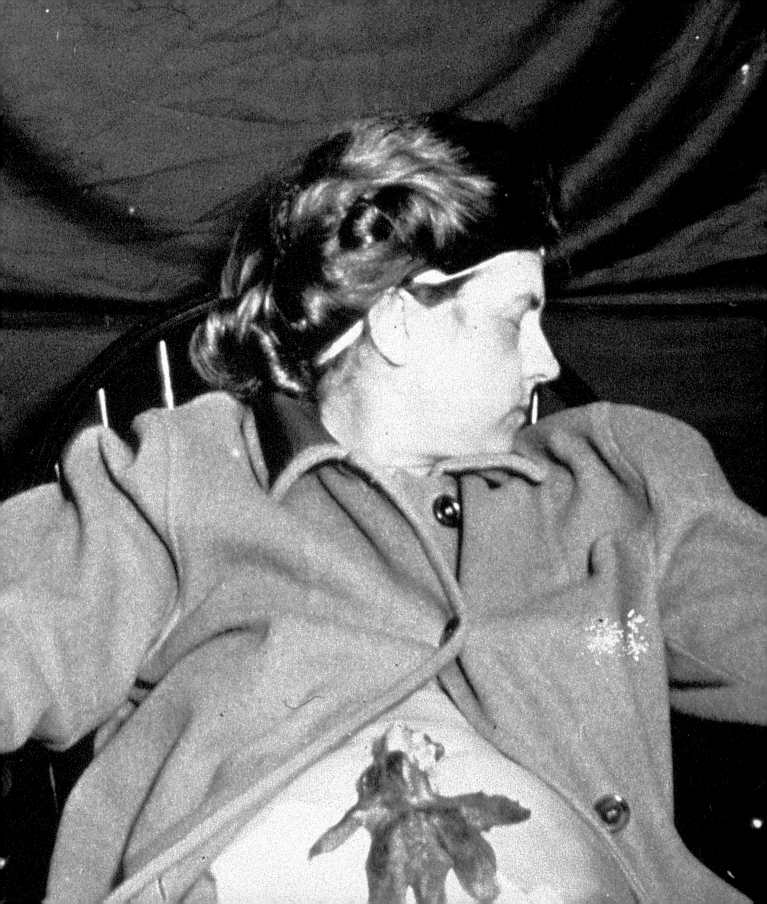

Chapter Four
ECTOPLASM

ECTOPLASM

In 1905, two amateur psychic researchers, General Noel and his wife, invited Professor Charles Richet from Paris to their villa in Algiers. Like William Crookes and Oliver Lodge, Richet combined a career in scientific research with a passion for psychic experimentation. In 1913, he won the Nobel Prize in medicine for his work on allergens, but continued to investigate most of the famous mediums of his time. The Noels had discovered powers in Marthé Beraud, the nineteen-year-old daughter of an officer in their garrison. In the style of previous materializing mediums such as Florence Cook, Marthé was able to materialize the full entity of Bien Boa, an Indian Brahmin who had died 300 years previously. For the twenty séances which Richet conducted with her in a locked room above the stables, Marthé sat in a cabinet improvised from a drawn curtain. She wore a thin dress because of the heat, and as Richet ran his hands in magnetic passes over her body he satisfied himself that she was concealing nothing. Finally, after a long wait in the dark, Richet noticed a white vapour forming in front of the cabinet curtains. This rose, becoming spherical, then grew into the upper part of a floating human form with a helmet and beard. Twice the form sank to the floor with a clicking sound like a collapsing skeleton, and twice rose up again. Richet took several photographs, which his colleague and close friend Oliver Lodge said were the best psychic photographs he had seen.[55] (See Figure 37.)

By 1909 Marthé had moved to Paris. She had passed into the close care of Juliette Bisson and was now operating under the name Eva C. The two submitted themselves to experiments conducted by Baron Schrenck-Notzing, a doctor who had become interested in hypnotism and psychic phenomena as a student. He had married well and now, being of independent means, was free to pursue his passion. Over the next four years he held hundreds of séances with Eva C in his Munich apartment, two Paris flats, and a villa by the sea.

Together the three slowly developed a new form of materialization, not the theatrical unveiling of a full-bodied personality from between the cabinet curtains, but the slow painful extrusion of wet organic matter from the visible body of the medium, which gradually formed itself into an entity. The theories the European investigators developed to explain these new phenomena were an organic elaboration on the nineteenth-century theory of spirit materialization. This was a much more mysterious process of the direct physicalization of psychic forces, not necessarily coming from beyond the grave, but inherent in the medium herself. The materializations were ectoplasms, psychoplasms, or teleplasms, akin to telekinesis and telepathy in that they were unknown forces extruding themselves into our world.

Schrenck-Notzing's preliminary medical examination had found Eva C physiologically normal, but psychologically weak and hysterical. Before some of the séances he examined her orally and vaginally, put her into tights and sewed her at the waist, back, neck and sleeves into an apron dress. At some séances she was fed bilberries to colour anything she

Figure 37. CHARLES RICHET, *Spirit of Bien Boa, 'Indian Brahmin', materialized by the medium Marthé Beraud, 1905. Gelatin silver photograph, American Philosophical Society, New York.*

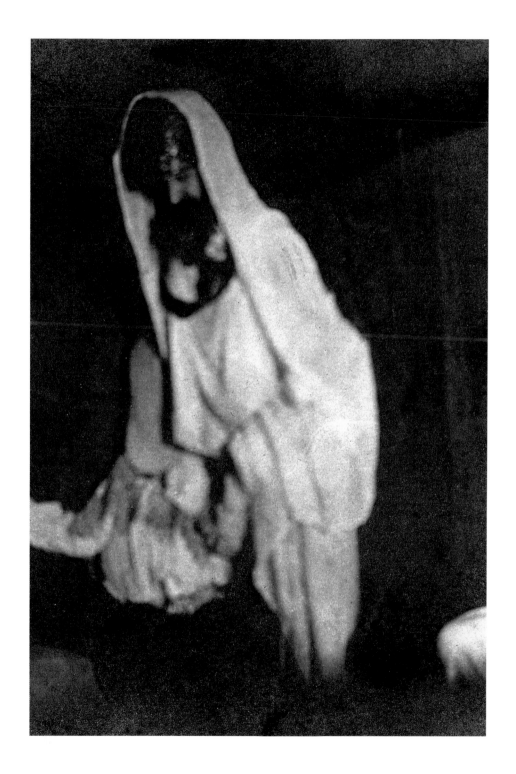

ECTOPLASM

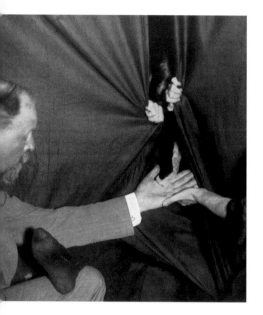
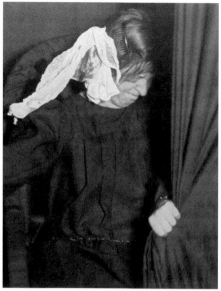
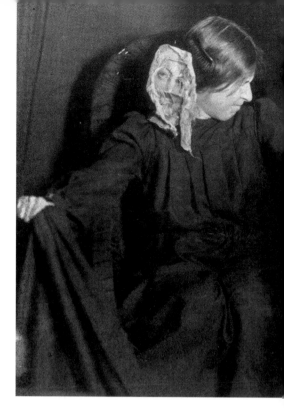

Left: Figure 38. ALBERT SCHRENCK-NOTZING, *First flashlight photograph by the author, 21 August 1911. Half-tone reproduction, from Albert Schrenck-Notzing,* Phenomena of Materialization, *1920.*

Centre: Figure 39. ALBERT SCHRENCK-NOTZING, *flashlight photograph of 22 November 1911. Half-tone reproduction, from Albert Schrenck-Notzing,* Phenomena of Materialization, *1920.*

Right: Figure 40. ALBERT SCHRENCK-NOTZING, *flashlight photograph of 8 May 1912. Half-tone reproduction, from Albert Schrenck-Notzing,* Phenomena of Materialization, *1920.*

66

regurgitated. After other séances she was given emetics to establish whether or not she had swallowed anything. But as they progressed these precautions were relaxed, the issue of fraud having been settled to Schrenck-Notzing's satisfaction. Eva C was hypnotized before the séances and fell into a trance, apparently controlled by a spirit calling herself Berthe. She whimpered, groaned and gasped behind the cabinet curtains as she produced the ectoplasm. Materializations were supposedly sensitive to light and touch, but it was found that Eva C could manage to withstand the painful shock of a brief flare of magnesium flash if the séance room was lit with dim red light, and she was allowed to ripen the materializations behind closed curtains and open the curtains herself when she was ready. So Schrenck-Notzing documented the phenomena with 225 photographs taken by a battery of five ordinary and stereoscopic cameras. Enthusiasts could purchase copies of the photographs for eight Deutschmarks each. As the séances proceeded, the complexity of the materializations gradually increased, starting from amorphous clumps of flocculent or diaphanous material. At an early séance on 21 August 1911, Eva C gave Schrenck-Notzing his long-desired-for result when she delivered a strip of moist, cool and viscous material into his hand from her mouth, which although it was fibrous, was to him comparable to abdominal connective tissue.[56] (See Figure 38.) By November, faces and heads were being photographed. Mask-like, flat looking, crumpled, veiled with cloth, and often with real hair attached, they were taken to be entities only partially completed by the teleplasmic forces.[57] (See Figures 39 and 40.)

In January 1913 Eva operated naked for her close mentor, Madame Bisson, alone. Bisson photographed a web of a substance, akin to intestinal connective tissue, stretched between

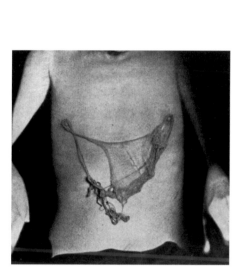

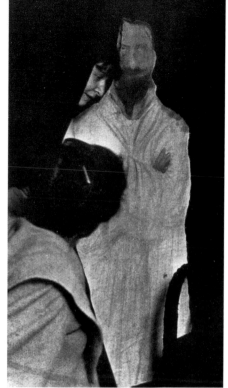

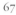

her nipples and navel. (For publication the shape of her breasts was retouched out – see Figure 41). She also photographed partially formed hands and fingers, and reported seeing a full-sized human head come out of Eva's vagina, which looked at her before disappearing again. By March 1913, Eva was partially manifesting the full figure of a male phantom, who appeared beside her economically suspended in two dimensions, rather than three (see Figure 42). Schrenck-Notzing planned to film Eva C with a cinematographic camera, but was unsuccessful. However, in mid-1913 he photographed another medium, Stanislava P, emitting ectoplasm though a veil which had been tied over her head, and cinematographed ectoplasm expanding and contracting into her mouth (see Figures 43 and 44).

Towards the end of his 300-page account of the Eva C séances, Schrenck-Notzing reflected on the inevitable accusations of fraud they would receive. He was the first to concede to his critics that the manifestations certainly bore all the signs of being cloth, pictures, or drawings, tightly folded and smuggled into the cabinet to be produced for the camera behind the curtain, under the cover of Eva C's labouring moans and groans. And, from time to time, he himself had even found pins and threads in the cabinet after the séance. But, to him, this evidence that he was the victim of a magician's sleight-of-hand remained purely circumstantial, and the possibility that he had discovered a previously unknown scientific phenomenon continued to beckon ever more strongly to him. So he fell back for assurance onto the 'scientific' manner in which he had conducted his experiments. He had searched every one of Eva's orifices except her anus, he had purchased a square yard

Left: Figure 41. JULIET BISSON, *flashlight photograph of 5 January 1913 (retouched). Half-tone reproduction, from Albert Schrenck-Notzing,* Phenomena of Materialization, *1920.*

67

Right: Figure 42. JULIET BISSON, *flashlight photograph of 24 March 1913. Half-tone reproduction, from Albert Schrenck-Notzing,* Phenomena of Materialization, *1920. British Library, London.*

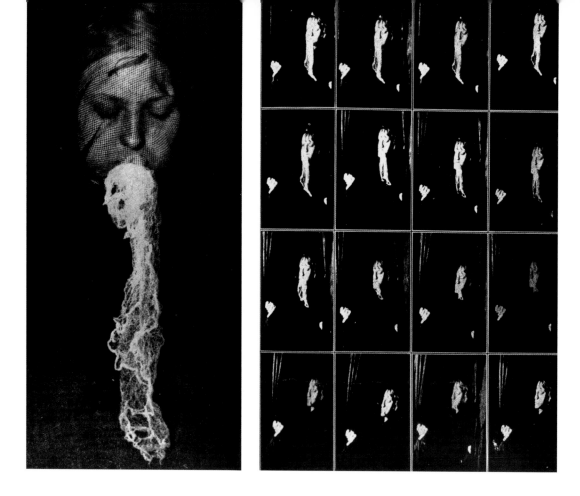

Left: Figure 43. ALBERT SCHRENCK-NOTZING, *Stanislava P., 1913. Half-tone reproduction, in Albert Schrenck-Notzing,* Phenomena of Materialization, *1920.*

Right: Figure 44. ALBERT SCHRENCK-NOTZING, *Selected cinematograph pictures of 25 June 1913, showing absorption of the substance into the mouth. Half-tone reproduction, from Albert Schrenck-Notzing,* Phenomena of Materialization, *1920. British Library, London.*

of the finest muslin and found he could only compress it down to the size of a small apple, he had ensured that the medium's hands were held by himself or Bisson during the séance, and he had meticulously recorded the lightning-like speed with which the materializations seemed to appear and disappear, without the medium's body appearing to move. He thus allowed himself to conclude, that, however suspicious Eva C might seem to the untrained eye, to the trained eye of the serious investigator her phenomena must follow a new natural law:

> If the play of a natural law, unknown to us, consisted in presenting to us optical images which are sometimes plastic, sometimes coarse, and sometimes equipped with the finest detail; having all the appearance of life on one occasion, and none of these on another occasion, we should have to accommodate ourselves to the fact, however strange it might appear ...[58]

Indeed, he argued, following the familiar logic of previous investigators, there were many reasons why the unknown force would manifest itself in this peculiar, two-dimensional way – it might be using a picture language already known to us in order to be intelligible, or in

order to economize on the use of the medium's teleplasmic matter. Charles Richet agreed: 'the materialization of a plaster head, or a lithographic print, is not in itself more absurd an idea than that of a human head, containing blood, movement and thought.'[59]

When Bisson, who Schrenck-Notzing never suspected might be an accomplice to Eva C's phenomena, had published her own book on Eva C in 1914, she included one of his photographs taken at a séance by a camera placed inside the cabinet. The photograph showed a creased white disc apparently coming from the side of the medium's head, and on the back of the disc a large printed word, looking uncannily like the masthead of the illustrated magazine *Le Miroir*, could be clearly discerned.[60] (See Figure 45.) This reproduction met with particular derision from the mainstream press. Debunkers went through back issues of *Le Miroir* and found distinct similarities between some of Eva C's entities and pictures of the President of the French Republic, President Woodrow Wilson, the King of Bulgaria and the actress Marie Leconte, which had been reproduced on its cover. But, unshakable in his convictions, Schrenck-Notzing replied:

> Is it rationally thinkable that, amidst the most puzzling phenomena which are sometimes exhibited even on the medium's naked body, suddenly a *Miroir* reproduction should appear? That is not only improbable, considering the course of the sitting, but is impossible on account of the experimental conditions observed during the sitting.[61]

Bisson also quickly improvised an explanation for the word. Eva C acted rather like a radio detector that makes audible sound waves out of inaudible radio waves. 'Miroir' had appeared as a sign to indicate that: 'What we see is never the thing itself but always the reflection of the thing which exists in another plane and is made visible in ours by Eva's strange material organisation.'[62]

In early 1918 another researcher, Dr Gustave Geley, who like Schrenck-Notzing was also a medical practitioner turned psychic researcher, began to examine Eva C at bi-weekly séances in his laboratory at the Paris Institute Metapsychique International, which, like the SPR, had been set up to scientifically examine psychic phenomena. Eva C, always accompanied by her close protector Bisson, manifested moving fingers and hands in the midst of ectoplasmic masses. Geley saw apparent ectoplasmic masses extend from her mouth, nose, eyes and fingertips, and, suspended from umbilical cords, form themselves before his eyes into beautiful doll-like heads. Geley was often so moved and surprised that he forgot to press the button for the flash that operated his stereoscopic cameras.[63]

Schrenck-Notzing had contented himself largely with detailing his observations, whereas Geley attempted to synthesize a theory of materialization into a 'metaphysical embryology'.[64] The ectoplasm emerged from the midst of the medium's birth pangs as a polymorphous protoplasm which, although not yet organised, was nonetheless

independently mobile and sensitive to the touch. Over time, this protoplasm organised itself into either complete body organs – fingers, faces or heads of various sizes – or representations looking like drawings or photographs.

> I have, for instance, seen the substance issue from the hands of the medium and link them together; then, the medium separating her hands, the substance has lengthened, forming thick cords, has spread, and formed ... epiploic [caul-like] fringes. Lastly, in the midst of these fringes, there has appeared by progressive representation, perfectly organised fingers, a hand, or a face.[65]

At this stage of biological research, well before the discovery of DNA, it was only through some unexplainable 'life force' that, for instance, an inchoate egg yolk was understood to organise itself into the different constituent parts of a chicken. Perhaps, psychic investigators reasoned, a psychic force could analogously form ectoplasm into spirit beings. But sometimes, even to Geley, Eva C's ectoplasmic entities appeared to be clearly simulacra, as if cut from paper. But these, he reasoned, must be products of a weakened psychic force: 'Like normal physiology, the so-called supernormal has its complete and aborted forms, its monstrosities, and its dermoid cysts. The parallelism is complete.'[66]

Like Schrenck-Notzing, Geley was convinced that he had eliminated all possibility of trickery. As William Crookes had done before him, he put on record his gratitude to the young medium for supplying him with the phenomena he was seeking: 'the intelligent and self-sacrificing resignation with which she submitted to all control and the truly painful tests of her mediumship, deserve the real and sincere gratitude of all men of science worthy of the name.'[67] (See Figure 46.)

In 1920 Eva C and Juliette Bisson were invited to London. They stayed for two months, and held forty séances for a committee from the SPR (see Figures 47–49). The SPR hired the photographic firm of Elliot and Fry to document the séances with electronic flash. Eva was stripped naked and given an oral, but not a vaginal, examination by the lady members of the committee, and sewn into a pair of tights to prevent previously hidden ectoplasm being surreptitiously produced. During the séances Eva cried out to Bisson, in French, 'Call, Juliette, call', and Bisson asked the investigating committee to encourage the phenomena by replying, in a chorus of French, 'Come! Come!'. While Bisson held her hands and encouraged her to give herself up to the forces possessing her, Eva would breathe stertorously, eventually managing to produce small white objects, flat photo-like faces with trailing tendrils of black fibrous hair, and proto-hands, one of which seemed to gesture to the Society's research officer, Eric Dingwall. As the sittings progressed, Bisson became tetchier and tetchier at Dingwall because he was reluctant to say anything other than that he was 'almost' convinced, even though he had been unable to detect any specific fraud.[68]

70

At the same time, the world's greatest magician, the American Harry Houdini, was also in London performing his feats of escapology on the London stage. There had always been a close, but fraught relationship between magic and Spiritualism. Mediums plundered the rich history of mesmerism, phantasmagoria and ventriloquism for their spiritualistic effects, but modern stage magicians had also emerged from exactly the same traditions.[69] In the nineteenth century, American mediums such as the Davenport Brothers toured the world presenting séances as theatrical events. Rival magicians such as John Nevil Maskelyne, who advertised himself as an illusionist and anti-spiritualist, trumped them by replicating Spiritualistic phenomena and scientifically debunking mediums on stage. Spiritualists accommodated themselves to these exposures by simply choosing to believe that they were passing off as conjuring what were actually genuine mediumistic powers. In the twentieth century, the Occult Committee of Britain's Magic Circle regularly entrapped mediums and spirit photographers, as did Houdini. Although Houdini was a passionate believer in the afterlife, he used his inside knowledge of stage illusion to expose those mediums he found to be frauds duping other, more innocent, believers.

Bisson usually banned stage magicians from Eva's séances because, she said, 'our work is serious and real, and the gift of Mlle Eva might disappear forever if some awkward individual insists on thinking there is fraud involved, instead of real and interesting facts, which especially interest the scientific.' In order to be favoured with an invitation, Houdini

Left: Figure 45. ALBERT SCHRENCK-NOTZING, *Side view (enlarged) taken within the cabinet, 1912. Half-tone reproduction, in Albert Schrenck-Notzing,* Phenomena of Materialization, *1920. British Library, London.*

Right: Figure 46. GUSTAVE GELEY, *The materialization of the upper portion of the face and of the eyes is more perfect than the lower portion, c. 1918. Gravure reproduction, from Gustave Geley,* From the Unconscious to the Conscious, *1920.*

offered free tickets to Bisson and Eva C for one of his own performances (in which he escaped from a packing case built on stage by experienced carpenters). In accepting the tickets, Bisson told Houdini that she had decided to make an exception to her rule for him, so that she could hear him:

> tell us all, after you have been thoroughly convinced yourself, that [the merit of Eva's performance] is far beneath your own, for these manifestations depend merely upon allowing the forces of nature to act, and lie simply in truth of fact. Whereas with you, it is your merit, your talent, and your personal valour that have enabled you to attain the place of King in your art.[70]

At the first séance he attended, Houdini resolved to adopt a positive frame of mind towards the séance. He saw Eva produce a quantity of foam from her mouth and nose, an unrolled bandage with a face on it, and a piece of inflated rubber. With the trained eye of a magician

Figure 47. SOCIETY FOR PSYCHICAL RESEARCH, *Eva C séance, 1920. Gelatin silver photograph, Cambridge University Library, Society for Psychical Research.*

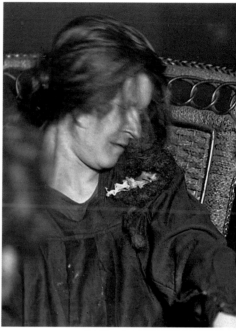

Houdini saw her sleight-of-hand the rubber back into her mouth, while every other sitter thought they had seen it suddenly disappear into thin air. For himself, Houdini finally concluded that Eva C regurgitated the ectoplasm, assisted by Bisson who put suggestions into the minds of the sitters as to what they were seeing. Subsequent chemical analysis of some of the ectoplasmic residue found it to be paper. The various members of the SPR committee, however, failed to agree on a definite conclusion that the effects were entirely fraud.

Eva C eventually broke up with Bisson, and withdrew from the séance circuit without ever being definitively exposed. Some time later her SPR investigators heard that she had married well, and returned a wealthy woman to North Africa, with a husband who ignored her paranormal past.[71]

✛

Left: Figure 48. SOCIETY FOR PSYCHICAL RESEARCH, *Eva C séance with ectoplasmic photograph emerging from under medium's chin, 1920. Gelatin silver photograph, Cambridge University Library, Society for Psychical Research.*

Right: Figure 49. SOCIETY FOR PSYCHICAL RESEARCH, *Eva C séance with ectoplasm on shoulder, 1920. Gelatin silver photograph, Cambridge University Library, Society for Psychical Research.*

In December 1922, the popular science magazine *Scientific American* offered $2,500 to the first person who could produce a psychic photograph, or other psychic phenomena, to the satisfaction of a committee that included conventional scientists, the principal research officer of the American Society for Psychical Research (ASPR), Walter Prince, and Harry Houdini. The magazine had previously offered similar prizes for investigations into Wilhelm Röntgen's claims that he had discovered X-rays; perpetual motion; and Einstein's theories of relativity and gravitation.[72] The contest was the idea of a *Scientific American* reporter, J. Malcolm Bird, a mathematician who was already convinced of the reality of psychic phenomena. 'One might as well try to deny Niagara or radio broadcasting as deny this. The thing occurs. What are we to do in the way of explaining it?' he asked his readers.[73]

Of all the mediums who came forward, only two were chosen to be examined closely by the committee. The first was quickly dispensed with when an electrical mechanism recorded him as being out of his chair at the same time as psychic phenomena were occurring in the total darkness of the séance. The second medium to be examined, known as 'Margery', proved to be much more difficult to deal with. She was controlled by the impish spirit of her deceased brother, Walter, and conducted her séances in close collaboration with her husband, the wealthy Boston surgeon L. R. G. Crandon. Together they had visited Europe and produced psychic phenomena in Paris, to the satisfaction of Geley and Richet. In London she had sat at the SPR and the British College of Psychic Science with similar success. Although the *Scientific American* committee purpose-built an extraordinary range of mechanical equipment to test the extraordinary range of phenomena she produced – telekinetically moving furniture across the carpet, apporting pigeons and roses into the séance, generating psychic lights that floated around the room, speaking in the direct voice of various spirits from different parts of the darkened room – they still split along party lines. Houdini quickly denounced her as a fraud and angrily left the committee, as other sympathisers insisted on giving her the benefit of the doubt.[74] As the interest of the popular press increased, fuelled by lurid details fed to them by Bird, more investigators were drawn to Margery. As the various investigators, who now included Eric Dingwall who was sent over from London by the SPR, gathered around Margery and her husband, they acrimoniously jostled with each other to produce definitive evidence, either exposing her as a fraud or confirming her as genuine, Margery responded by delivering new and more elaborate manifestations, finally moving into the photography of ectoplasmic extrusions.

At one sitting a photographic expert from the Massachusetts Institute of Technology took a photograph, which was reproduced in the *Scientific American*, of a cloud of light containing an ectoplasmic hand, which also caught an ectoplasmic baby's hand holding the little finger of one of the sitters.[75] (See Figure 51.)

Dingwall was eager to see more ectoplasm. In early 1925 Margery and her husband agreed to grant him a series of private séances, at which she wore only an open dressing gown

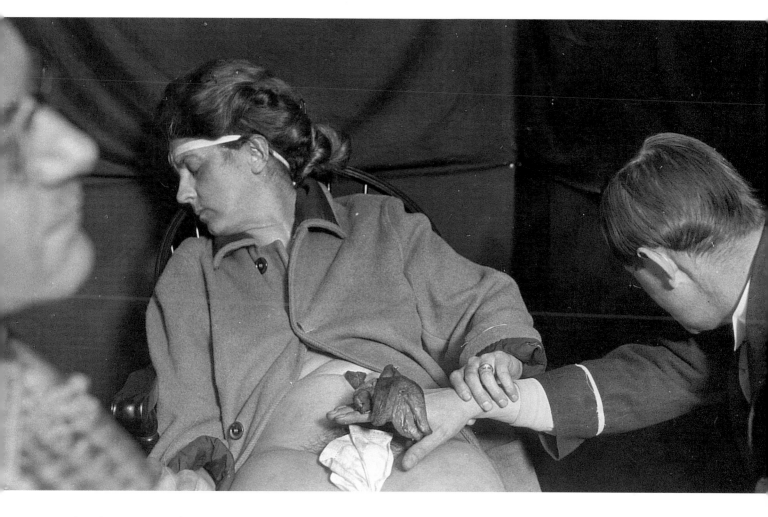

and stockings. At an early séance in the series, an excited Dingwall felt his hand touched by a tongue-like substance. By the light of a piece of cardboard painted with luminous paint, he saw a mitten-like hand slide across the table with a stealthy gliding motion. Later, hearing a rustling sound coming from her lap, he ran his hand up Margery's stocking until he felt a cold mass like uncooked liver on her thigh. This was flicked onto a luminous plaque on the table and, in silhouette, was seen to grow out finger-like tuberosities while still connected umbilically to Margery's abdomen. Later, Dingwall received permission from Margery's spirit control Walter to photograph this ectoplasmic extrusion (see Figures 50 and 52) by magnesium flash in the dark, but only at the precise moment Walter gave him permission. Dingwall showed the flashlight photographs of the ectoplasmic hand to William McDougall, chair of the *Scientific American* committee and professor of psychology at

Figure 50. SOCIETY FOR PSYCHICAL RESEARCH, *Margery séance, 19 January 1925. Eric Dingwall* (left) *and L. R. G. Crandon* (right). *Gelatin silver photograph, Cambridge University Library, Society for Psychical Research.*

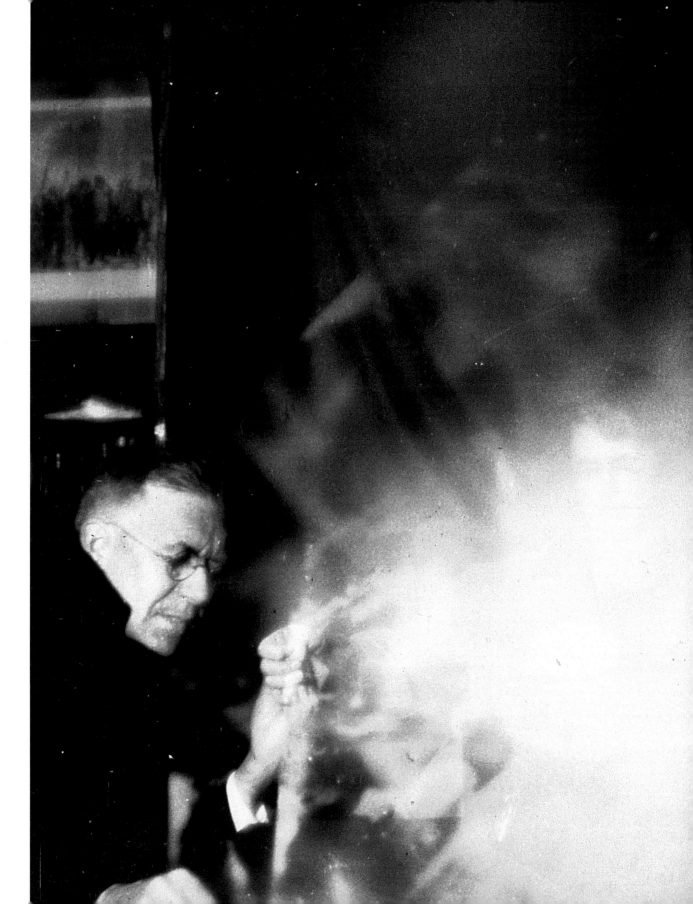

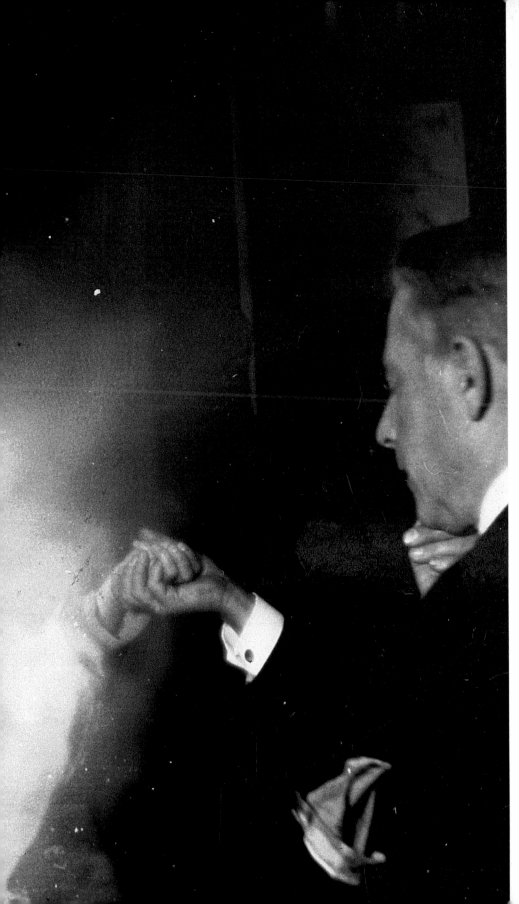

Figure 51. SOCIETY FOR PSYCHICAL RESEARCH, *'Walter promises photograph of his hand ringing the bell box. Taken by an instructor in physics at Mass Tech with his own quartz lens camera and plate. Flashlight, red light before and after. Beside Walter's hand in a cloud of ectoplasm, note the baby-like hand grasping the little finger of left-hand sitter. (Medium in cloud of light)'. Gelatin silver photograph, Cambridge University Library, Society for Psychical Research.*

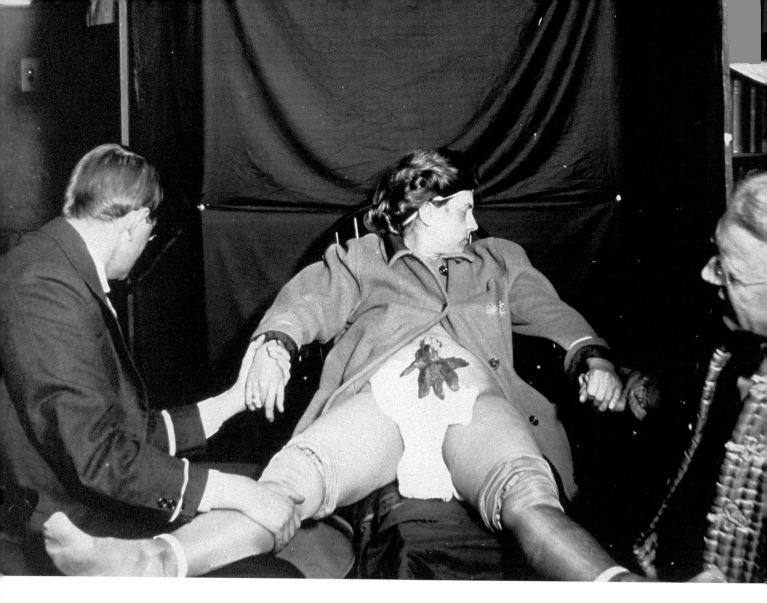

Harvard. Under his magnifying glass, they looked to him more like an animal's trachea and lung cut crudely into the shape of a wrist, palm and fingers, than 'genuine' ectoplasm. Dingwall next showed the photographs to a gynaecologist who confirmed that the substance, whatever it was, could be packed into a vagina and expelled. Shortly after this, Margery suffered a uterine haemorrhage and the weeks of séances came to an end. In the conclusion to his extended and forensically detailed report on these séances to the SPR, Dingwall felt he could manage to categorise all of the ectoplasmic phenomena as possible fraud. But he remained at a loss to explain the other uncanny phenomena he had experienced, like the sudden chill wind he felt at one of the final séances, and the unexplainable slowing down and speeding up of a gramophone record.[76]

From 1916 to 1920, another self-appointed psychic investigator, W. J. Crawford, conducted an extended series of experiments with the young Belfast medium Kate Goligher. Goligher was an eighteen-year-old blouse-cutter. Her family, led by her father, a collar-cutter, were known throughout British Spiritualism as the Goligher Circle (see Figure 53). The men who had investigated Eva C and Margery – Richet, Schrenck-Notzing and Geley – were medical doctors, and for their investigations Eva C seemingly produced various quasi-organic phenomena around which they developed elaborate physiological metaphors. Crawford, however, was not a medical doctor, but a mechanical engineer lecturing at the Belfast polytechnic. Correspondingly, the ectoplasmic phenomena Goligher created for him to observe appeared to follow familiar mechanical, as well as physiological, principles.

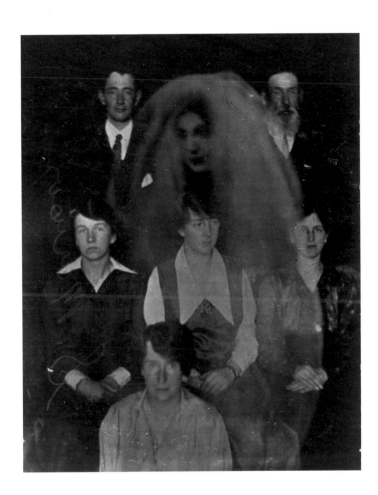

79

In 1916, Crawford began to investigate the Circle's ability to levitate tables and produce spirit rappings. The medium's feet were tied together, and then to the back legs of her chair, and all the hands of the sitters were supposedly held in a circle. The séances were conducted in darkness. However, if the invisible operator who controlled the medium was given warning, a dim ruby-lamp could be lit, a piece of card painted with phosphorescent paint unveiled, or a flashlight photograph taken. One such photograph showed what appeared to be a vertical column of light in the middle of the image. To our eyes the effect could be interpreted as the result of a light leak or a dribble of chemical fixer on the plate, but Crawford saw it as a 'psychic structure' with curved legs as a base and cantilevered arms (see Figure 54). Remembering how the medium had convulsed and shuddered for ten minutes after the photograph was taken, he reasoned that it must be an ectoplasmic structure briefly made visible for his camera in order to give him an indication of the invisible psychic mechanics, which had been employed to lever the table up.

Figure 53. WILLIAM HOPE, *The Goligher Circle, the sisters Goligher and their father and brother-in-law, with the brother-in-law's deceased mother appearing as an extra, c. 1920. Gelatin silver photograph, Barlow Collection, British Library, London.*

80

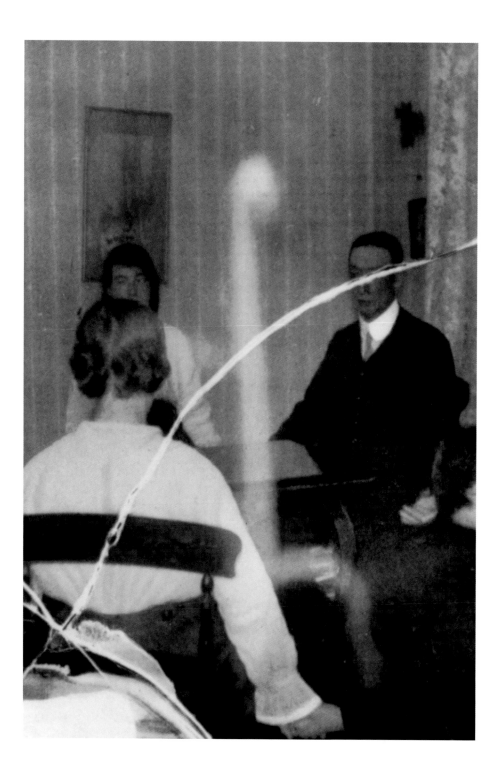

Figure 54. W. J. CRAWFORD,
*The psychic structures of the
Goligher Circle, 1917. Half-tone
reproduction from Crawford's*
The Psychic Structures of
the Goligher Circle, *1921.*

In fact, it is not too much to say that this whitish, translucent, nebulous matter is the basis of all psychical phenomena of the physical order. ... It is what gives consistence to the structures of all kinds erected by the operators in the séance chamber ... whether such structures are ones similar to those with which I am particularly dealing, or whether they are materializations of bodily forms like hands or faces.[77]

For the next four years Crawford explored the mechanical properties of these invisible psychic structures, asking his readers to remember that, 'I had to feel my way bit by bit with nothing to guide me. There was not a single signpost on the road.'[78]

The invisible operators demonstrated their presence by lifting a table using psychic rods that apparently emanated from the body of the medium. Working in the near-darkness of Goligher's séance room, Crawford deduced that the rods varied in diameter from about half an inch to three or four inches, and the free end of each rod seemed able to assume various shapes and different degrees of hardness. The ends could also expand to act like suckers to adhere to the underside of a table. As the table tossed in the air in front of the entranced medium, Crawford thought he could hear the suckers slipping over the wood in the dark. In a 1917 séance, one of these rods was laid in Crawford's upturned palm and he felt its flattened end. The rods had a feel of their own which was nearly impossible for Crawford to describe in words: soft, dense, plasmic, half solid, half liquid. If the rods were in a less tensile gaseous state, Crawford reported that he could even feel his hand passing through them, feeling a cold breeze of disagreeable, spore-like matter.[79]

Crawford put trays of wet clay under the table for the rods to leave an impression of themselves. He found the texture of Goligher's stocking fabric in the clay. But this, he reasoned, wasn't the result of the medium's foot being loose from its bonds. Rather, as the glutinous fibrous ectoplasm had oozed out of her body, it must have been pulled through the weave of her stocking before being wrapped around the inner core-force of the rods by the invisible operators, so it had retained the texture of her stocking. Sometimes he had heard peculiar 'fussling' noises from the neighbourhood of her bound feet and ankles, just prior to the phenomena. These noises occurred in spasms and were, he reasoned, probably due to psychic stuff fluxing through the material of the stocking. Likewise, when he found clay on her shoe, that also was consistent with the rod being retracted from the tray of clay, up her leg, and back into her body.[80] In some séances Crawford thought he could just make out the ectoplasm wriggle back up her leg like a snake.[81]

Crawford needed to track the rods to their source in the medium's body. Under his wife's supervision, Goligher put on white calico knickers into which he had sprinkled powdered carmine. In other tests he put carmine in her shoes. The theory was that the plasma would pull a trail of carmine behind it. After extensive experiments he proved to his

81

own satisfaction that the plasma came out of Goligher's trunk between her legs, traveled down her legs to her shoes (see Figure 55), and stiffened out to form rods, then returned by the same route. Crawford also felt Goligher's body undergo great stress as she produced the phenomena. A doctor who attended one séance measured her pulse rising from 72 to 126. As with the other psychic investigators and their ectoplasmic mediums, for Crawford,

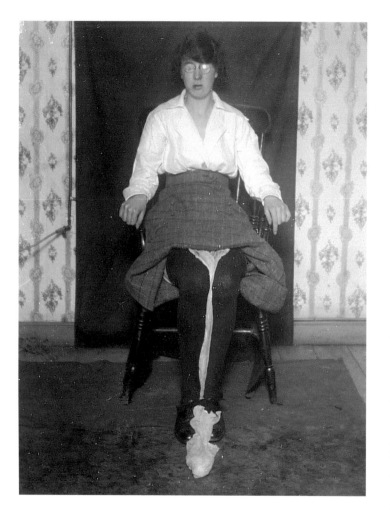

Goligher's psychic convulsions inevitably became metaphorically linked with the feminine mysteries of sex and birth. At another séance, Crawford put his hand on her thigh and felt the flesh seemingly become soft and cave in, then fill out again as the psychic stuff apparently returned to her. He felt her breasts become very hard and full during the occurrence of another psychic action.[82]

Crawford was desperate for photographs of the fully materialized psychic structures. The operators informed Crawford, through a code of raps, that he would be successful if he gradually worked Goligher up to being able to withstand the shock of the flashlight on her exteriorized plasmic body. Under the supervision of Crawford's wife, Goligher removed her knickers, corsets and petticoats before the photographic séances, and replaced them with underwear supplied by Crawford. Her head was often covered with a black cloth, and her dress often flipped up above her knees. In complete darkness the invisible operators produced the phenomena, and indicated by rapping when they were ready for the flash. After the flash, the séance room remained in complete darkness as the medium shivered violently for up to five minutes. As the photographic séances progressed, small patches of white were photographed between the medium's ankles, which gradually became longer columns and arms connecting the medium's body to the table.[83]

To more sceptical observers, however, these plasmic rods, when finally captured by the camera, looked remarkably like nothing more than stretched folds of cloth (see Figure 56).

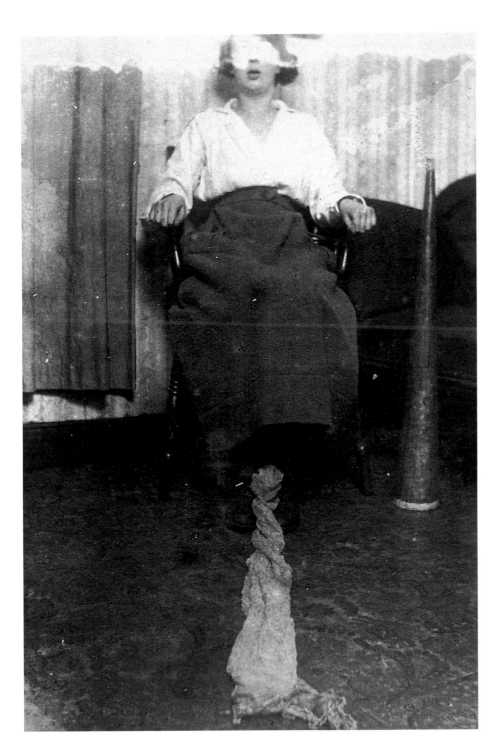

Opposite: Figure 55. W. J. CRAWFORD, *Kate Goligher with psychic structures, 1920. Gelatin silver photograph from the album 'Photographs taken at Belfast with The Goligher Circle 1920/21', Cambridge University Library, Society for Psychical Research.*

Left: Figure 56. W. J. CRAWFORD, *Kate Goligher with ectoplasm and speaking trumpet, 1920. Gelatin silver photograph from the album 'Photographs taken at Belfast with The Goligher Circle 1920/21', Cambridge University Library, Society for Psychical Research.*

ECTOPLASM

Crawford met Houdini when they were both in London. They talked for several hours and Crawford showed Houdini the photographs.

> 'Do you honestly believe that everything you have experienced through your contact and experiments with the girl is genuine?' Houdini asked.
> 'I am positive in my belief,' Crawford answered.
> After Crawford had gone Houdini was asked, 'What do you think of Dr Crawford?'
> 'He seems mad to me,' Houdini answered.[84]

While his third book on the Goligher Circle was still in manuscript, Crawford suffered a nervous collapse and committed suicide. Just before his suicide he had written to the editor of *Light*.

> My psychic work was all done before the collapse, and is the most perfect work I have done in my life. Everything connected with it is absolutely correct, and will bear every scrutiny, it was done when my brain was working perfectly, and it could not be responsible for what occurred. ... I wish to affirm my belief that the grave does not finish all.[85]

Crawford's literary executor and fellow Spiritualist investigator F. W. Warrick, asked E. E. Fournier d'Albe, who had just finished sitting with Eva C in her London séances, to continue Crawford's work in Belfast. Attempting to make shadowgraphs of the ectoplasmic rods, d'Albe placed some photographic paper on the floor under the table, on the underside of which he also placed two light bulbs attached to a switch. After much groaning and hymn singing, the operators indicated by three raps that they had flopped an ectoplasmic rod across the paper and were ready for the exposure. At the next séance he quizzed the operators about the resulting shadowgraphs (see Figure 57).

> 'I cannot make out this structure. In some places it appears as if woven. Have you a loom in your world?'
> 'No.'
> 'Is any of the structure shown on the photographs of what we call a textile or woven character?'
> 'No.'
> 'Is the apparent texture due to the way the substance emanates from the medium?'
> 'Yes.'
> 'In waves?'
> 'Yes.'[86]

At a subsequent séance, d'Albe showed the Golighers how he had been able to exactly imitate the ectoplasmic shadowgraph using ordinary muslin. 'You have got nothing yet', they told him, 'Dr. Crawford was four years working before he was satisfied. You will get what you want if you go on for some time.'[87] However, d'Albe was already regretfully concluding that the Golighers were frauds. And, as shots from the Irish Troubles rang out in the streets, he concluded his séances. He wrote later to *Light*:

> I had gone to Belfast fresh from Eva C's séance with a ... firm faith in Dr Crawford's reliability and accuracy. I expected a gifted medium surrounded by her honest folks, but then came the blows: first, the contact photographs, then the evidence of trickery. The sight of the 'medium' raising a stool with her foot filled me with bitter disappointment. The simple, honest folks turned out to be an alert, secretive, troublesome group of well-organized performers.[88]

Whether carried out under the reign of biological or mechanical metaphors, the quasi-scientific investigations of Crawford, Geley, Schrenck-Notzing or Richet shared two characteristics. They myopically concentrated on accumulating and analysing mountains of evidence, which they had to break down into smaller and smaller details in order to fit them incrementally into their predetermined psychic theories. And they cultivated glaring blind-spots – to the possibility, for instance, that their apparently simple and guileless mediums might actually be colluding with that medium's supposedly genuine and solicitous protectors. But the investigators were driven men following a long trail of tantalising evidence. They were led on as the intensity of the phenomena seemed to swell in direct response to the urgency of their search. The potential rewards were great: the intoxicating experience of being the first to witness apparently extreme theatres of bodily revelation beyond the reach of most people; and the possibility of going down in history as scientific pioneers. But the dangers, as the trails of evidence refused to ever lead to a definitive end, were just as great.

Figure 57. E. E. FOURNIER
D'ALBE, *Shadowgraph of
ectoplasm, 13 June 1921. Gelatin
silver photograph from the album
'Photographs taken at Belfast with
The Goligher Circle 1920/21',
Cambridge University Library,
Society for Psychical Research.*

THE RETURN
OF THE DEAD

THE RETURN OF THE DEAD

One Saturday afternoon in 1905, a carpenter from the English town of Crewe was experimenting with photography with a friend. In his later account of the day he told how he was surprised to find on one of the plates a transparent form, through which a brick wall remained visible. The friend recognized it as his sister, who had been dead for many years. Shortly afterwards the carpenter, William Hope, formed a séance circle with the medium Mrs Buxton, the wife of the organist from the Crewe Spiritual Hall. The circle concentrated on spirit photography, with Hope photographing in a ramshackle glasshouse behind his house. In 1908, the circle's powers were investigated by the keen Spiritualist, Archdeacon Thomas Colley, the Rector of Stockton. He came for a sitting and recognized his mother as the extra. However, she had never been photographed in her life, so his recognition couldn't be verified. He advertised in his local paper, asking all those who had known his mother to come to his rectory. Eighteen people came, and identified the extra out of several other photographs. Colley reproduced the photograph in a flyer in which he also included excerpts from a letter he had sent to his Bishop:

> Can anyone suppose that after my many years' experience in amateur photography, I would befool myself in such a sacred matter of family affection, or being a Beneficed Clergyman of the Church of England, would be utterly lost to all sense of honour and truth as to enact so base a fraud?[89]

In order to encourage Hope and Buxton, he presented them with a quarter-plate camera. Hope would later solemnly inform his sitters: 'Archdeacon Colley knelt just where you are standing ... and prayed, thanking God for what he had received'.[90]

Hope and the Crewe Circle came into their own immediately after the First World War, when the world was swept with a new craze for Spiritualism following the immense combined death toll of the war and the influenza epidemic. Their work was eagerly examined, promoted and endorsed by the Society for the Study of Supernormal Pictures, the SSSP, which had been formed by a group of well-credentialled and eminent Spiritualists in 1918. Soon after its formation Hope photographed a meeting of the Society, who collectively received an extra of the father of one of their members lying on his side in the middle of the image (see Figure 58).

If clients made the pilgrimage to Crewe, Hope charged four shillings and sixpence for a dozen prints, based on his wages as a carpenter. As his fame grew, he regularly travelled to London to hold sittings at the imposing premises of the British College of Psychic Science. The BCPS had been set up in 1920, in opposition to the more circumspect investigations of the SPR. It was owned by Mr and Mrs McKenzie, two zealous promoters of Spiritualism

Figure 58. WILLIAM HOPE, *The Society for the Study of Supernormal Pictures with an extra, c. 1921. Gelatin silver photograph, Barlow Collection, British Library, London.*

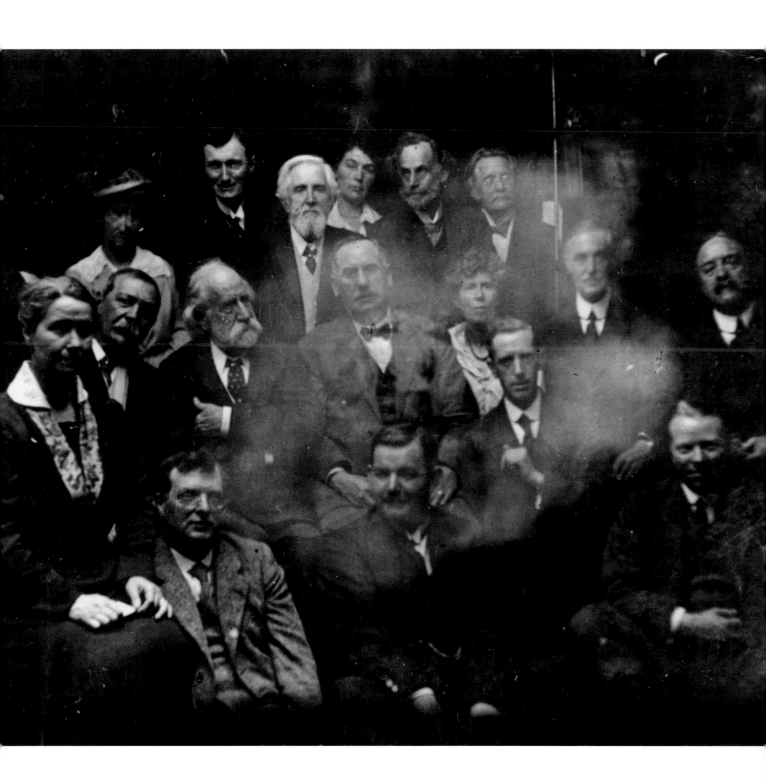

THE RETURN OF THE DEAD

who had lost their son to the war. They charged two guineas for a sitting with Hope, although Hope continued to use the rickety old camera originally given to him by Colley. For some reason spirit extras eschewed the multi-exposure roll-film cameras that were becoming standard in the post-war period, and would only appear on glass plates in old-fashioned plate-holders where, conveniently, each negative had to be individually handled by the photographer. On departure, sitters signed an agreement indemnifying the BCPS against any legal action. And they were not allowed to take the negatives from the premises.

Figure 59. Curious photographic effect, taken by the Official Photographer, Brisbane 1921; 'absolutely mystifying' is his description. Half-tone reproduction, from Arthur Conan Doyle, The Wanderings of a Spiritualist, *1921.*

The famous creator of that arch-rationalist Sherlock Holmes, Sir Arthur Conan Doyle, had been a jingoistic propagandist during the First World War. Following the deaths of his brother and his eldest son, Kingsley, as a result of wounds received in the war, he became an evangelical Spiritualist. He used his wealth and fame to proselytise the cause in bluff pugnacious lectures delivered from platforms across the world. In 1920 and 1921 he spoke to 50,000 people in Australia alone. He was feted by Spiritualists, and criticized by conventional churchmen, while he lobbied the press and courted politicians. He was even occasionally attended by the odd unexplainable psychic phenomena of his own. In Brisbane, for example, he showed his good will by investing £2,000 in Queensland Government Bonds. The government photographer turned up to take his portrait as he handed over the cheque on the steps of Parliament House, but Sir Arthur was obscured by what appeared to be a cloud of ectoplasmic light on the plate (see Figure 59). Doyle's equable comment was:

> I am prepared to accept the appearance of this aura as being an assurance of the presence of those great forces for whom I act as humble interpreter. At the same time, the sceptic is very welcome to explain it as a flawed film and a coincidence.[91]

In each town and city Doyle gave three lectures, two on Spiritualism, and one, illustrated by glass lantern-slides projected onto a screen, on spirit photography. The public meeting and lantern-slide lecture were just as important to the Spiritualist experience as the home séance. Nineteenth-century Spiritualists commonly used the very new, very modern and very practical communication technology of the telegraph as a metaphor to explain spirit

communication. In the twentieth century, the telegraph was joined by the wireless broadcast and the lantern-slide projection as technologically updated metaphors for the psychic experience. For example, in 1917 a message 'telegraphed' from a discarnate spirit through the mechanism of automatic writing asked people receiving thought-messages from the other side to keep the screen of their minds bare of conscious thought, so as not to blot out the thought-images projected by the spirits.[92]

The idea of this blank 'thought-screen' was technically related to the unexposed photographic plates and to the white cinema screens prior to images being cast onto them, but it also drew upon every individual Spiritualist's intimate, but communal, relationship with the lantern-slide lecture. During Doyle's first Australian lantern-slide lecture in Adelaide, a strange phenomenon occurred which he could only explain as a ghost inhabiting the machine itself. He was showing a slide of a single spirit face appearing amongst a crowd of terrestrial faces, but the slide was fogged with condensation. Like every seasoned lantern-slide lecturer, Doyle knew that such fogging always dried from the edges inward, leaving a dull spot in the middle as the last area to clear, but not this one.

> Suddenly, as I turned away, rather abashed by my failure, I heard cries of 'There it is', and looking up again I saw this single face shining out from the general darkness with so bright and vivid an effect that I never doubted for a moment that the operator was throwing a spotlight upon it.

Later the lantern operator told him that never, in all of his thirty years of experience, had he seen a slide clear from the centre outwards, as this one had.[93]

Conan Doyle's lectures provided implicit comfort to the bereaved. The Melbourne *Age* reported: 'Unquestionably the so-called "dead" lived. That was his message to the mothers of Australian lads who died so grandly in the War, and with the help of God he and Lady Doyle would "get it across" to Australia.'[94] In the context of collective post-war grief, the spirit photographs by Boursnell, Wyllie and Hope, which Doyle had brought to show during his lectures, worked in quite a different way, in their open-endedness, from the monumental and mute funeral portrait. In 1919, the Australian Spiritualist newspaper *Harbinger of Light* took delight in quoting the Rev. T. E. Ruth, the minister of the Collins Street Baptist Church, Melbourne:

> I have been impressed by the fact that [spiritualist literature] has been concerned with the practical comfort of mourning multitudes, while ordinary church papers have been almost as deficient in spiritual consolation and guidance as that dreadful 'In Memoriam' doggerel about there being nothing left to answer but the photo on the wall.[95]

Doyle was one of the vice-presidents of the SSSP, and a key promoter of Hope. He had been to Hope to obtain a photograph of his fallen son, and published the resultant image in newspapers and magazines around the world. The *Sunday Pictorial* reproduced the photograph flanked by a photographic reproduction of Doyle's handwritten testimony:

> The plate was bought by me in Manchester. On reaching Mr Hope's studio room in Crewe, I opened the packet in the darkroom and put the plate in the carrier. I had already carefully examined the camera and lens. I was photographed, the two mediums holding their hands on top of the camera. I then took the carrier into the darkroom, took out the plate, developed, fixed and washed it, and then, before leaving the darkroom, saw the extra head upon the plate. No hands but mine ever touched the plate. On examining with a powerful lens the face of the 'extra' I have found such a marking as is produced in newspaper process work. It is very possible that the whole picture, which has a general, but not very exact, resemblance to my son, was conveyed onto the plate from some existing picture. However that may be, it was most certainly supernormal, and not due to any manipulation or fraud.[96]

Ordinary Spiritualists also endorsed Hope with their personal testimony. After calling on Hope without an appointment, a Mrs E. Pickup wrote to him:

> No words of mine can express my gratitude to you ... The extra one is my dear husband, and just as I prayed he might come — an exact copy of the one I have at home and the one I liked the best. Every detail is so clear and correct, even to the dimple in the chin. What could be more convincing ... That visit will remain imprinted on my memory as one of the brightest days of my life. I am sure after such evidence as this and the way in which you carried out your work, I need never suffer the pangs of loneliness again, because I believe that God has taken him to a higher sphere.[97] (See Figures 60 and 61.)

Above and opposite: Figures 60 and 61.
WILLIAM HOPE,
Mr E. Pickup (above) and Mrs E. Pickup and the psychic likeness of her husband (opposite), c. 1922. Gelatin silver photographs, Barlow Collection, British Library, London.

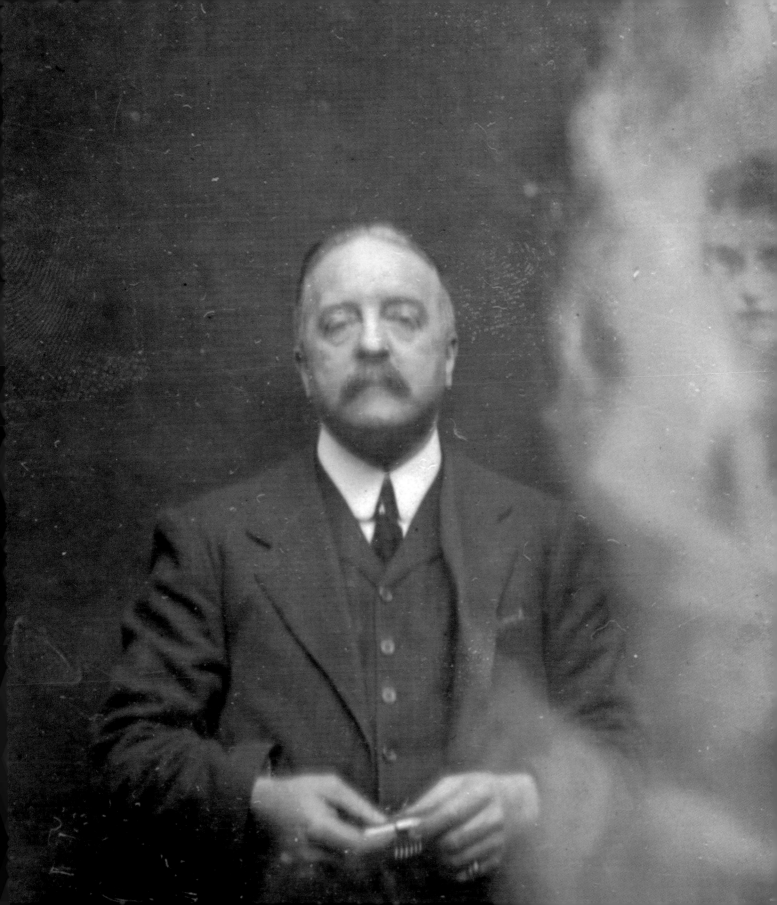

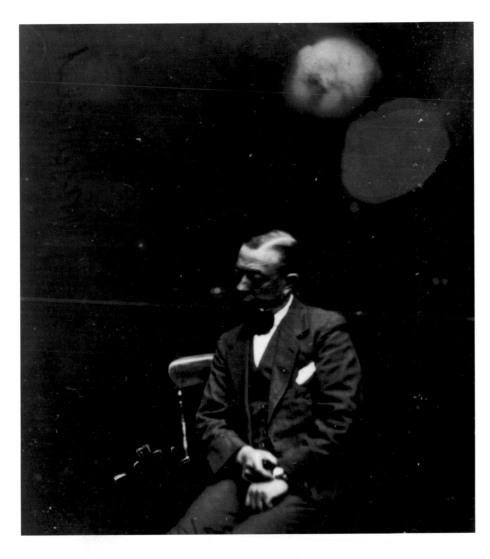

Other fans of Hope, such as the enthusiastic member of the SSSP, Major R. E. E. Spencer, who had been in the photograph of its annual meeting, was not only photographed by Hope in life, when he received some unidentified extras, but also reappeared as an extra on several of Hope's plates after his own death (see Figures 62 and 63).

The director of the Institute Metapsychique International, Dr Gustave Geley, who had already published two weighty tomes on his investigations of Eva C, planned to join his British collaborator and translator, Stanley de Brath, in an investigation of Hope. However, just before he was due to come to England for the sittings, he was killed in a plane crash in Warsaw whilst returning from the investigation of a Polish medium. De Brath went alone to

Opposite: Figure 62 . WILLIAM HOPE, Major Spencer with unidentified extra, 1921. Gelatin silver photograph, Barlow Collection, British Library, London.

Above: Figure 63. WILLIAM HOPE, Major Spencer as an extra with his son, 1923. Gelatin silver photograph, Barlow Collection, British Library, London.

their prearranged sitting with Hope, and received an extra of the suddenly deceased Geley. At a séance the following day, a spirit control, who obviously subscribed to the by now widely accepted 'memory-mould' theory of the way photographic extras were manufactured on the other side and imprinted onto the photographic plate, reassured de Brath: 'He was at last calmed and put to sleep; his guide and helpers made the model and then brought it. Conditions were so loving and desirous to help that the way was clear.'[98] Nine days after the crash, de Brath sat for Hope again at the BCPS with Mrs McKenzie and Felicia Scatcherd, and once more received the face of Geley suspended above them (see Figure 65).

Hope's extras took two forms: either a small round circle of light, which to the sceptical was consistent with a positive transparency taped over the top of a small flashlight torch being hidden in a sleeve and pushed briefly against the plate; or a face cocooned in an arch of diaphanous material, which was also consistent with a cut-out face being embedded in a swathe of chiffon and pre-exposed onto a plate against a black background. However, Spiritualist believers theorised these psychic arches to be the remnants of an ectoplasmic bag, out of which the invisible operators had formed the face of the extra. The President of the Scottish Society of Magicians, Mr William Jeffrey, and his daughter experienced this process first hand, as the slightly distorted face of the late Mrs Jeffrey emerged from an ectoplasmic bag in a sequence of two photographs.[99] (See Figure 64.)

Hope was frequently exposed during his career. In 1915 he was forced to admit, after they were reproduced side by side in the *Psychic Gazette*, that the famous extra of Archdeacon

Figure 64 (left and right). WILLIAM HOPE, *William Jeffrey and his daughter, with an extra of his wife emerging from an ectoplasmic bag, c. 1922. Gelatin silver photograph, Barlow Collection, British Library, London.*

Opposite: Figure 65. WILLIAM HOPE, *Barbara McKenzie, Stanley de Brath, Miss Scatcherd and the spirit extra of Gustave Geley, 1924. Gelatin silver photograph, Barlow Collection, British Library, London.*

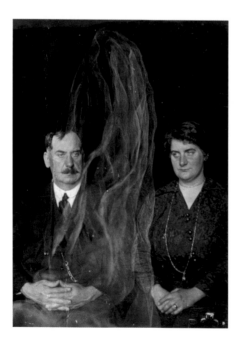 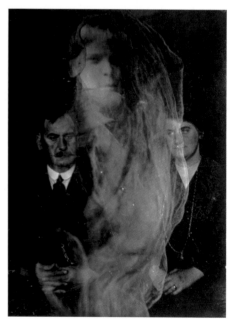

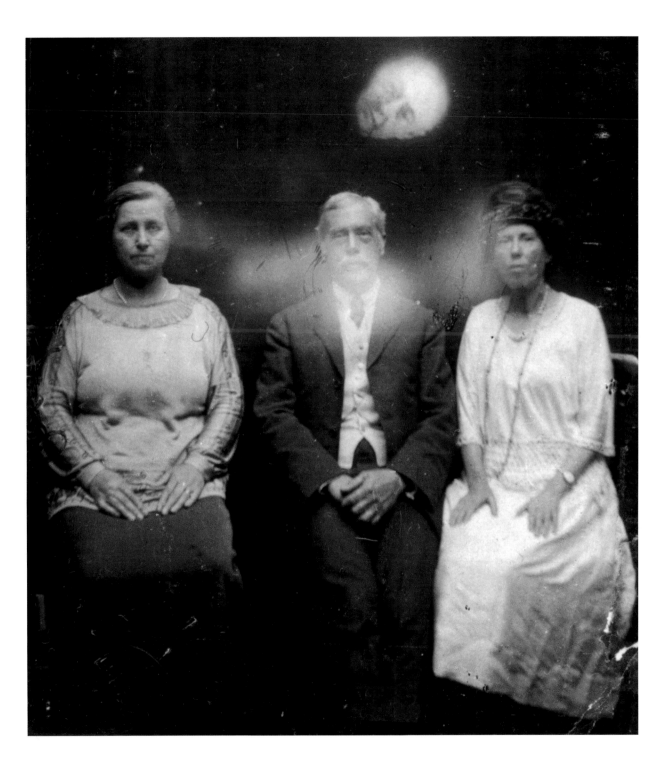

THE RETURN OF THE DEAD

Colley's mother was in fact a portrait of the grandmother of a Mrs Spencer.[100] In the trenchant 1920 pamphlet, *Spirit Photography Exposed*, the sceptic Edward Bush recounted how he had entrapped Hope by sending him a photograph of his still-living son-in-law, along with a letter saying it was a deceased person he wished to contact. At his second séance, after it had been returned to him, an image copied from the photograph he had sent duly appeared as an extra. Bush's pamphlet included instructions for making a fake spirit photography apparatus out of an old blacking tin, flashlight bulb, battery, and set of transparencies. A readymade apparatus could be purchased from the author for twenty-one shillings, as long as the purchaser signed a guarantee that it would only be used to demonstrate Spiritualism's hollowness.

The intense post-war climate of mass grief had upped the stakes for both Spiritualist convert and sceptic alike.[101] Sir Arthur Conan Doyle maintained a strong, but in his own words curious, friendship with Harry Houdini. They made an odd couple: Houdini, small, energetic and muscular; Doyle, big, blusterous and self-important. But both were brought together by a passionate interest in the afterlife, and both were publicly caught up in a cult of the dead. Doyle had been bereaved by the war, and Houdini worshipped the memory of his sainted mother, at whose grave he regularly prayed. Doyle had all the born-again zeal of the convert to the Spiritualist movement, which revered him as their famous public apostle. Houdini had made pacts with fourteen different people for them to attempt to reach him from the other side, and he visited hundreds of mediums over many years.

In Doyle's own words, 'the sight of a world that was distraught with sorrow and eagerly asking for help and knowledge' had made him realize psychic studies were no longer a mere intellectual pursuit, but were of immense practical importance.[102] At the same time, Houdini was watching the great wave of Spiritualism sweep the world with the deepest concern. Although he believed in the afterlife, to him Spiritualism was taking such a hold over persons of neurotic temperament, especially those suffering from bereavement, that it had become a menace to health and sanity.[103] Houdini was disappointed by Doyle's boundless credulity, just as Doyle believed that Houdini's scepticism prevented genuine phenomena from occurring in his presence.[104] In writing to Houdini about Hope, Doyle used the familiar Spiritualist escape clause that even genuine mediums were sometimes weak enough to resort to trickery: 'I *know* Hope to be a true psychic … but you can give no man a blank cheque for honesty on every particular occasion, whether there is a temptation to hedge when psychic power runs low is a question to be considered.'[105]

In 1921, while on a tour of Britain, Houdini had attempted to have a sitting with Hope, but had been informed that he was booked out for months. So he got an unknown magician from Glasgow to request an appointment which, interestingly, was arranged immediately. After loading Hope's plate-holder with his own plates, the Glasgow magician saw Hope place the holder on a shelf, then throw it into shadow by moving the darkroom lamp

(ostensibly to give him more light to load his own dark-slide), then pick up a different plate-holder from the gloom, before asking him to sign the plates with his name. In the developing dish the switched plate developed quickly, as though it had been over-exposed, and revealed a spirit extra. Houdini's magician colleague had also brought his own plates and camera, which Hope agreed to try. However, rather than using the camera's shutter, he regulated the exposure by cupping his hand over the lens. On development, the sitter's face was covered with what Mrs Buxton called a 'spirit light', but which was also consistent with a spot of a phosphorescent substance on Hope's palm.[106]

Members of the SPR hoped for an eventual proof of the existence of psychic phenomena just as passionately as the Spiritualists already believed in it. But the Society's adopted stance of superior scientific scepticism, and their aggressive methods of exposing fake mediums, angered Spiritualism's many converts. For some time the SPR had been trying without success to make an appointment to test Hope, so it went undercover. In 1922 its research officer, Eric Dingwall, and the well-known conjurer and psychic investigator, Harry Price, arranged for the Imperial Dry Plate Company to secretly X-ray their logo, a lion, through a lead stencil across the corners of four of their plates. These plates were sealed in the company's wrapping and sent to the SPR in late January. In late February, Price took the plates and went with an accomplice for his sitting with Hope and Buxton at the BCPS. After a round of 'Nearer my God to Thee', and a long improvised prayer from Hope, all the sitters placed their hands on the packet of plates and recited the Lord's Prayer, as well as singing other hymns.

Price surreptitiously marked the plate-holder he had been given with a pin-pricking instrument slipped over his thumb. In the darkroom he noticed Hope do a quick half-turn away from the safe-light, while slipping the plate-holder into his breast pocket and apparently taking it out again. When they returned to the studio Price noticed that his marks were now missing. On development the company's X-rayed logo failed to appear, but a female apparition did. Later that day Price developed the unused plates and saw the remaining parts of the logo. He also noticed that the plates Hope had developed were of thinner glass than those he had taken in. About a week later, in early March, the SPR received an anonymous package wrapped in paper from the BCPS. Pencilled on the outside of the parcel was: 'Open in the dark, from a friend, fix in the dark.' The parcel contained four plates which, when developed, revealed a missing part of the lion logo on one plate, and lonely spirit extras on the others. A few weeks later, a second parcel arrived from the anonymous friend containing more undeveloped plates, and miniature glass transparencies of the faces of magicians, such as might be used to secretly imprint extras on an undeveloped plate. Price published his exposure of Hope in May, in the august pages of the SPR's journal; and having a flare for self-publicity as Britain's foremost ghost hunter, he also printed it up as a sixpenny pamphlet called *Cold Light on Spiritualistic Phenomena*.[107]

In response the secretary of the SSSP, Fred Barlow, could only manage to put up the weak defence that Hope must have been in an abnormal mental condition at the time and so was not responsible for his actions.[108] But after returning from a lecture tour of America Doyle, summoning all of his rhetorical powers as an adventure writer, immediately swung to Hope's defence and published his own pamphlet, *The Case for Spirit Photography*. Firstly, he established Hope's character:

> In person Hope is a man who gives the impression of being between fifty and sixty years of age, with the manner and appearance of an intelligent working man. His forehead is high and indicates a good, if untrained brain beneath it. The general effect of his face is aquiline with large, well-opened, honest blue eyes, and a moustache which is shading from yellow to grey. His voice is pleasant with a north-country accent which becomes very pronounced when he is excited. His hands with their work nails and square-ended fingers are those of a worker, and the least adapted to sleight of hand tricks of any that I have seen. Mrs Buxton, who aids him, is a kindly, pleasant-faced woman on the sunny side of middle-age. ... They and all their circle are spiritualists of a Salvation Army type, much addicted to the hearty singing of hymns and the putting up of impromptu prayers. ... It is this type of character which associates itself sometimes, I admit, with a loathsome form of hypocrisy, but which has in it something peculiarly childlike and sweet when it is perfectly honest and spontaneous as it is, to the best of my belief, in the case of the two mediums in question.[109]

He then used the familiar Spiritualist method of argument by documenting the many experiences of recognition testified to by Hope's clients. Doyle even submitted the posthumous testimony of Spiritualism's highest scientific authority, the patrician Sir William Crookes. In 1916 Crookes had been prostrated with grief by his wife's death, and had returned fully to the bosom of Spiritualism. In one of his last interviews with a Spiritualist journal in 1919, shortly before his death at the age of eighty-seven, he put on record that he himself had visited Hope, and under test conditions received an extra which he recognized as his late wife (see Figure 66). After forty or so years of scholarly prevarication he was finally able to write privately to Lodge, 'I am glad to say this definite proof of survival has done my heart much good.' According to his assistant, the picture showed clear signs of double exposure, but Crookes clung to the conviction that it was a real spirit photograph and treasured it accordingly.[110] Doyle was unable to reproduce this important image because Crookes had been unwilling to give out too many copies, saying to inquirers: 'I look upon the picture as a Sacred Trust, and do not like the idea that one is in a stranger's hands, to be shown about to anyone as a curiosity.'[111]

Figure 66. WILLIAM HOPE, *Sir William Crookes with the purported image of Lady Crookes, 1916. Gelatin silver photograph, Mary Evans Picture Library.*

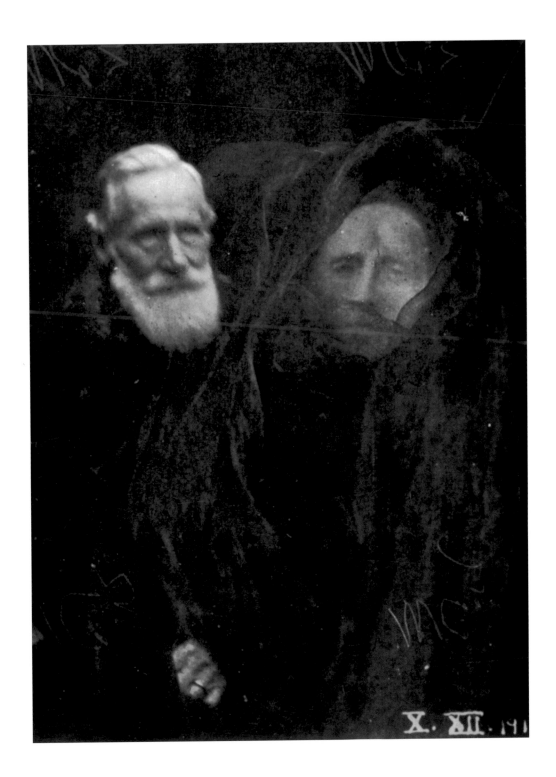

THE RETURN OF THE DEAD

Doyle then proceeded to the next stage of his argument, which began to sound rather like a Sherlock Holmes adventure. He defended Hope on the same forensic level on which the SPR had attacked him. Plate-holders are made of hard wood, how could Price be certain the pin-prick he made had even left a mark? If Price had seen Hope switching the dark-slide, why hadn't he challenged Hope at the end of the sitting and located the discarded holder? Doyle finally turned the tables on the SPR by concentrating on the twenty-four days the packet of plates lay in a drawer at the SPR before the test séance, and the mysterious return of the undeveloped X-rayed plates. If Price had gone to the BCPS incognito, and two of his plates had remained undeveloped, who knew that they had anything to do with the SPR? Why, only the SPR itself. It must have been one of the SPR conspirators themselves who had secretly broken the seal on the packet while it was still at the SPR and imprinted a fake extra onto one of the marked plates so that, if Hope claimed it as his own, he could be accused of fraud. Then, having second thoughts, they again broke the seal and substituted a different plate for the tampered-with plate. It was on this plate that Hope innocently received an authentic extra. Later, out of sheer mischief, the SPR conspirator sent the SPR itself the original tampered-with plate wrapped in stolen BCPS stationery. This theory, although wildly improbable, was nonetheless sufficient to thoroughly confuse the issue.

Doyle concluded by suggesting that, in contrast to Hope's simple and humble servitude to his powers, Dingwall's and Price's character and motives were arrogant and self-aggrandizing. In a shrill exchange of letters with the SPR, the BCPS demanded that the SPR return the wrappings of the plates to them for analysis. Almost in parody of the SPR's scientific methods, they returned a photo to the SPR documenting what they claimed was evidence of the label being lifted with a penknife, as well as creasing and tampering. They said they had sent a sample of the gum used to seal the package to be chemically analysed to see if it actually matched the gum used by the Imperial Dry Plate Company.[112] A self-appointed committee from the BCPS, including Doyle, re-examined all of the evidence and unanimously exonerated Hope, at the same time as offering a reward for the exposure of the SPR mole.[113]

The controversy reached across the Atlantic, and was reported on by the *Scientific American*:

> Those seeking pictures are usually folk who have lost someone near and dear to them. Imagine them sitting with a canting, psalm singing humbug of the type of William Hope, who goes through the mockery of a religious ceremony ... knowing full well the spirit is already made and carefully planted.[114]

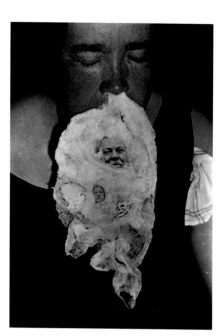

Above: Figure 67. T. G. HAMILTON, Teleplasm revealing a likeness of the late Sir Arthur Conan Doyle and others, 1932. Gelatin silver photograph, University of Manitoba Library.

Opposite: Figure 68. WILLIAM HOPE, Fred Barlow (left) and Major Rampling Rose (right), with unidentified sitter, c. 1932. Gelatin silver photograph, Barlow Collection, British Library, London.

104

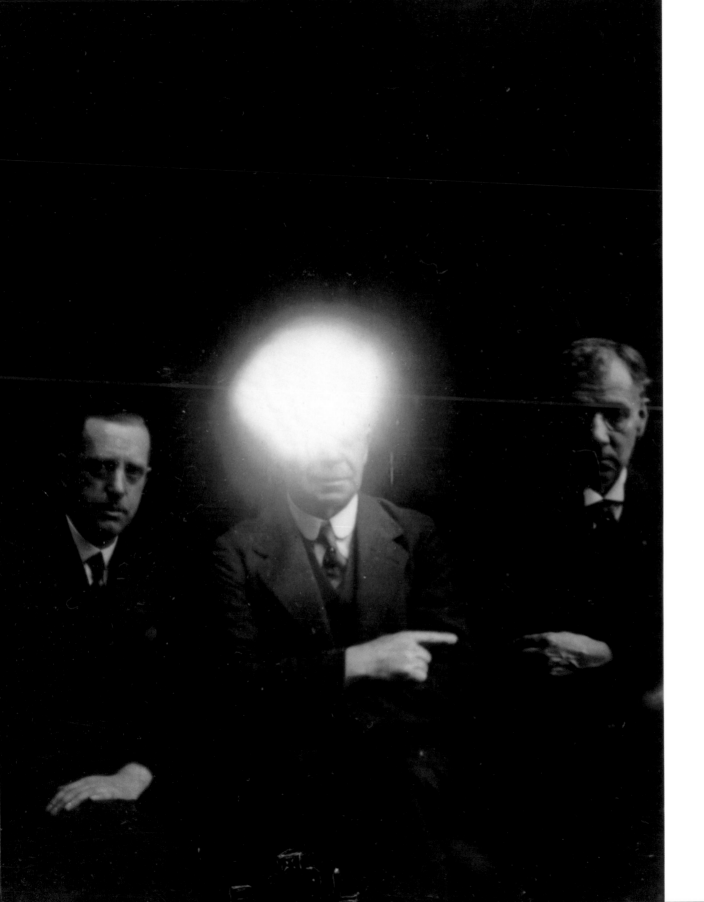

Figure 69. WILLIAM HOPE,
*Professor Haraldur Nielsson
from Iceland, with extra, 1923.
Gelatin silver photograph,
Barlow Collection,
British Library, London.*

Opposite: Figure 70. WILLIAM
HOPE, *Fred Barlow, his mother
and cousin (Mrs Burgess) with
an unrecognized extra, c. 1920.
Gelatin silver photograph,
Barlow Collection, British
Library, London.*

106

THE RETURN OF THE DEAD

Hope kept on practising for the next ten years (see Figures 68–73). In July 1930 Doyle died, but apparently continued his Spiritualist activities from beyond the grave as busily as ever, for instance in 1932 he sent his likeness through to appear in the ectoplasm coming from the nose of a medium in Winnipeg, Canada, (see Figure 67). He also returned to some of Hope's photographic plates, appearing on a portrait of his eldest surviving son Denis, and sent greetings through to the Spiritualists as psychographic writing on a Hope plate. Lady Doyle kept up the Spiritualist crusade by reproducing these photographs in the *News Chronicle* and giving a simplified theory of spirit photography to its readers.

> A photographic medium is one who gives out enough special ectoplasm for the spirit folk to use in impressing their faces on the plate with the human sitter. The sensitive photographic plate can register so much more than the retina of the human eye. That is why it is so valuable a material witness for the Truths of Spirit Return.[115]

Immediately following Hope's own death on 8 March 1933, the controversy erupted again. During the 1920s Fred Barlow had drifted from the Doyle camp into the orbit of Eric Dingwall of the SPR. With Hope in his grave, he published articles in both the *Proceedings* of the SPR and in the Spiritualist magazine *Light*, stating that a further ten years of continuous experimentation had finally convinced him that he was mistaken. Hope, whom he had personally championed and defended for fifteen years, did not have genuine gifts. What had led to his final disillusionment was the discovery by a friend of a flashlight apparatus for imprinting extras in Hope's bag. The chairman of the SPR meeting, to which Barlow read his apostatizing paper, put on record that he desired particularly to 'congratulate Mr Barlow on the courage he had shown in coming forward in the way he had done to calmly and dispassionately explain that his previous convictions as to the genuineness of spirit-photography had been mistaken'.[116]

During another round of attacks on, and defences of, the genuineness of Hope's mediumship, Mrs McKenzie, owner of the BCPS and strident defender of Hope against the SPR, finally admitted that in fact, ten years earlier, she too had discovered a flashlight apparatus in Hope's bag, which he always kept locked and in a special place while he was at the BCPS. But, because she still believed that Hope from time to time was genuine, she had kept quiet about her discovery.[117] But in his

Opposite: Figure 71. WILLIAM HOPE, *Mr Robinson and unidentified sitter with unidentified extra, c. 1920. Gelatin silver photograph, Barlow Collection, British Library, London.*

Below: Figure 72. WILLIAM HOPE, *Mr Engholm from the magazine* Light *and unidentified sitter with unidentified extra, 1922. Gelatin silver photograph, Barlow Collection, British Library, London.*

109

Figure 73. WILLIAM HOPE, *Unidentified sitters, c. 1920. Gelatin silver photograph, Barlow Collection, British Library, London.*

obituary, the editor of *Light* had already covered for Hope by writing that he had become so accustomed to accusation and abuse that he had become 'case hardened'. In his almost cynical indifference he was given to play tricks on sceptical enquirers by pretending to cheat. Grateful Spiritualists raised a subscription to place a memorial brass to William Hope in Weston Church near Otley, Yorkshire.[118]

Spiritualism was always followed for selfish reasons. It was not concerned with the transcendently numinous, so much as the immediate desires of each individual soul for solace. When, in 1888, forty years after they began modern Spiritualism, the Fox sisters publicly confessed to their childhood fraud in front of a packed house at the New York Academy of Music, Spiritualists throughout the house cried out at having to face again the loss of loved ones they thought restored to them forever.[119] Later, a disenchanted Spiritualist wrote to one of the sisters.

> It is perhaps better that the delusion was swept away by one single word, and that word 'fraud'. I know what the pursuit of this shadowy belief has wrought upon my brain and that I am no longer my old self. Money I have spent in thousands within a few short years [but] it is true that never once have I received a message or token of a word that did not leave an unsatisfied longing in my heart, a feeling that it was not really my loved one after all who was speaking to me ... It is better that the delusion is past, after all, for had I kept on in that way, I am sure I should have gone mad.[120]

But just as Spiritualism made some adherents vulnerable to feeling abandoned and alone, for others it continued to provide a powerful collective experience. Although the product of extreme credulity, spirit photography was nonetheless a collective act of imagination which in many ways was no more than an amplification of the way normal photographs were coming to be used every day in people's habitual processes of remembering and mourning. In many ways, spirit photographs served the same function as precious family photographs. But they were not snapshots of passing events, rather, they were the central magic objects in elaborate rituals and performances. They didn't find their truth in the documentation of a prior reality, they created their truth within the wounded psychology of their audience. Their truth was manifested and sealed by the undeniable thud of recognition viscerally felt by the customers for whom they were made.

 The power of the spirit photograph was not built around the conventional mechanism of the snapshot – the camera, the lens and the shutter. Instead, it was compressed into the sensitive photographic plate alone. Photographic emulsion was imaginatively linked to ectoplasm and activated as a soft, wet, labile membrane between two worlds – the living and the dead, experience and memory. The spirit photograph's emulsion was sensitized chemically by the application of developers, and psychically by the meeting of hands and the melding of mutual memories. No spirit photographer exemplified this better than Mrs Ada Emma Deane (see Figure 74), who joined William Hope on the British Spiritualist scene in 1920.

Although Ada Deane said that she had many psychic experiences as a child – she played with a spirit girl in an attic, was teased by a spirit boy while lying in bed, and was seen by some nuns to float down a set of stairs – it was not until 1920, when she was fifty-eight years old, that she began to develop her psychic powers. Her husband had left her many years before, and she had brought up three children on her own by working as a servant and charwoman. With the children grown, she branched out into other occupations. She began to breed pedigree dogs, and she purchased a rickety old quarter-plate camera for nine pence with which she photographed her children, friends and neighbours. She also became involved in Spiritualism.

Once, when photographing a friend, Deane got a freakish result on her photographic plate: the head appearing on the shoulders of the sitter was not that of the sitter herself. Later, while attending a local séance in North London, the medium conducting the séance predicted that she would become a psychic photographer. She sat with that medium regularly for the next six months, attempting to develop her powers, and finally obtained her first psychic photograph in June 1920. Her reputation soon spread amongst Spiritualists and she became one of Britain's busiest photographic mediums, holding over 2,000 sittings.[121] (See Figures 75–92.)

Figure 74. ADA DEANE, *Ada Deane with her camera and upside-down extra, c. 1922. Gelatin silver photograph, Barlow Collection, British Library, London.*

Late in 1920 Deane, accompanied by her daughter Violet, who was also developing psychic abilities, visited the Birmingham home of Fred Barlow to submit herself to a series of tests and experiments. He had supplied Deane with a packet of photographic glass plates two weeks before the tests for her to pre-magnetize by keeping them close to her body. On development, the portraits Deane took held the faces of psychic extras swathed in chiffon-like and cottonwool-like surrounds. 'It appears', Barlow reported, 'as though the plates in some peculiar way became impregnated with the sensitive's aural or psychic emanations.'

A final photograph, taken just before they said goodbye, confirmed for him that he had discovered in Deane an extraordinary phenomenon. Using his own half-plate camera, and his own photographic plate, Barlow took a group portrait of himself and his wife, along with Ada and Violet Deane, arranging and then at the last moment rearranging the group himself. During their stay, the mediums had mentioned several times that their spirit

controls had promised to be with them. After exposure he immediately developed the plate and was delighted to see that the beautiful guides of the mediums were to be seen on the negative, in correct relation to the sitters: 'Bessie', Ada Deane's control appeared right above her head; while 'Stella', the control of Violet Deane, appeared above hers. To Barlow, the manifest beauty of this psychic picture was in itself wonderfully evidential.[122] (See Figure 75.)

If Barlow was seeking any further proof that Deane was genuine, he found it a year later in August 1921. In the interim his father had died, and in the last solemn moment of his father's earthly life Barlow's repeated but unspoken cry was: 'Father, if it is possible, come back and prove to us that you still live.' Barlow's young female cousin was visiting the family, and at a home séance Barlow's father manifested himself and told her, 'Don't return home yet – stay on a little longer!' The following day, Deane and her family arrived to spend their August holidays with the Barlows. After a short religious service, Deane photographed Barlow's cousin, who had taken the spirit's suggestion and decided to stay on. On one of the plates they secured as an extra a likeness of Barlow's father which was immediately recognized by all of the family as very similar to how he had appeared during the last moments of his earthly life. Barlow concluded: 'Our would-be critics are silenced! How can they be otherwise in face of perfect proof, such as this, which week by week is steadily accumulating?'[123] A year or so later, Barlow and three sceptical friends motored to Crewe for a sitting with Deane's fellow spirit photographer William Hope. They disturbed the family at tea, but Hope agreed to make some exposures by magnesium flashlight. The four received, as an extra, an image of Barlow's father that was identical with the extra previously received on Deane's plate (see Figure 76).

But rather than interpreting this as evidence of collusion between Deane and Hope, Barlow diverted it to a further elaboration of the 'memory-mould' theory of spirit photography. He speculated that the duplication was because the subconscious portion of

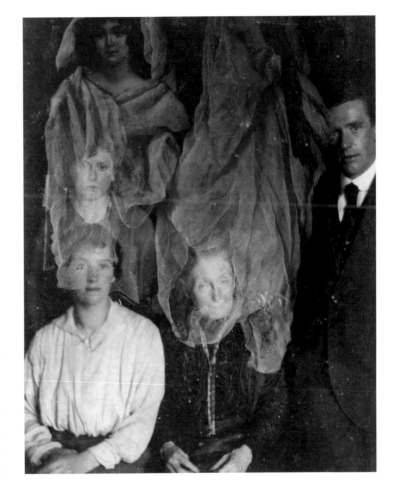

Figure 75. ADA DEANE, *The spirit guides 'Stella' and 'Bessie' with Mrs Barlow, Fred Barlow, Violet and Ada Deane, 1920. Gelatin silver photograph, Barlow Collection, British Library, London.*

Figure 76. (left) ADA DEANE, *Mrs Burgess, Fred Barlow's cousin, with an extra of his father;* (right) WILLIAM HOPE, *Fred Barlow and three others with an extra of his father, 1922. Gelatin silver photographs, Barlow Collection, British Library, London.*

his mind, in which visual memories of his father were stored, was being somehow employed to project, or print, the picture onto the plates. But how was he to know whether the images he was examining originated entirely in his own mind and were projected onto the photographic plate by his own mental force and that of the medium, or whether his unconscious mind had become an instrument used by the invisible operators for the production of visual phenomena originating on the other side?

Is it blind or automatic intelligence that sends these photographs in response to the prayers of the widow and the cry of the mother for proof that the dead still live. Are they just brain freaks? Chemical results produced by ourselves to deceive ourselves? Man's commonsense and woman's intuition revolt against

such a likelihood. In many instances we see clear evidence that other minds are at work, distinct from and often superior in intelligence to those of medium and sitters. These intelligences claim to be the so called dead. They substantiate their claims by giving practical proof that they are those who they purport to be. In no uncertain voice they claim to be discarnate souls. Surely *they* ought to know![124]

Deane did have her detractors, though. By this stage she had joined Hope in offering sittings at the BCPS. The satirical newspaper *John Bull* sent two anonymous investigators to a sitting. They had refused to send in their plates for pre-magnetization and didn't receive any clear extras. But, amazingly, Deane agreed to give them some plates that she had already pre-magnetized. They immediately took these to the photographic manufacturer Ilford who examined them and confirmed that they had been pre-exposed to light in a plate-holder. The paper headlined with: AMAZING SPIRIT CAMERA FRAUDS, PSYCHIC EXPERIMENTER CAUGHT RED HANDED IN TRANSPARENT DECEPTION AND TRICKERY. The reporter described the experience of a psychic sitting with Deane:

> We were asked to sit on a wicker settee before a dark screen or background. Then, handing us each a hymn-book, a hymn was selected and sung. At the close of this Deane commenced to sing vigorously *We Shall Meet on the Beautiful Shore*, and intimated that we should 'join in'. We did so, but I must confess that the reverence usually associated with the singing of sacred verse was difficult to maintain. The broad daylight; Deane's somewhat shrill voice; the absence of any accompaniment to the singing; the business like appearance of the studio; all of these things were entirely opposed to the creation of a 'spiritual atmosphere' such as one would regard as being most essential when dealing with the 'living dead'. Deane then collected our slides in her hands, placing one at the top and one at the bottom. She instructed us to place our hands in a similar manner over hers, and in this position we recited the Lord's Prayer. The next minute she was bustling about the studio arranging the camera and ourselves.[125]

Eric Dingwall also arranged to send an anonymous sitter to Deane. When the BCPS confirmed her appointment, and requested she send in her plates for pre-magnetization, their letter advised: 'The plate should not be wrapped in a metal box or cotton wool as both these materials seem to be impervious to magnetizing and a careful sealing of a cardboard box is obviously quite as sufficient a precaution against possible fraud.'[126] On this occasion the hymn sung was *Blest are the Pure in Heart*, chosen, according to Deane, because it was short. She exposed the plates long enough to allow her to step to one side of the camera, fold her

hands, put her head slightly to one side and close her eyes for a moment or two. The result was inconclusive and Mrs Creasy was unable to detect any fraud, but she left, 'with a lively desire to try again to circumvent the wily lady'.[127]

Shortly afterward Dingwall himself made an appointment to visit Deane, accompanied by a Mrs Osmaston. He elaborately sealed the package of plates he sent in for pre-magnetization, dying the ends of the cotton with invisible ink, lightly gluing sable hairs across the folds of paper and pricking aligned pinholes through the layers of paper. On their arrival for the appointment, however, they found that the packet had not been opened. They opened the packet themselves and loaded the plate-holders, before giving them to Deane. But, Dingwall observed, Deane had ample opportunity to switch the plate-holders as she then proceeded across the room and thrust her hands, with the plate-holders, into her capacious handbag in order to retrieve her prayer book for the first hymn.

The most popular spiritualist book by far during this period was *Raymond: or Life and Death*, written by Sir Oliver Lodge.[128] Raymond, his youngest and most adored son, had been killed on the Somme in 1916, but got quickly back in touch with the family in London through various direct-voice mediums, using the spirit control Freda, a giggling young girl. He established his identity by referring to photographs that had been taken at the Front but not yet seen in London, and by referring to childhood incidents verifiable by family snaps. His message to his father, and to the thousands of readers who read the book during its nine impressions from 1916 to 1932, was that he was still alive, along with the thousands of his fallen comrades, on the other side in a place called Summerland – a place rather like an English Country Club. His comrades, he reported, were all happy and well, and proud to have given their lives for their Motherland. They wanted their loved ones back on the Earth plane to grieve less because they were not gone, but living different, higher lives. Lodge's book spawned many imitators, with texts usually received from the other side by automatic writing, such as: *Subaltern in Spirit Land, The Nurseries of Heaven, Rachel Comforted, Thy Son Liveth*, and *The Dead Have Never Died*.

Deane visited Sir Oliver Lodge on his estate and stayed there for three nights taking several psychic photographs with the aid of one of Lodge's trusted assistants. The results were so successful that Lodge offered Deane a substantial fee to stay near his estate for several months to undergo more experiments. But, because she had three children to look after in London, she had to decline. What had ultimately convinced Lodge of Deane's power were the comments that the spirit of Raymond made about his experiments on Deane. These remarks were made at two independent London séances, one held by Mrs Leonard, one of London's biggest mediums and Lodge's long-time favourite, the other held by an amateur medium new to the scene. The remarks showed a clear knowledge of what went on in the experiments, and also identified who the extras were meant to be, 'To get such a result', Lodge patiently reasoned with the sceptical Dingwall, 'we should have to assume that

both Mrs Leonard and another, and amateur, lady medium were in the trick in collusion with Deane.' To Lodge it was evidently simply inconceivable that three women, from different class backgrounds and with different professional statuses within Spiritualism, might be sharing information about their trusting clients.[129]

The Occult Committee of the Magic Circle duly tested Deane and found the sealed packet of plates they sent to her for pre-magnetization had been tampered with (see Figure 77). But without hesitation Doyle, who had sat for Deane himself and got a female face smiling from an ectoplasmic cloud (see Figure 78), sprang to her defence:

> The person attacked is a somewhat pathetic and forlorn figure among all these clever tricksters. She is a little elderly charwoman, a humble white mouse of a person, with her sad face, her frayed gloves, and her little handbag which excites the worst suspicions in the minds of her critics.[130]

Another Spiritualist believer, Mr F. W. Fitzsimons, also couldn't understand how such a simple, earnest soul, who had brought comfort and joy to thousands of sorrowing hearts, could be periodically attacked by sceptics and accused of cheating her clients with elaborate sleight-of-hand tricks. He visited Deane at her home and discovered the old lady busily washing a number of pedigree puppies. He found Deane to be a cheery, pleasant-faced old soul, simple and uneducated in the ways and evils of the world of men, and with the hallmark of absolute honesty imprinted on her face. He could have talked dogs with her all afternoon, but finally she bustled off to wash her hands, slip off her overalls, and get out her rickety old tripod and camera. On another visit Fitzsimons found that his appointment time clashed with that of a sad, care-worn-looking man in the garb of a clergyman (appointment clashes weren't uncommon with Deane). The clergyman was clutching a psychic photograph of his recently deceased wife which had been taken by the spirit photographer William Hope. Fitzsimons and the clergyman fell to talking:

> 'My wife and I had been married twenty years, and we were childless. She was all I lived for. Recently she died, and my religion has given me no comfort or solace. I was in despair, and grew resentful against God. A friend told me about faces of deceased people appearing on photographs. I had four exposures made. Two were blanks, one had the psychic face of someone I did

Figure 77. ADA DEANE, The *Magic Circle test, Mr J. B. Seymour, Mr Walter Frueth and Mr Fred Hocking with extra, c. 1922. Gelatin silver photograph, Barlow Collection, British Library, London.*

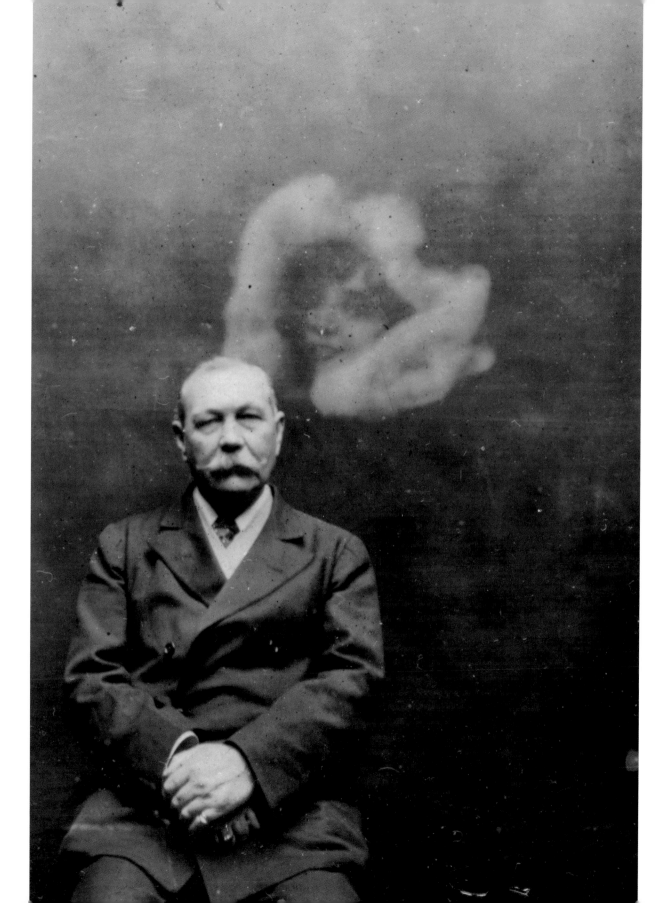

not recognise, and the other held that of my wife, and here it is.'

He held it up again for inspection.

'Can such a thing be true?' he asked me, tears gathering in his eyes, 'To me it seems impossible, yet I succeeded in getting the picture of my wife. If such a thing be true, why does not the suffering, anguished world know about them?' he cried.

'Because', I answered, 'people as a whole are steeped in materialism, self-conceit, ignorance, intolerance and bigotry.'

'Yes, I fear so,' he sighed.[131]

However, the indefatigable Dingwall kept on Deane's tail. He suspected that Deane's brother, who was a professional photographer and who had initially taught her amateur photography, might be supplying her with the photographed heads she would need to manufacture fake spirit extras. He found out who employed the brother and wrote to them asking to look through the firm's old proof sheets. The head of the firm politely declined, but was nonetheless intrigued enough, and ambivalent about Spiritualism enough, to suggest:

> Perhaps I could obtain a sitting with Deane, she need not know who I am and if she is genuine she can perhaps produce the image of my boy who I lost in the war, on the other hand I may be able to detect the fraud, in which case I would do my utmost to expose it.[132]

F. W. Warrick, the wealthy chairman of a wholesale druggist firm, became progressively obsessed by Deane and her predominantly female household. Over eighteen months, from 1923 to 1924, Warrick visited Deane's house twice a week for personal sittings during which she exposed over 400 plates, mostly of Warrick himself. Deane's seemingly ingenuous personality immediately convinced him that her psychic powers were real, a view he never wavered from even after 1,400 inconclusive experiments with her. He assured Dingwall:

> She makes no profession of honesty, but she is just honest. ... Mrs Deane is very friendly towards me. I now know her family well and have entree to their kitchen and scullery. I am perfectly convinced that Mrs D. practices no fraud. I admire her character and the sturdy independence of her spirit. She is not 'out for money'.[133]

Nonetheless, Warrick imposed increasingly rigorous conditions on his experiments, cunningly sealing the packets of plates he gave to Deane for pre-magnetization, and insisting on using his own camera and, most importantly, plate-holders. Although, as he admitted to Dingwall, the imposition of these stringent conditions resulted in the departure of the

119

Figure 78. ADA DEANE, *Sir Arthur Conan Doyle with unidentified psychic extra, c. 1922. Gelatin silver photograph, Barlow Collection, British Library, London.*

veiled extras, he determined to go on as long as Deane was willing, and his opinion of her remained the same. He switched his attention from the extras to the multitude of 'freakmarks' – chemical smudges and smears, and bursts of light – which appeared on her plates. These further investigations were also fruitless, but they did eventually lead him to undertake another 600 inconclusive thought transference experiments on Deane over the

next three years. These tested her ability to write letters on sealed slates and to make marks on pieces of cartridge paper placed against her body. For the purposes of these experiments Warrick had Deane and her family move into a house he owned. One room was reserved for séances and a darkroom was built into it, as well as a small sealed cabinet for the thought transference experiments. While Deane sat in the cabinet with her hands imprisoned in stocks, Warrick crouched outside and attempted to transmit his thought images to her.

Warrick scrupulously recorded all of his experiments. In the tradition of previous obsessive psychic researchers he compiled and published them, along with his extended but inconclusive reasoning as to what they might mean, in a monumental 400-page book. Warrick reasoned that the disappearance of Deane's extras as more stringent conditions were applied might be because his own desire for scientific proof was putting off Deane's invisible operators; or perhaps his excessive precautions might be producing a subconscious inhibitory resentment in Deane herself. As always, such convoluted lines of reasoning were nudged along by supposedly unimpeachable advice coming from beyond the veil. At the weekly private séances Warrick attended in Mrs Deane's kitchen, she fell into a trance and spoke in the direct voice of her various controls, while Warrick had a battery of four cameras ready to flash at any crucial moment. At one of the séances Warrick asked the control Hulah, a young girl, about the absence of the extras; she replied that Warrick 'worried the medium'. At a later séance another of Deane's spirit guides, the American Indian Brown Wolf (see Figure 80), also confirmed that Warrick himself was the cause of the non-success of his own experiments.[134]

*Opposite and left: Figures 79
and 80.* ADA DEANE, *Violet
Deane with her spirit control;
Mrs Deane with her red indian
control, 1920. Gelatin silver
photographs, Barlow Collection,
British Library, London.*

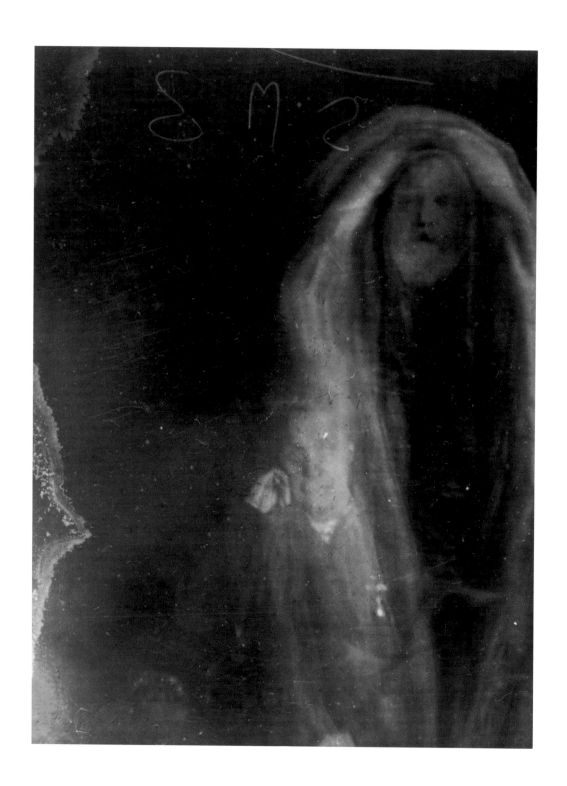

122

Despite these commentaries from the other side, Warrick's examination of the evidence of the photographic plates themselves still forced him to the conclusion that some of the extras which she had previously produced, and still produced with other sitters, could be nothing else than pictures cut from newspapers and photographed against pads of cotton wool against a black background. But, his inexorable reasoning continued, how could anybody, let alone someone as conspicuously guileless and simple-hearted as Deane, produce such obvious fakes when they were sure to attract opprobrium? Yet someone, or something, <u>had</u> done it; the question was, who? Theoretically, the invisible operators could as easily appropriate a newspaper picture from this side of the veil to use as a psychic image-mould, as prepare an original image-mould on the other side. Alternatively, they could easily induce trance states in Deane. Therefore, the only answer he could possibly come to was that the invisible operators were producing psychic effects that <u>looked</u> like fakes, or inducing Deane to fake some of her psychic photographs while in a trance, out of sheer mischievousness.

However, Warrick's obsessive fascination with Deane's extras remained. She gave him access to her negative collection and he had 1,000 of them printed up and bound, in grids of twelve per page, into four large albums, embossed with her name, which he presented to her. He asked the Society for Psychical Research to be responsible for their eventual preservation because, 'the prints may be of great value – and may be sought after the world over for the purposes of study. They are unique in the world.'[135]

Eventually, Warrick's exhausting experiments and exhausted reasoning led him to a conclusion that Barlow had previously dismissed as being too wildly improbable. Deane's extras weren't portraits of the dead at all, but mental pictures, reproductions of memory images fixed in some as yet undiscovered mental substance (which he called mnemoplasm) and held in vast banks within ourselves, but also accessible to an invisible operator (or an inhabitant of the fourth dimension, who he called a tetramet) through the mediumship of Deane. In a phone call to the Society for Psychical Research in 1954, when he was ninety-five years old, he left his final reasoning on the subject: 'All psychic photographs are "memory pictures exteriorised" and in the future doctors will be able to read the brain in post mortems and thus see individuals' memories.'[136]

Deane's moment of greatest notoriety came in 1924 through her involvement with Estelle Stead, another eminence of the Spiritualist movement who ran a Spiritualist church and library called the Stead Bureau. Estelle Stead (see Figure 81) was the daughter of the W. T. Stead who had been photographed in the 1890s with the 'thought mould' extra of his spirit guide Julia. Stead was clairvoyant, but this faculty didn't prevent him from booking a passage on the maiden voyage of the *Titanic*. Shortly after he drowned, however, his spirit reappeared at a London séance and continued his Spiritualist activities as busily as ever. He transmitted the posthumous experience of the passengers on the *Titanic* through automatic writing to his daughter, who published them as *The Blue Island*.

123

Figure 81. WILLIAM HOPE, *Estelle Stead and the spirit of her father William Stead, c. 1920. Gelatin silver photograph, Barlow Collection, British Library, London.*

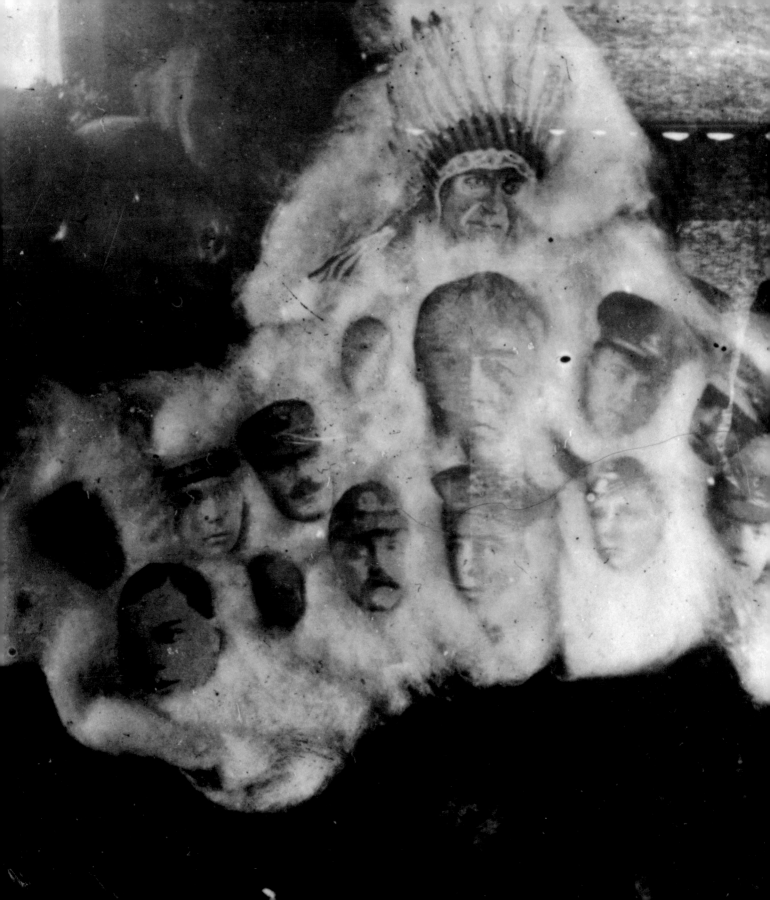

Towards the end of 1921 the discarnate W. T. Stead told his daughter, through automatic writing, that a group of 'Tommies' and 'Hearts of Oak Men' (sailors) who had passed on in the Great War had been prepared for photography, and if she carried out their directions they had every hope of getting their image onto a photographic plate. The spirits requested that Deane take a picture of the platform during the Two Minutes' Silence at the Stead Bureau's Armistice Day service. In the resulting photograph an arch of fifteen men appeared, surmounted by an American Indian Chief, thought to represent Deane's spirit guide Brown Wolf.[137] (See Figure 82.)

A year later, Estelle Stead received another 'wireless message' from her father instructing that they should arrange for Deane to take a photograph in Whitehall during the Two Minutes' Silence that year. A group of spiritualists were placed in the crowd to produce a 'barrage of prayer' and so concentrate the psychic energy, and Deane took two exposures from a high wall over the crowd, one just before the Silence, and one for the entire two minutes of the Silence. When the plates were developed, the first showed a mass of light over the praying Spiritualists, and in the second what was described by W. T. Stead's spirit as a 'river of faces' and an 'aerial procession of men' appeared to float dimly above the crowd. The images were commercially printed together and distributed amongst Spiritualists (see Figure 83).

Conan Doyle took this image with him on his second tour of America, which featured an entire lantern-slide lecture on spirit photography. In April 1923 he lectured to a packed house at Carnegie Hall. When the image was flashed upon the screen there was a moment of silence and then gasps rose and spread over the room, and the voices and sobs of women could be heard. A woman in the audience screamed out through the darkness, 'Don't you see them? Don't you see their faces?' and then fell into a trance.[138] The following day the *New York Times* described the picture on the screen:

125

Figure 82. ADA DEANE, *Armistice Day 1921. Gelatin silver photograph, Barlow Collection, British Library, London.*

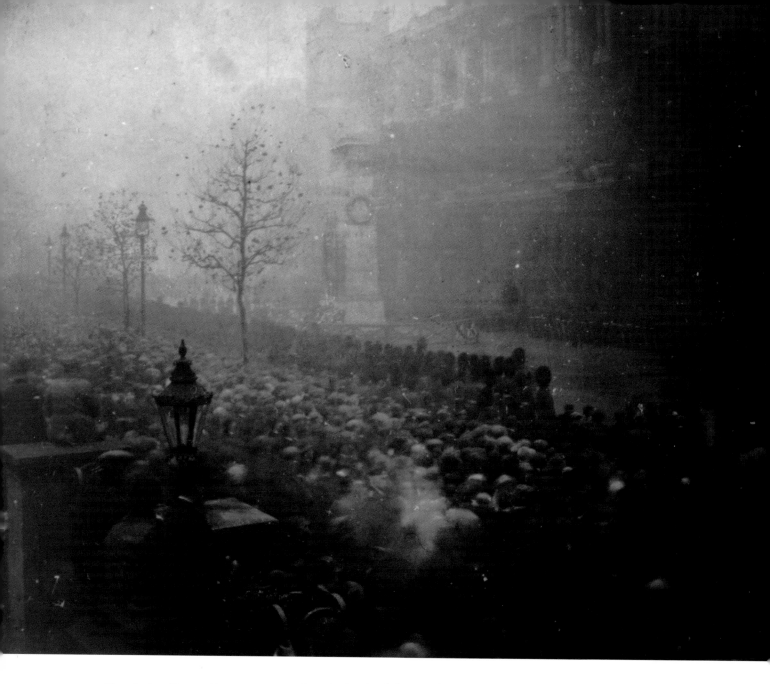

Figure 83. ADA DEANE, *Two photographs taken before and during the Two Minutes' Silence at the Whitehall Centotaph, London, 1922. Gelatin silver photograph, Barlow Collection, British Library, London.*

Over the heads of the crowd in the picture floated countless heads of men with strained grim expressions. Some were faint, some were blurs, some were marked out distinctly on the plate so that they might have been recognized by those who knew them. There was nothing else, just these heads, without even necks or shoulders, and all that could be seen distinctly were the fixed, stern, look of men who might have been killed in battle.[139]

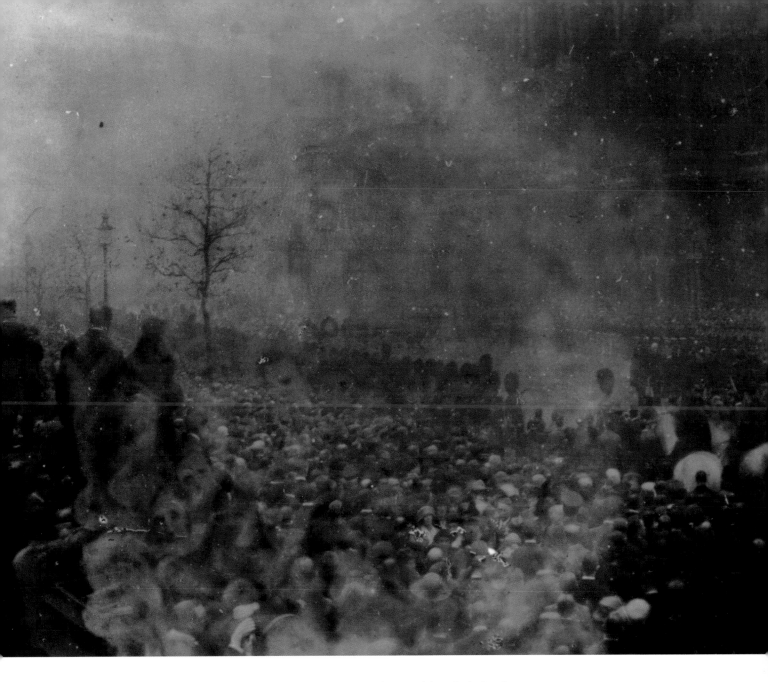

Two more photographs were taken during the following year's Silence. Although the heads of the fallen were impressed upside down on Violet Deane's plate, the pictures were circulated through the Spiritualist community. Many people recognized their loved ones among the extras, and those on the other side often drew attention to their presence in the group. H. Dennis Bradley, for instance, was in contact with the spirit of his brother-in-law, who told him, through a medium, that he was, 'on the right-hand side of the picture, not very low down'. The following day Bradley obtained a copy of the photograph and, to his

astonishment, among the fifty spirit heads visible in the picture he found one in the position described which, under the microscope, revealed a surprising likeness to his deceased brother-in-law.[140] A Californian woman, Mrs Connell, received a copy of the picture from a friend. Intuitively feeling that it might be meant particularly for her, she got out her ouija board to communicate with her fallen son David. She asked him if he was in the picture. 'Yes', he said, 'to the right of Kitchener'. She found Lord Kitchener's face and there, to the right of it, was a face she recognized as her son's.[141]

During 1924 there was much excitement on both sides of the veil in the lead up to Armistice Day. Estelle Stead was continually getting messages about preparations on the other side, where there seemed to be a great deal of training and grouping and other excitements. She was even told to give up smoking and meat to enhance her psychic sensitivity. At Deane's own private séances there was also much discussion amongst her various spirit guides about the upcoming event. Hulah said that the spirits were trying to arrange for a border of nurses' heads to frame the boys. And, on 21 October, the guides requested that there be no more sittings until after Armistice Day to store up power.

Deane and her daughter took two more photographs of the Cenotaph at Whitehall during the Two Minutes' Silence. By this time Deane's powers had apparently increased to the point that she no longer required the plates beforehand for pre-magnetization, and Stead supplied her and her daughter with factory-sealed plates on the day. The *Daily Sketch* beat its rival, the *Daily Graphic*, to get the rights to the pictures from Stead and reproduce them in their pictorial section. Initially the paper took an ambivalent approach to the images. The caption simply asked of the unseen faces: "Whose are they?"[142]

The paper answered its own question with its front-page story two days later: HOW THE DAILY SKETCH EXPOSED 'SPIRIT PHOTOGRAPHY', 'GHOSTS' VERY MUCH ALIVE, FACES OF POPULAR SPORTING IDENTITIES IDENTIFIED IN ARMISTICE DAY PHOTOGRAPH. It reproduced the portraits of twelve footballers and boxers, matching with faces in the Armistice Day photograph. It was no longer ambivalent:

> The exposure of truth in regard to alleged spirit photography, which deeply interests and affects multitudes of people, would not have been possible if the *Daily Sketch* had not, at the risk of some obloquy to itself, submitted the pictures to the rigorous searchlight of publicity, and thereby set at rest the minds of thousands who at various times have been tempted to believe in 'spirit' photography.[143] (See Figure 84.)

But, Estelle Stead protested, if anybody wanted to deliberately perpetuate a trick, the last thing they would do would be to use such easily recognized images. Besides, a person as

Figure 84. How the Daily Sketch *exposed 'Spirit Photography'. Letter-press, front page,* Daily Sketch, *15 November 1924, British Library, Newspaper Library, Colindale.*

WAR ON DEAR LOAF PROFITEERS MUST START AT ONCE

DAILY SKETCH

£500 FOOTBALL COUPON in Page 15

No. 4,884. Telephones {London—Holborn 6510. Manchester—City 6501. LONDON, SATURDAY, NOVEMBER 15, 1924. [Registered as a Newspaper.] ONE PENNY.

HOW THE DAILY SKETCH EXPOSED "SPIRIT PHOTOGRAPHY"

No. I.—Pym, Bolton Wanderers. Compare these with Nos. I and 2 on the "Spirit" photograph.

Nos. 2 and II.—Dr. Paterson, of The Arsenal.

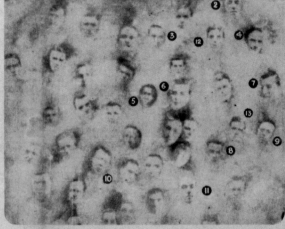

The alleged spirit photograph. It has been numbered to compare with the portraits in this page, but it has been touched in no other way.

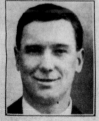

No. 3.—Clem Stephenson, Huddersfield.

No. 4.—Osborne, Tottenham Hotspur.

Miss Estelle Stead (left), whose statement appears in a news page, and Mrs. Deane, who took the photographs.

No. 5—Battling Siki.

No. 6.—Jimmy Wilde.

No. 7.—Grimsdell, of the Spurs.

No. 8.—McDonald, of the Spurs.

No. 9.—Molyneux, late of Chelsea.

No. 10.—P. Baugh, Wolverhampton Wanderers.

No. 12.—Tunstall, Sheffield United.

No. 13.—Baker, of the Arsenal.

In order to test the belief of Miss Estelle Stead and her friends that "spirits" were photographed in Whitehall on Armistice Day the Daily Sketch, being sceptical, reproduced the photographs on which their faith rested and invited comment and criticism. As a result of this bold measure, the Daily Sketch is able to-day to demonstrate beyond all doubt or cavil that the supposed "spirit faces" are nothing of the kind. They are, in fact, the faces of well-known footballers and professional boxers, all of whom are alive—the liveliest ghosts, in fact, ever photographed. This exposure of the truth in regard to alleged spirit photography, which deeply interests and affects multitudes of people, would not have been possible if the Daily Sketch had not, at the risk of some obloquy to itself, submitted the pictures to the rigorous searchlight of publicity, and thereby set at rest the minds of thousands who at various times have been tempted to believe in "spirit" photography.

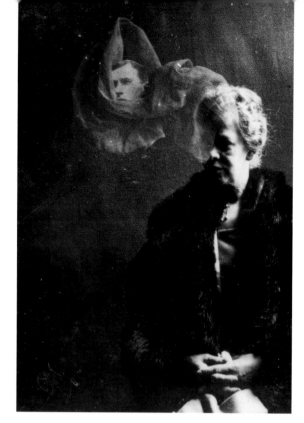

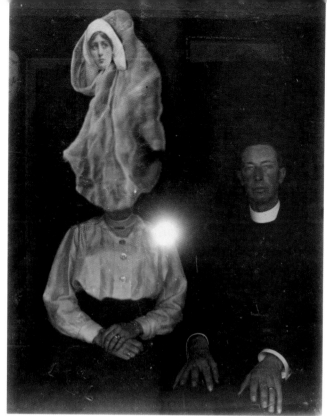

Above left: Figure 85. ADA
DEANE, *Unidentified sitter,
c. 1922. Gelatin silver photograph,
Barlow Collection, British
Library, London.*

Above right: Figure 86. ADA
DEANE, *Rev. Charles Drayton
Thomas, c. 1922. Gelatin silver
photograph, Barlow Collection,
British Library, London.*

Opposite: Figure 87. ADA
DEANE, *Unidentified sitters
(two women), c. 1922.
Gelatin silver photograph,
Barlow Collection, British
Library, London.*

simple as Deane would have no idea how to prepare such a picture. The paper found Deane
herself to be unflappable, and formed quite a different impression of her personality from
the one promoted by her Spiritualist supporters. To the reporter, this little grey-haired
middle-aged woman was the least disturbed person of the lot. Unlike the others involved in
the furore, she said little but answered all questions put to her with a practised ease that
bespoke an unusually capable woman. She simply refused to accept that the sportsmen's
faces were the same as those in her print.

Three days later, one of the paper's staff photographers duplicated Deane's effects under
the same test conditions. He explained how he had secreted a pre-exposed and developed
photographic positive plate of copied faces into the front of his plate-holder, through which
his ordinary negative plate was exposed (thus offering one explanation for the extraordinarily
long exposure times of Deane). The paper also published some readers' views on the incident.
'Does it not appear dastardly cruel and harsh', one reader wrote, 'that individuals, especially
women, should resort to these spirit photographs, thereby ridiculing these heroes of war, and
perhaps causing sorrow and distress in many homes?' Another reader agreed, 'when it comes
to monkeying about with something as sacred as the Two Minutes Silence you are going just
a step too far and are guilty of something more than merely bad taste.'[144]

That day the paper also challenged Deane to produce spirit photographs using its
equipment and facilities, offering £1,000 to charity if she succeeded under fair conditions.
'Will Mrs Deane accept the challenge?' its front page asked. Not surprisingly, she refused. 'She

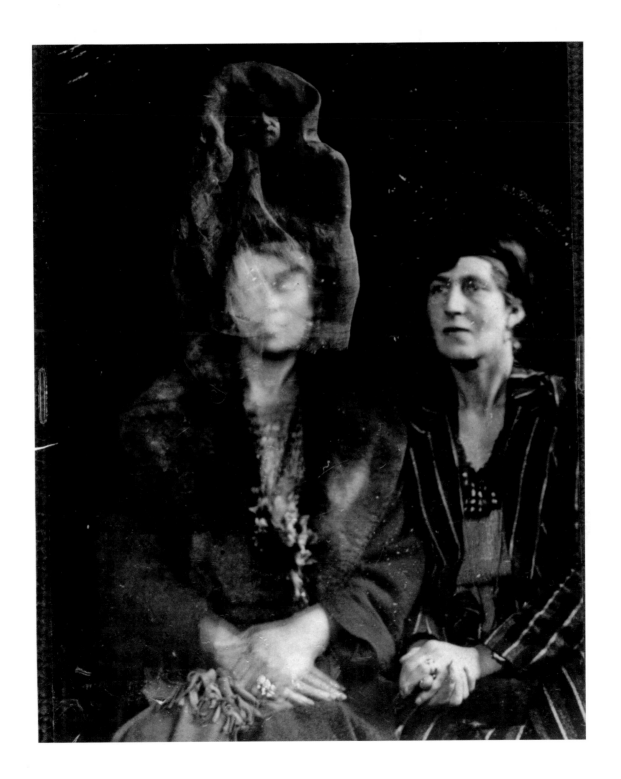

THE RETURN OF THE DEAD

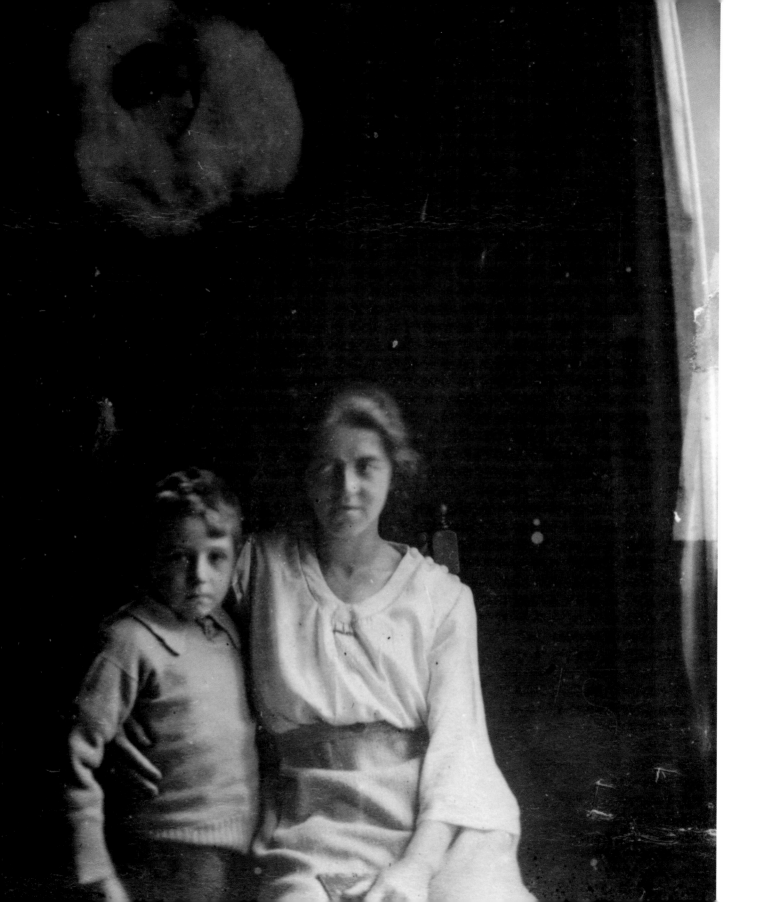

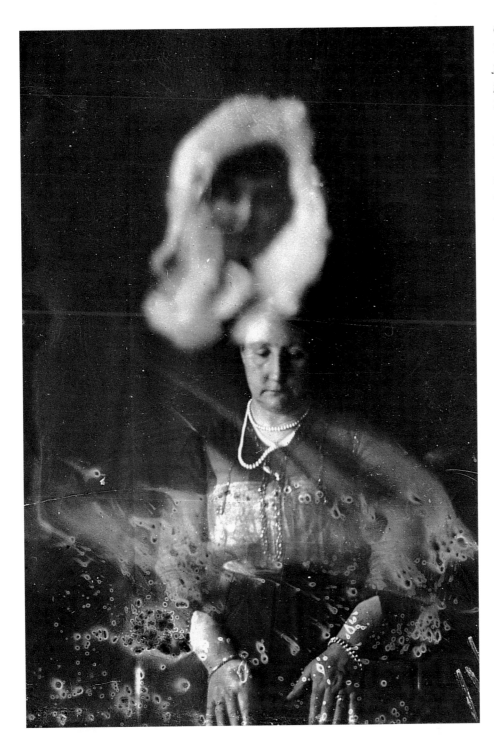

Opposite: Figure 88. ADA DEANE, *Mother and son and female extra, c. 1922. Gelatin silver photograph, Barlow Collection, British Library, London.*

Figure 89. ADA DEANE, *Unidentified sitter and extra, c. 1922. Gelatin silver photograph, Cambridge University Library, Society for Psychical Research.*

THE RETURN OF THE DEAD

Figure 90. ADA DEANE, *Woman holding lilies on shoulders, c. 1922. Gelatin silver photograph, Cambridge University Library, Society for Psychical Research.*

is a charlatan and a fraud', the paper claimed, 'who has already too long imposed on the sorrows and hopes of those who lost sons and husbands and brothers in the war.'[145] Deane replied:

> You challenge me to do a psychic photograph under your conditions. Do you not understand that I cannot do one under any <u>conditions</u>? They do not come from me. They come from some power which works through me over which I have no control. My results are often very different from what I expect. Such a power may work to console the afflicted folk. But I doubt if money would tempt it to come at the bidding of a newspaper man.[146]

W. T. Stead, communicating from the other side at a séance, seemed very pleased with the newspaper furore. 'We want to impress the Crowd,' he said, 'it is all important – that is what our work at the Cenotaph is for.' Any publicity was good publicity for the cause. As in the case of the 1923 photographs, many people claimed to recognize their loved ones in the photographs. Doyle saw his nephew, and Mr Pratt from Burnley saw his son Harry, who had been killed in action in 1918. 'This knocks the *Daily Sketch* argument on the head', he wrote, 'for if only one is claimed, the case for genuine spirit photography is made out.'[147]

At her discarnate father's suggestion Estelle sent copies of the two photographs to the medium Mrs Travers-Smith, asking her to submit them to her spirit guide, Johannes, to get further comments from the other side. He said, through the medium:

> This is an arrangement prepared beforehand from our side. The person who took this [Mrs Deane] must have been very easy to use. I see this mass of material has poured from her. It is as if smoke or steam were blown out of an engine. This material has made the atmosphere sufficiently clear to take the impress of the prepared mould which you see here. It is not as it would be if the actual faces had pressed in on the medium's mind. A number of faces were wanted for this photograph, so a mould was prepared. The arrangement is unnatural and does not represent a crowd pressing through to the camera because it has all been carefully prepared beforehand.[148]

After this incident Deane was no longer as publicly active, but she continued her spirit photography for at least another ten years. After Doyle died, his face featured as the centrepiece of an arrangement of Fallen Soldiers in Deane's Armistice Day photograph of 1931.

Fred Barlow had included Ada Deane in his 1933 denunciation of William Hope and spirit photography. Warrick, who was now Deane's one remaining staunch friend and patron, asked her what she thought of Barlow's sudden repudiation, since he had been her very first sponsor in Spiritualism thirteen years before:

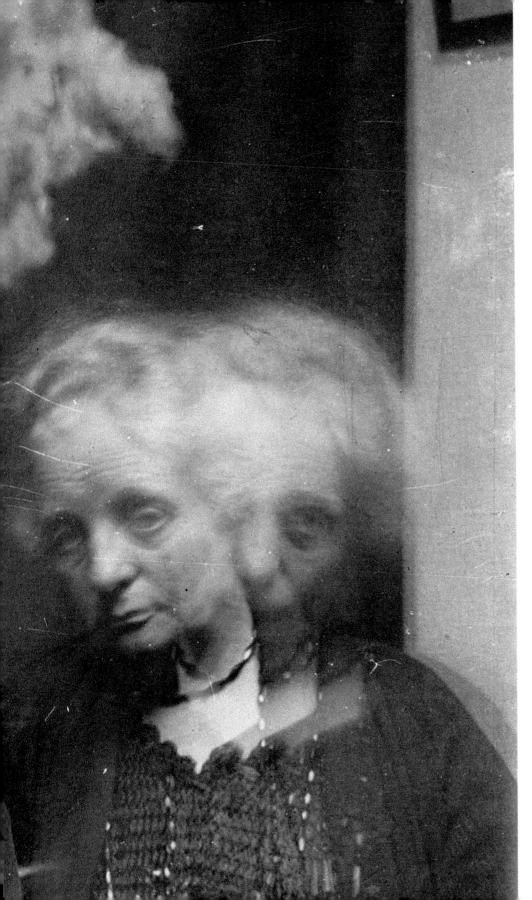

Figure 91. ADA DEANE, *Two women, c. 1922. Gelatin silver photograph, Cambridge University Library, Society for Psychical Research.*

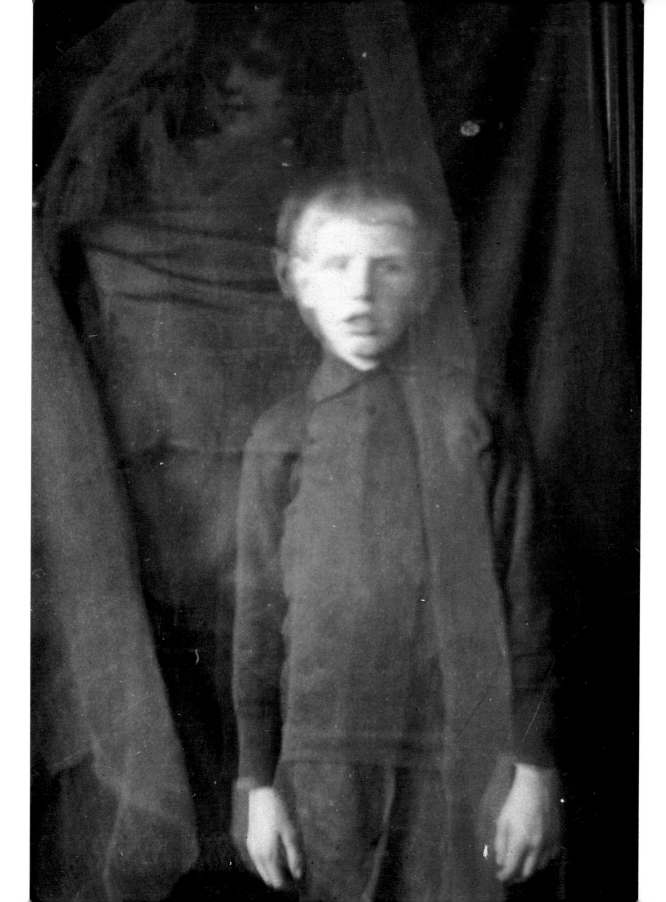

138

It was a sorry day for me when I discovered this photographic power. My life has lost all its ease and serenity. Before that I was respected and happy in my work, though poor; and today I am poor and look back on twelve years of worry and trouble and am a cock-shy for any newspaper penny-a-liner. I cannot understand Mr Barlow now saying that every Extra face that appeared on plates used by me has been put there by me fraudulently. In those days I was unsuspicious and not resentful of inquiry nor fearful of accusations. I had no knowledge then of the length the sceptic will go in his treatment of an unfortunate medium, as I am called. I put no obstacle in Mr Barlow's way and was willing to accommodate myself to his every wish. ... Once again, Mr Warrick, I assure you I have never consciously deceived sitters; I admit that many of the results obtained through me (in a way I have not the least inkling of) have every appearance of having been produced by trickery but I do no more understand how or why than you do.[149]

Figure 92. ADA DEANE, *Unidentified boy with extra, c. 1923. Gelatin silver photograph, Cambridge University Library, Society for Psychical Research.*

THE SPIRITS' LEGACY

EPILOGUE: THE SPIRITS' LEGACY

Eighty years after the heyday of Spiritualism, the belief in spirit photography is now only maintained by a few of the most wilfully credulous. While the general belief in the presence of ghostly experiences has not substantially diminished since the 1920s,[150] the faith in photography as a foolproof way of positively recording them is now only found scattered at the outer limits of paranormal enthusiasm, or in the furthest reaches of the World Wide Web. The Spiritualist religion, once a mass-scale social movement which somewhat uneasily overlapped with mainstream Christianity, has given way to a plethora of New Age spiritualities. Plenty of earnest psychic investigators still exist, but they have shrunk in eminence and shifted their attention to other supposedly paranormal phenomena, such as extrasensory perception. The great celebrity mediums of the past, who conducted their séances before batteries of scientists, have been succeeded either by franchised telephone psychics, advertising their clairvoyant services at the back of supermarket magazines, or by flashy entertainers, supposedly channelling the loved ones of their studio audience in late-night television programmes.

During the late nineteenth and early twentieth centuries, Spiritualism implanted its powerful visions and mysterious characters deeply into popular consciousness. Even non-believers couldn't help but be fascinated. And this legacy of ideas and images is still very much with us. Spiritualism's phantasmagoric images haunted our entertainment media right from the start. Spiritualist mediums shared many of their surreptitious techniques with the impresarios of nineteenth-century stage magic acts. Like stage magicians, mediums would also ventriloquize disembodied voices, slip out of supposedly tightly bound knots, secrete objects on or in their body, divert the attention of their sitters, and use sleight-of-hand. Spiritualist photographers shared many of their techniques with eighteenth-century phantasmagoria shows, nineteenth-century magic lantern shows, and twentieth-century cinema, and they also used special effects such as phosphorescence, masking, and double exposure. In 1856, five years before the first spirit photographer, William Mumler, was embraced by Spiritualists, the early photographic pioneer David Brewster was already explaining to his readers how: 'for the purposes of amusement, the photographer might even carry us even into the regions of the supernatural. His art ... enables him to give a spiritual appearance to one or more of his figures, and to exhibit them as "thin air" amid the solid realities of the [photographic] picture.' To create the impression of a transparent 'aerial personage', Brewster advised his readers to have an accomplice, suitably attired, walk quickly into a scene just before the completion of the camera's exposure, and stand still for a few seconds.[151]

Within a few years of the invention of cinema, trick films such as G. A. Smith's *Photographing a Ghost, 1898*, or Georges Melies' *The Spiritualist Photographer, 1903*, were openly displaying in the film theatre the same special effects of double exposure and

superimposition as the spirit photographers were cunningly deploying in their studios and darkrooms. The films were explicitly tricks, and generally poked fun at Spiritualism, but they too relied on evoking, within the conventions of entertainment, a parallel sense of wonder at the uncanny visual world the new technology of the cinema was opening up.[152] Later, in the 1920s, Hollywood responded to the post-war craze for Spiritualism by making many films featuring Spiritualistic phenomena, which were represented as being either fake or real depending on the plot of the film. For example *Darkened Rooms*, 1929, starred a fake spirit photographer who is tricked by his kind-hearted girlfriend, posing as a spirit, into renouncing his dubious profession; while *Earthbound*, 1920, featured the apparition of a murdered man, earthbound by his allegiance to the worn-out credo of no God and no afterlife, being finally able to release himself by appearing to his wife and making amends for his sins. Films such as this, even though they used special effects to re-create spiritualistic phenomena, received the warm approbation of Spiritualists. One Spiritualist, Dr Guy Bogart, even visited the set of another film with a pro-Spiritualistic theme, *The Bishop of the Ozarks*, which featured a séance and mental telepathy, and was convinced he saw a real spirit manifest itself on the set to complement the film's special effects.[153]

The Spiritualists were modernists. They understood the phenomena they witnessed, and believed in, to be part of the same unfolding story of progress as science and technology. Their mediums were thaumaturges who, for their adherents, shared characteristics with other modern wonder-workers such as doctors, psychiatrists and scientists. Even if they failed in their expectation that they would be the heralds of a new dawn of expanded awareness, the imaginative world the Spiritualists created for themselves still provides compelling ideas and powerful images for the present. In the last decade or so, the relatively moribund ideas and images of Spiritualism have undergone a resurgence in contemporary culture. Historians of cinema, photography and visual culture have begun to pay attention to spirit photography and to treat it as an important part of the experience of modernity.[154] The enigmatic figure of the spirit photographer is beginning to make occasional appearances in novels.[155] The plots of many contemporary horror films are twisting again on the spectral convergence of the ghost and the photographic, or video, image.[156] Various contemporary artists are using new technologies to create spectral effects that art viewers are able to recognize and respond to because of popular culture's long-term absorption of Spiritualist iconography. In many of these contemporary artworks, video images of disembodied entities seem to be cast adrift from their moorings in our mass-media landscape. By the use of such tools as video compositing and projection they are made to float in an electronic void – a technologically occulted 'beyond' that is a counterpart to the day-to-day environment of media messages we take for granted. Like the Spiritualists before them, the artists imagine this as a world sundered from our own, yet still connected to it by the various mysterious transmissions of the electro-magnetic ether.[157] And finally the idea of

143

'haunting' – where unquiet 'ghosts' from the historical past return to the present to challenge us to redeem them – is being increasingly invoked in contemporary philosophy and cultural studies. It even has its own name: hauntology.[158]

There is no doubt that the Spiritualists were extremely credulous. But credulity is a relative term, most often used by those with social or intellectual authority to dismiss those who have none. The Spiritualists' legacy can still be felt today because they used their credulity actively and creatively. Most people buffeted by the incredible wars, deaths, losses and changes of the late nineteenth and early twentieth centuries managed their emotions, thoughts and desires through such safe and conventional means as private mourning, public memory and established religious ritual. But the Spiritualists took these relatively contained processes of psychological fantasy, private reverie and public ceremony and unleashed them – they communally dramatized them in their séances, or projected them into new and uncanny technologies such as telegraphy, the wireless, or photography.

The Spiritualists' sense of themselves as pioneers of a new age meant that they were able to take existing ideas and use them for their own ends. They took the idea of the afterlife, present in the Judeo-Christian tradition for thousands of years, and domesticated it, bringing it down to the scale of the parlour. They took the idea of photography, which had been touted for decades as a personal mnemonic machine able to capture and fix the shadows of family and friends, and gave it the power to link the world of the living with the world of the dead. In the end, spirit photography turned out to not be a scientific truth, or a religious miracle, but, for its historical time, it remains an extraordinary act of collective imagination. Together, gullible clients, cunning mediums, opportunistic mentors and hubristic investigators created a rich imaginative economy where ideas, images and interpretations circulated, cross-infected and interpenetrated each other.

Photography remained the central tool in the psychic investigator's arsenal for so long because it promised mechanical objectivity. In 1891, the scientist and Spiritualist Alfred Russel Wallace challenged the SPR to properly investigate spirit photographs because they were 'evidence that goes to the very root of the whole inquiry and affords the most complete and crucial test in the problem of the subjectivity or objectivity of apparitions.'[159] But what ensnared those who looked to photographic evidence as a forensic test was that photographs had exactly the same problem of subjectivity and objectivity as spirit apparitions. The faces they documented changed, depending on who was looking at them. Eleanor Sidgwick, the SPR's most clear-headed thinker, pointed out: 'It must be remembered that if one frequently sees a portrait of an absent person, one's recollection is of the portrait, not really of the original, so that once a person has clearly made up his mind as to the likeness, his recollection of the original would adapt itself.'[160]

When a client chose to believe that the dead lived and were struggling to transmit news of their continued existence back from the other side; and when, in the mysterious

alchemical cave of the darkroom, that client saw before their very eyes a face emerge to join their own face on a photographic plate; and when they decided, perhaps even after some initial trepidation, to let themselves be flooded with the absolute conviction that they recognized that face as a lost loved one; then a certain photographic truth was revealed. Not a forensic truth, but an affective truth. That incontrovertible truth remains as relevant today as it ever was. Photographs are never just simple images of reality, they are also ideas and interpretations. The portrait photograph is not just made by the bald technical operation of snapping someone in front of the camera, it is also constituted by the context of the 'performance' of the portrait, and by the way the resultant image is incorporated into people's lives after it is made.

The sheer magical power of the portrait photograph was what essentially drove spirit photography, and that power remains to this day. Despite all the subsequent technological changes of the late twentieth and early twenty-first centuries, and despite the complete digitization and computerization of the photographic process, when we look back to spirit photography's overheated milieu and intense images, we can still see our own attitudes to, and uses of, the portrait photograph written large – very large. For us, as for those who made the decision to visit spirit photographers, looking into a photograph allows us to believe that we can see and feel the presence of someone sundered from us by the passage of time, or by death itself.

Bibliography

JOURNALS AND NEWSPAPERS listed chronologically.

'UNSEEN MEN AT CENOTAPH', *Daily Sketch*, 13 November 1924, p. 1.

'HOW THE DAILY SKETCH EXPOSED "SPIRIT PHOTOGRAPHY"', *Daily Sketch*, 15 November 1924, p. 1.

'"SPIRITS" WHILE YOU WAIT', *Daily Sketch*, 18 November 1924, p. 2.

'£1000 TEST FOR MEDIUM/BIG SUM FOR CHARITY IF CENOTAPH CLAIMANT CAN TAKE "SPIRIT" PICTURES UNDER FAIR CONDITIONS/WILL MRS DEANE ACCEPT THE CHALLENGE?', *Daily Sketch*, 19 November 1924, p. 2.

"SPIRIT" PHOTOGRAPHER RUNS AWAY', *Daily Sketch*, 21 November 1924, p. 1.

'Different Viewpoints!' *Harbinger of Light*, October 1919.

'Sir Arthur Conan Doyle at Carnegie Hall', *Harbinger of Light*, July 1923.

'Conan Doyle in Australia', *Light*, 18 December 1920.

'A Stupendous Fraud', *New York Times*, 13 April 1869, p. 5.

'The Spiritual Photograph Case – A Letter to Justice Dowling', *New York Times*, 21 April 1869, p. 10.

'Spiritual Photographs', *New York Times*, 22 April 1869, p. 8.

'Spiritual Photography', *New York Times*, 24 April 1869, p. 4.

'Spiritual Photographs', *New York Times*, 4 May 1869, p. 1.

'Our Quest in the Psychic Field', *Scientific American*, May 1923, p. 300.

'Mysterious "Spirit" Photograph', *Sunday Pictorial*, 13 July 1919.

BOOKS

Baer, U., *Spectral Evidence: Photography and Trauma*, Cambridge, Mass.: MIT Press, 2002.

Barlow, F., 'Psychic Photographs, Interesting Experiments with a New Sensitive', *The Two Worlds*, 19 November 1920, p. 1.

———, 'Psychic Photography. Perfect Proof', *Light*, 20 August 1921, p. 543.

———, 'Does Psychic Photography Prove Survival?, *Light*, 28 October 1922.

———, 'Psychic Photography Debated: Major W. R. Rose and Mr Fred Barlow State their

146

Case against William Hope's Work', *Light*, May 1933.

Barlow, F., and Rampling-Rose, W., 'Report on an Investigation in Spirit Photography', *Proceedings of the Society for Psychic Research*, 41, March, p. 139.

Beaufort, M., letter to Eric Dingwall, 5 March 1922, Society for Psychical Research Archives, Cambridge University Library, Deane Medium File.

Bird, J. M., 'Our Psychic Investigation: Its Scope, Conditions and Procedure, as far as they can be Laid Down', *Scientific American,* January 1923, p. 6.

———, 'Our Psychic Investigation: The "Direct Message" and the Relation Which It may Ultimately Have to Our Work', *Scientific American*, February 1923, p. 84.

———, 'Our Quest in the Psychic Field', *Scientific American*, May 1923, p. 300.

Black, J., 'The Spirit-Photograph Fraud: The Evidence of Trickery, and a Demonstration of the Tricks Employed', *Scientific American*, October 1922, p. 224.

Brandon, R., *The Spiritualists : The Passion for the Occult in the Nineteenth and Twentieth Centuries*, London: Weidenfeld and Nicolson, 1983.

Braude, A., *Radical Spirits : Spiritualism and Women's Rights in Nineteenth-century America*, Bloomington: Indiana University Press, 2001.

Brewster, D., *The Stereoscope: Its History, Theory and Construction, with its Application to the Fine and Useful Arts and to Education*, London: John Murray, 1856.

British College of Psychic Science, letter to Mrs Creasy, 11 April, 1921, SPR Archives, Cambridge University Library, Deane Medium File.

Broad, C. D., 'Cromwell Varley's Electrical Tests with Florence Cook', *Proceedings of the Society for Psychical Research*, 54, March 1964, p. 195.

Bush, E., *Spirit Photography Exposed*, Southport: Nehushtan Crusade, 1920.

Castle, T., 'Phantasmagoria: Spectral Technology and the Metaphorics of Modern Revery', *Critical Inquiry*, 1988, pp. 26–61.

Coates, J., *Photographing the Invisible: Practical Studies in Spirit Photography, Spirit Portraiture, and other Rare but Allied Phenomena*, London: L.N. Fowler & Co, 1911.

Connell, M., letter to SPR, 4 March 1925, Society for Psychical Research Archives, Cambridge University Library, Deane Medium File.

Crandon, L. R. G., 'The Psychic Investigation: "Report of Progress" from "Margery's" Point of View', *Scientific American*, January 1925, p. 29.

Crawford, W. J., *The Psychic Structures of the Goligher Circle*, London: John M. Watkins, 1921.

Creasy, M., letter to Eric Dingwall, 1921, Society for Psychical Research Archives, Cambridge University Library, Deane Medium File.

Crookes, W., *Researches into the Phenomena of Spiritualism*, Manchester, London: Two Worlds Publishing Company, Psychic Bookshop, 1926.

d'Albe, E. E. F., *The Goligher Circle: May to August 1921*, London: John M. Watkins, 1922.

————, *The Life of Sir William Crookes*, London: T. Fisher Unwin, 1923.

d'Esperance, E., *Shadow Land: or Light from the Other Side*.

Derrida, J., *Specters of Marx: The State of the Debt, the Work of Mourning, and the New International*, New York: Routledge, 1994.

Dingwall, E., The Barlow Collection of Psychic Photographs, The catalogue (unpublished manuscript).

Dingwall, E., 'Report on a series of sittings with Eva C.' *Proceedings of the Society for Psychic Research*, vol 32, issue 44, 1922, pp. 209–343.

————, 'Report on a Series of Sittings with the Medium Margery', *Proceedings of the Society for Psychic Research*, vol 36, issue 48, 1926–28, pp. 79–198.

————, *The Critics' Dilemma; Further Comments on Some Nineteenth Century Investigations*, Crowhurst, Sussex: E. J. Dingwall, 1966.

Doyle, A. C., *The Wanderings of a Spiritualist*, London: Hodder and Stoughton, 1921.

————, *The Case for Spirit Photography*, London: Hutchinson and Co, 1922(A).

————, *The Coming of the Fairies*, London: Hodder and Stoughton, 1922(B).

Doyle, Lady C., 'Evidence of Conan Doyle's Survival/An Autographed Message/'No Death'/My Husband's Return', *News Chronicle*, 7 April 1931, pp. 1, 14.

Ferris, A., 'The Disembodied Spirit', in *The Disembodied Spirit*, ed. Ferris, A., Brunswick, Maine: Bowdoin College, 2003.

Fitzsimons, F. W., *Opening the Psychic Door: Thirty Years Experiences*, London: Hutchinson & Co, 1933.

Fodor, N., *Encyclopedia of Psychic Science*, London: Arthurs Press Limited, 1933.

Geley, G., *From the Unconscious to the Conscious*, London: William Collins & Sons, 1920.

————, *Clairvoyance and Materialisation: A Record of Experiments*, London: T. Fisher Unwin, 1927.

Gerry, E. T., *The Mumler 'Spirit' Photograph Case: Argument of Mr Elbridge T. Gerry, Counsel for the People, before Justice Dowling, on the Preliminary Examination of Wm H. Mumler, Charged with Obtaining Money by Pretended 'Spirit' Photographs. May 3rd, 1869, Reported by Andrew Devine*, New York: Baker, Voorhis & Co. Law Publishers, 1869.

Gettings, F., *Ghosts in Photographs: The Extraordinary Story of Spirit Photography*, New York: Harmony Books, 1978.

Gordon, A. F., *Ghostly Matters: Haunting and the Sociological Imagination*, Minneapolis: University of Minnesota Press, 1997.

Gunning, T., 'Phantom Images and Modern Manifestations: Spirit Photography, Magic Theatre, Trick Films, and Photography's Uncanny', in *Fugitive Images: From Photography to Video*, ed. Petro, P., Bloomington: Indiana University Press, 1995.

———, 'Haunting Images: Ghosts, Photography and the Modern Body', in *The Disembodied Spirit*, ed. Ferris, A., Brunswick, Maine: Bowdoin College, 2003.

Hall, T. H., *The Spiritualists: The Story of Florence Cook and William Crookes*, London: Gerald Duckworth & Co, 1962.

Hamilton, T. G., *Intention and Survival*, Toronto: MacMillan, 1942.

Henry, T. S., *Spookland! A Record of Research and Experiment in a Much-Talked-of Realm of Mystery, with a Review and Criticism of so called Spirit Materialisation, and Hints and Illustrations as to the Possibility of Artificiality Producing the Same*, Sydney: W. M. Maclardy and Co, 1894.

Holmes, O. W., 'Doings of the Sunbeam', *Atlantic Monthly*, July 1863, p. 14.

Houdini, *A Magician Among the Spirits*, New York: Harper & Brothers, 1924.

Houghton, G., *Chronicles of the Photographs of Spiritual Beings and Phenomena, Interblended with Personal Narrative*, London: E. W. Allen, 1882.

———, *Evenings at Home in Spiritual Séance, Prefaced and Welded Together by a Species of Autobiography*, London: Trubner & Co, 1881.

Jameson, F., 'Marx's Purloined Letter', *New Left Review*, 209, January/February.

Jephson, M., letter to Eric Dingwall, 23 March 1922, Society for Psychical Research Archives, Cambridge University Library, Vearncombe file S.P. 8.

Jolly, M., 'Spectres from the Archive', in *Le Mois de la photo à Montreal*, ed. Langford, M., Montreal: McGill-Queens University, 2005.

Jones, G., *Sixty Lights*, London: Random House, 2004.

Jones, K., *Conan Doyle and the Spirits: the Spiritualist Career of Sir Arthur Conan Doyle*, Wellingborough: Aquarian Press, 1989.

Krauss, R. H., *Beyond Light and Shadow: The Role of Photography in Certain Paranormal Phenomena: An Historical Survey*, Nazraeli Press: 1994.

Lodge, O., letter to Eric Dingwall, 14 April 1922, Society for Psychical Research Archives, Cambridge University Library, Deane Medium File.

———, *Raymond revised*, London: Methuen, 1932.

Lodge, O., and Lodge, R., *Raymond*, London: Methuen & Co, 1916.

Lombroso, C., *After Death—What? Spiritistic Phenomena and their Interpretation*, London: T. Fisher Unwin, 1909.

Luckhurst, R., *The Invention of Telepathy, 1870–1901*, Oxford and New York: Oxford University Press, 2002.

McDougall, W., ' The "Margery Mediumship"', *Scientific American*, May 1925, p. 339.

Medhurst, R. G., and Goldney, K. M., 'William Crookes and the Physical Phenomena of Mediumship', *Proceedings of the Society for Psychical Research*, vol 55, part 195, March 1965, pp. 27–153.

Medhurst, R. G., Goldney, K. M., and Barrington, M. R., *Crookes and the Spirit World*, London: Souvenir 1972.

Mumler, W., *The Personal Experiences of William H. Mumler in Spirit Photography Written by Himself*, Boston: Colby and Rich, 1875.

Noakes, R. J., 'Telegraphy is an Occult Art: Cromwell Fleetwood Varley and the Diffusion of Electricity to the Other World', *British Journal of the History of Science*, December 1999, pp. 421–59.

Norman, H., *The Haunting of L.*, London: Picador, 2003.

Oppenheim, J., *The Other World: Spiritualism and Psychical Research in England, 1850–1914*, Cambridge and New York: Cambridge University Press, 1985.

Owen, A., *The Darkened Room: Women, Power and Spiritualism in Late Nineteenth Century England*, London: Virago, 1989.

Pearsall, R., *The Table-Rappers*, London: Michael Joseph, 1972.

Phillips, P. C., 'Close Encounters – Thematic Investigation: Photography and the Paranormal', *Art Journal*, 62, Fall 2003, p. 3.

Pilley, B. W. C., 'AMAZING SPIRIT CAMERA FRAUD. PSYCHIC EXPERIMENTER CAUGHT RED HANDED IN TRANSPARENT DECEPTION AND TRICKERY', *John Bull*, 17 December 1921, p. 5.

Podmore, F., *Mediums of the Nineteenth Century*, New York: University Books, 1963.

Price, H., *Cold Light on Spiritualistic Phenomena*, London: Kegan Paul, Trench, Trübner & Co, 1922.

'Psyche', *A Counterblast to Spookland, or Glimpses of the Marvellous*, Sydney: W. M. Maclardly & Co, 1895.

Read, P., *Haunted Earth*, Sydney: University of New South Wales Press, 2003.

Richet, C., *Thirty Years of Psychical Research: Being a Treatise on metaphysics*, London: W. Collins and Sons, 1923.

Schrenck-Notzing, B. A., *Phenomena of Materialisation: A Contribution to the Investigation of*

Mediumistic Teleplastics, London: Kegan Paul, Trench, Trubner & Co., 1920.

Sconce, J., *Haunted Media: Electronic Presence from Telegraphy to Television*, Durham, NC: Duke University Press, 2000.

Sidgwick, E., 'On Spirit Photographs: A Reply to Mr A. R. Wallace', *Proceedings of the Society for Psychical Research*, vol 7 part 19, 1891–92, pp. 268–89.

Stead, E., 'And Some of Them Are Photographed', *Harbinger of Light*, February 1918.

———, *Faces of the Living Dead*, Manchester: Two Worlds Publishing,1925.

Stephenson, C. J., 'Further Comments on Cromwell Varley's Electrical Test on Florence Cook', *Proceedings of the Society for Psychic Research*, 54, April 1966, p. 198.

Taylor, J. T., '"Spirit Photography" with Remarks on Fluorescence', *British Journal of Photography*, 17 March 1893.

Thurschwell, P., 'Refusing to Give up the Ghost: Some Thoughts on the Afterlife from Spirit Photography to Phantom Films', in *The Disembodied Spirit,* ed. Ferris, A., Brunswick, Maine: Bowdoin College, 2003.

Wallace, A. R., *Miracles and Modern Spiritualism*, London: Spiritualist Press, 1955.

Warrick, F. W., letter to Eric Dingwall, 25 May 1923, Society for Psychical Research Archives, Cambridge University Library, Deane Medium File.

———, letter to Eric Dingwall, 28 January 1924, Society for Psychical Research Archives, Cambridge University Library, Deane Medium File.

———, *Experiments in Psychics: Practical Studies in Direct Writing, Supernormal Photography, and Other Phenomena Mainly with Mrs Ada Emma Deane*, London: Rider & Co, 1939.

———, note of telephone call, 22 October,1954, Society for Psychical Research Archives, Cambridge University Library, Deane Medium File.

Wijnants, E. P., 'Phenomena on Trial: Crossing Over P. 5', Institute for Sociology and the History of Ideas, http://sociologyesoscience.com/crossing05.html,2003.

Winter, J., *Sites of Memory, Sites of Mourning: The Great War in European Cultural History*, Cambridge: Cambridge University Press, 1995.

Wiseman, R., Smith, M., and Wisman, J., 'Eyewitness Testimony and the Paranormal', *Skeptical Inquirer*, November/December 1995.

Wiseman, R., Watt, C., Stevens, P., Greening, E., and O'Keefe, C., 'An investigation into Alleged "Hauntings"', *British Journal of Psychology*, 94, 2003, pp. 195–211.

Wynne, C., 'Arthur Conan Doyle and Psychic Photographs', *History of Photography*, 22, Winter 1998, p. 4.

Notes

Full details of publications cited in these notes can be found in the Bibliography.

1. Dingwall, unpublished manuscript, p. 6.

2. See, Brandon (1983); Oppenheim (1985); Owen (1989); and the indispensable Fodor (1933).

3. 'Spiritual Photographs', *New York Times*, 4 May 1869, p. 1.

4. 'Spiritual Photographs', *New York Times*, 24 April 1869, p. 8; 'Spiritual Photography', *New York Times*, 24 April 1869, p. 4; 21 April 1869, p. 10.

5. 'Spiritual Photographs', *New York Times*, 22 April, p. 10.

6. Gerry, (1869).

7. 'Spiritual Photographs', *New York Times*, 4 May 1869, , p. 1; 'A Stupendous Fraud', *New York Times*, 13 April 1869, p. 5.

8. Holmes (1863), p. 8.

9. 'A Stupendous Fraud', *New York Times*, 13 April 1869, p. 5.

10. The *Spiritual Magazine,* March 1863, quoted in F. Gettings (1978), p. 26.

11. Holmes (1863), pp. 11–12, 14.

12. Mumler (1875), pp. 3, 8.

13. Ibid., pp. 30–41.

14. Ibid., pp. 64–68.

15. Stainton Moses, *Human Nature,* May 1875, cited in Podmore (1963), vol. 2, p. 121.

16. Coates (1911), p. 54.

17. Madame Leymarie, *Procès des spirites*, Paris, 1875, quoted in Podmore (1963), vol. 2, p. 122.

18. *Procès des spirites*, quoted in Wijnants (2003).

19. Fodor (1933); Krauss (1994), p. 131.

20. G. Houghton (1882), p. 4.

21. Ibid., p. 36.

22. Sidgwick (1891–2), p. 271.

23. Houghton (1882), pp. 29, 64.

24. d'Albe (1923), pp. 123–4.

25. Crookes (1926).

26. Podmore (1963), p. 98.

27. Hall (1962); Fodor (1933), pp. 405–6.

28. Brandon (1983), pp. 109–12.

29. Varley, 'Electrical experiments with Miss Cook when entranced', *Spiritualist* (1874), cited in Noakes (1999), p. 455. See also, Broad (1964) p. 195, and Stephenson (1966), p. 198.

30. Crookes (1926), p. 126.

31. Hall (1962), p. 85.

32. Ibid., pp. 81–85.

33. Crookes (1926), p. 128.

34. William Crookes, 'On Radiant Matter', *Nature*, 20 (September 1879), cited in Luckhurst (2002), p. 81.

35. Quoted in Pearsall (1972), p. 92.

36. Krauss (1994), p. 121.

37. Cambridge University Library, SPR Archives, SPR.MS 15/4/83–87. See also Brandon (1983) ; Dingwall (1966); Hall (1962); Medhurst and Goldney (1964), p. 195; Medhurst, Goldney and Barrington, (1972), and Owen (1989), p. 230.

38. For a discussion of female mediumship as an empowering and subversive practice see Owen (1989), and Braude (2001).

39. Lombroso (1909), pp. 199–200.

40. Fodor (1933), p. 85.

41. Henry (1894); 'Psyche' (1895).

42. Taylor (1893), p. 34.

43. 'Spirit Photography – A New Series of Psychic Pictures', *Borderland*, October 1895, cited in Gettings (1978), pp. 13–14. Krauss (1994), p. 158.

44. 'Cyprian Priestess Mystery', *Borderland*, July 1895, cited in Krauss (1994), p. 156.

45. Coates (1911), pp. 105–6.

46. Ibid., p. 119–21.

47. Warrick (1939), p. 326.

48. Coates (1911), pp. 237, 287.

49. Ibid., p. 253.

50. Ibid., p. 199.

51. Black (1922), p. 225.

52. Jephson (1922).

53. Quoted in Lombroso (1909), pp. 187–8. For more on science and spiritualism see Oppenheim (1985), part 3, and Luckhurst (2002).

54. Wallace (1955), p. 192.

55. Richet (1923), pp. 506–8.

56. Schrenck-Notzing (1920), p. III.

57. Ibid., p. 131.

58. Ibid., p. 269.

59. Quoted in Gettings (1978), p. 123.

60. Schrenck-Notzing (1920), p. 213.

61. Ibid., p. 294.

62. Doyle (1921), p. 172.

63. Geley (1927).

64. Geley (1920), p. 60.

65. Ibid., p. 57.

66. Ibid., p. 62.

67. Ibid., p. 61.

68. Dingwall (1922), p. 44.

69. For phantasmagoria see Castle (1988), pp. 26–61.

70. Houdini (1924), p. 167–8.

71. Society for Psychical Research Collection, Cambridge University Library, Eva C Box, SPR. MS 15/2/1–33.

72. Bird (January 1923), p. 6; (May 1923), p. 300.

73. Bird, (February 1923), p. 84.

74. Brandon (1983), pp. 164–89.

75. Crandon (1925), p. 29.

76. Dingwall (1926–28), 48; McDougall (1925), pp. 339–41. The Canadian psychic investigator T. G. Hamilton also photographed Margery and another ectoplasmic medium Mary M., see Hamilton (1942).

77. Crawford (1921), p. 19.

78. Ibid., p. 20.

79. Ibid., pp. 21–33, 62.

80. Ibid., pp. 59–60, 65, 81.

81. d'Albe (1922), p. 68.

82. Crawford (1921), p. 145–47.

83. Ibid., pp. 148–51.

84. Houdini (1924), pp. 173–4.

85. Crawford (1921), foreword by David Gow.

86. d'Albe (1922), p. 27.

87. Ibid., p. 42.

88. Houdini (1924), pp. 173–4.

89. Oppenheim (1985), p. 71.

90. Fodor (1933), pp. 175–6.

91. Doyle (1921), p. 252.

92. Stead (1918).

93. Doyle (1921), pp. 76–7.

94. 'Conan Doyle in Australia', *Light*, 18 December 1920.

95. 'Different Viewpoints!', *Harbinger of Light*, October 1919.

96. 'Mysterious 'Spirit' Photograph', *Sunday Pictorial*, 13 July 1919.

97. Doyle (1922(A)), p. 92.

98. Fodor (1933), p. 315.

99. Doyle (1922(A)), pp. 31–2.

100. *Psychic Gazette*, November 1915, cited in Bush (1920), p. 35.

101. For more on post-World War mourning see Winter (1995).

102. Fodor (1933), p. 106.

103. Houdini (1924), p. xvi.

104. The most notorious example of Doyle's credulity was his publication,
 in the Christmas 1920 edition of the *Strand Magazine*, of photographs of fairies,
 purportedly taken by two young girls at Cottingley. See Doyle (1922(B));
 Wynne (1998), p. 4; and Krauss (1994), pp. 186–97.

105. Houdini (1924), pp. 162–3.

106. Ibid., pp. 131–2.

107. Society for Psychical Research Collection, Cambridge Universitu Library,
 Hope Medium file, S.P.7; *Journal of the Society for Psychical Research*, August 1922,
 p. 271; Krauss (1994), pp. 175–86. Price (1922).

108. Doyle (1922(A)), p. 41.

109. Ibid., pp. 13–14.

110. Oppenheim (1985), p. 351.

111. d'Albe (1923), p. 404.

112. SPR Collection, Cambridge University Library, Hope Medium file, S.P.7.

113. Doyle (1922(A)), p. 60.

114. Black (1922), p. 286.

115. Doyle (1931), pp. 1, 14.

116. Barlow (1933); Barlow and Rampling-Rose (1933), p. 139.

117. *Light*, 2 June 1933, p. 342.

118. *Light,* 17 March 1933, quoted in Fodor (1933), p. 176.

119. Brandon (1983), pp. 228–9.

120. Houdini (1924), pp 14–15.

121. Warrick, p. 273–7.

122. Barlow (1920), p. 1.

123. Barlow (1921), p. 453.

124. Barlow (1922).

125. Pilley (1921).

126. Society for Psychical Research Collection, Cambridge University Library, BCPS, letter to Mrs Creasy, 11 April 1921, Deane Medium File.

127. M. Creasy, letter to Eric Dingwall, 1921, Deane Medium File.

128. Lodge, O. J., and Lodge, R. (1916), and Lodge, O. (1932).

129. Society for Psychical Research Collection, Cambridge University Library, O. Lodge, Letter to Eric Dingwall, 14 April 1922, Deane Medium File.

130. Doyle (1922(A)), p. 53.

131. Fitzsimons (1933), p. 241.

132. Society for Psychical Research Collection, Cambridge University Library, M. Beaufort, letter to Eric Dingwall, 5 March 1922, Deane Medium File.

133. Society for Psychical Research Collection, Cambridge University Library, F. W. Warrick, Letter to Eric Dingwall, 25 May 1923, Deane Medium File.

134. Warrick (1939), pp. 224–47.

135. Society for Psychical Research Collection, Cambridge University Library, F. W. Warrick, letter to Eric Dingwall, 28 January 1924, Deane Medium File.

136. Society for Psychical Research Collection, Cambridge University Library, F. W. Warrick, note of telephone call, 22 October, 1954, Deane Medium File.

137. Stead (1925), p. 27.

138. K. Jones (1989), p. 193.

139. 'Sir Arthur Conan Doyle at Carnegie Hall', *Harbinger of Light*, July (1923);
K. Jones (1989).

140. Fodor (1933), p. 79.

141. Society for Psychical Research Collection, Cambridge University Library, M. Connell,
letter to SPR, 4 March 1925, Deane Medium File.

142. 'UNSEEN MEN AT CENOTAPH', *Daily Sketch*, 13 November 1924, p. 1.

143. 'HOW THE DAILY SKETCH EXPOSED "SPIRIT PHOTOGRAPHY"',
Daily Sketch, 15 November 1924, p. 1.

144. '"SPIRITS" WHILE YOU WAIT', *Daily Sketch*, 18 November 1924, p. 2.

145. '£1000 TEST FOR MEDIUM BIG SUM FOR CHARITY IF CENOTAPH
CLAIMANT CAN TAKE "SPIRIT" PICTURES UNDER FAIR
CONDITIONS, WILL MRS DEANE ACCEPT THE CHALLENGE?',
Daily Sketch, 19 November 1924, p. 2.

146. '"SPIRIT" PHOTOGRAPHER RUNS AWAY', *Daily Sketch*, 21 November 1924, p. 1.

147. Stead (1925), p. 61.

148. Ibid., p. 59.

149. Warrick (1939), p. 310.

150. Wiseman, Smith and Wisman (1995); Wiseman, Watt, Stevens,
Greening and Keefe (2003).

151. Brewster (1856), pp. 205–6.

152. For more on magic, spirit photography and cinema see Gunning (1995).

153. Letter to Dr Prince from Dr Guy Bogart American Society for Psychical
Research, File #21, 05028/05028B. See the *American Film Institute Silent Film Catalog*,
www.afi.com/members/catalog/silentHome.aspx?s=1. For contemporary ghost
films see Thurschwell (2003).

154. Winter (1995); T. Gunning (2003); Phillips (2003); Sconce (2000).

155. Norman (2003); G. Jones (2004).

156. For instance *The Others*, 2001 and *The Ring*, 2002. See also Jolly (2005).

157. For instance the work of Susan Hiller, Tony Oursler, Zoe Beloff and many others.
See also Ferris (2003).

158. Derrida (1994); Gordon (1997); Jameson (1995); Baer (2002); Read (2003).

159. Quoted in Sidgwick (1891–2), p. 268.

160. Ibid., p. 282.

Adelaide, 93
Aksakov, Alexander, 37
Algiers, 64
American Civil War, 16
American Society for Psychical
 Research (ASPR), 74
Anderson, Francis, 37
apports, 38, 74
Armistice Day, Two Minutes'
 Silence, 125, 127, 128, 130, 135
Atlantic Monthly, 16
automatic writing, 46, 93, 116,
 123, 125

Banner of Light, 16, *16*
Barlow, Fred, 8, 102, *104*, *107*,
 109, 112, *113*, *113*, *114*, 123,
 135, *139*
Barnes, F. C., 47, *48*
Barnum, P. T., 15
Berthe (the spirit), 66
Bien Boa (the spirit), 64, *65*
Bird, J. Malcolm, 74
Birmingham, 112
Bishop of the Ozarks (film), 143
Bisson, Juliet, 64–73, *67*
Blackburn, Charles, 37
Blackwell, Henry, 50, 59, *59*
Boismont, A. Brierre de
 *Hallucinations: or the Rational
 History of Apparitions, Visions,
 Dreams, Ecstasy, Magnetism, and
 Somnambulism*, 15
Borderland, 46
Boston, 16, 19, 74
Bournsell, Richard, 46–51, *48*,
 49, 93
Bradley, H. Dennis, 127
Brady, Matthew, 18
Brewster, David, 142
Brisbane, 47, 92
British College of Psychic Science
 (BCPS), 74, 90, 92, 98, 101,
 104, 109, 115
British Journal of Photography, 46
British Library, 8
Brooks, Amelia V., 14
Brown Wolf (the spirit), 120,
 125

Buguet, Edouard, 20–23, *21*, *22*,
 30, 34
Bush, Edward
 Spirit Photography Exposed, 100
Buxton, Mrs, 90, 101, 102

California, 51
Cambridge University, 37
Carnegie Hall, 125
cartes-de-visite, 15, 16, 18, 19, 25, 27
cathode-ray tube, *36*, 37
Christianity, 15, 49, 142, 144
 the Baptist Church, *93*
 the Bible, *15*, 25
 the Catholic Church, *23*
cinema, 142
 Hollywood films, *143*
cinematography, 67
Cissie (the spirit), *40*, 41, *42*
clairvoyance, 30, 49, 123, 142
Coates, James, 51, *53*
 Photographing the Invisible, 51
Colley, Archdeacon Thomas, 90,
 92, 100
Conant, Mrs, *16*
Connell, Mrs, 128
Cook, Florence, 30–38, *31*, 64
Corner, Elgie, 32, 37
*Counterblast to Spookland, or Glimpses of
 the Marvellous*, 42
Crandon, L. R. G., 74, 147
Crawford, W. J., 79–85, *80*, *82*, *83*
credulity, 8, 61, 100, 111, 142, 144
Crewe, 90, 94, 113
Crookes, Sir William, 30–37, *30*, *35*,
 61, 64, 70, 102, *103*

d'Esperance, Madame (Elizabeth
 Hope), 38
 *Shadow Land: or Light from the Other
 Side*, 38, *38*, *39*
Daily Graphic, 128
Daily Sketch, 128, *129*, 135
Darkened Rooms (film), 143
Darwin, Charles, 61
Davenport Brothers, 71
de Brath, Stanley, 97, 98, *99*
Deane, Mrs Ada Emma, *2*, *6–7*, *9*,
 10–11, 111–130, *112*, *113*, *114*, *117*,

118, *120*, *121*, *124*, *126–127*, *130*, *131*,
 132, *133*, *134*, *135*, *138*
Deane, Violet, 112, 113, *113*, *120*, 127
Dingwall, Dr Eric, 8, 37, 59, 70, 74,
 75, *75*, 78, 101, 104, 109, 115,
 116, 119
DNA, 70
Dow, Moses A., 19, *19*
Doyle, Denis, 109
Doyle, Lady, 93, 109
Doyle, Sir Arthur Conan, 92, *92*,
 93, 94, 100, 102, 104, *104*, 109,
 117, *118*, 125, 135
 The Case for Spirit Photography, 102,
 147
Duguid, David, 50

Earthbound (film), 143
ectoplasm, 64, 66, 67, 69, 70, 73,
 74, 75, 78, 79, 81, 82, 84, 85,
 92, 98, 109, 111, 117
Edmonds, Judge John Worth, 14
Einstein, Albert, 74
electricity, 20, 30, 33, 36, 37, 74, 148
Empress of Austria, 47, *48*
Engholm, Mr, *109*
ether, 55, 61, 143
Eva C. (Marthé Beraud), 64–73,
 66, *67*, *72*, *73*, 79, 84, 85, 97
Evans, W. H., 49
extras (spirit), 14, 15, 20, 23, 26,
 46, 47, 49, 51, 53, 59, 90, 92,
 94, 97, 98, 100, 101, 102, 104,
 109, 112, 113, 115, 116, 119, 120,
 123, 127, 142

Fairlamb, Miss Annie, 24, 41
First World War, 90, 125
Fitzsimons, F. W., 117
Fox sisters (Kate and Margaret), 9,
 16, 111
Freda (the spirit), 116

Geley, Dr Gustave, 69, 70, 74, 79,
 85, 97, 98, 147
Geordie, (the spirit), 41, *43*
ghosts, 9, 26, 61, *68*, 93, *99*, 101, 143,
 144
Glasgow, 100

Glendinning, Andrew, 50, *50*
Goligher Circle and Kate
 Goligher, 79–84, *79*, *80*, *82*, *83*,
 147
Gully, Dr J. M., *35*
Guppy, Mr and Mrs, 24, *24*, 25, 32

Hamilton, T. G., *104*
Harbinger of Light, 93
Harvard University, 78
haunting, 9, 142, 144
Henry, T. S., 41, 42, 50, 59
 Spookland!, 42
Herald of Progress, 16
Holmes, Oliver Wendell, 16
Holmes, Sherlock, 92, 104
Home, D. D., 30, 32
Hope, William, 38, *79*, 90–117, *91*,
 95, *96*, *97*, *98*, *99*, 103, *105*, *106*, *107*,
 108, 109, *110*, *114*, *122*, 135
Houdini, Harry, 71–74, 84, 100,
 101
Houghton, Georgiana, 23–27, *27*, 61
 *Chronicles of the Photographs of
 Spiritual Beings and Phenomena
 Invisible to the Material Eye*, 25
 Evenings at Home in Spiritual Séance,
 25
Hudson, Frederick, 24–34, *24*, *27*,
 31, 41, 47, 61
Hulah (the spirit), 120, 128
Humphry, Mrs L. M., *58*, 59
hypnotism, 64, 66

influenza epidemic, 90
Institute Metapsychique
 International, 69, 97
invisible operators, 37, 47, 51, 59,
 79, 81, 82, 84, 93, 98, 114,
 120, 123

Jeffrey, Mr and Mrs, 98, *98*
John Bull, 115
Josephine (the spirit), 41, *41*
Julia (the spirit), 46, 47, 123

King, John (the spirit), 32
King, Katie (the spirit), 30, 32–38,
 35

158

Kitchener, Lord, 128
Krause, Arthur G., *51*

Lacey, C., 50
lantern-slides, 32, 92, 93, 125, 142
Leymarie, Pierre-Gattan, 20, *21*, 23
Light, 84, 85, 109, *109*, 110
Lodge, Sir Oliver, 61, 64, 102, 116, 117
London, 20, 24, 25, 30, 32, 46, 47, 50, 70, 71, 74, 84, 90, 112, 116, 123

Magic Circle, Occult Committee, 59, 117, *117*
magicians, 59, 67, 71, 72, 100, 101, 142
Manchester, 94
Margery, (the medium), 74, 75, *75, 76–77, 78, 78, 79*
Maskelyne, John Nevil, 71
Massachusetts Institute of Technology, 74
McDougall, William, 75, 148
McKenzie, Mr and Mrs, 90, 98, *99*, 109
mediums, 9, 16, 20, 25, 26, 32, 38, 41, 49, 53, 59, 64, 71, 74, 82, 85, 94, 100, 101, 102, 112, 113, 116, 142, 143, 144
Melbourne, 93
Melbourne *Age* newspaper, 93
Melies, Georges
 The Spiritualist Photographer (film), 142
Mellon, Mrs, *40*, 41, *41, 42, 43*
mesmerism, 20, 25, 55, 64, 71
Miroir, Le, 69
Moses, Stainton, 19, 22, 23, 150
Mumler, William, 14–24, *16, 17, 19, 20*, 30, 34, 36, 142
Munich, 64

Nature, 36, 150
Nielsson, Professor Haraldur, *106*
New Age, the, 142
New York, 8–16, 18, 111, 125
New York Supreme Court, 14

New York Times, 125
Newcastle, 38
News Chronicle, 109
Noel, General, 64

Paris, 16, 20, 37, 64, 69, 74
Payne, Maria, 53
photography
 cameras, 15, 19, 20, 25, 33, 41, 46, 47, 50, 53, 66, 67, 69, 79, 82, 90, 92, 94, 101, 111, 112, 115, 117, 119, 120, 135, 142, 145
 darkrooms, 14, 15, 51, 59, 94, 100, 101, 120, 143, 145
 Kodak, 53
 lighting, 33, 38, 50, 66, 69, 70, 75, 82, 113, 120
 photographic plates, 14, 16, 19, 20, 22, 25, 26, 32, 34, 38, 46, 47, 49, 51, 59, 79, 90, 92, 93, 94, 97, 98, 100, 101, 104, 109, 111, 112, 113, 114, 115, 116, 117, 119, 120, 123, 125, 126, 127, 128, 130, 139, 145
 studios, 14–16, 19, 20, 22, 23, 25, 30, 94, 101, 115, 142, 143
Pickup, Mrs E., 94, *94, 95*
Pierce, W. J., 50, *50, 51*
Poiret, Edouard, *21*
Pomar, Count de Medina, *21*
Pratt, Mr, 135
Price, Harry, 101, 104, 149
 Cold Light on Spiritualistic Phenomena, 101
Prince, Walter, 74
Proceedings of the Society for Psychical Research, 109
Progressive Thinker, The, 51
Psychic Gazette, 98

Quarterly Journal of Science, 30

Review of Reviews, 46
Revue Spirite, 20, 23
Richards, Mrs, *16*
Richet, Professor Charles, 64, 69, 74, 79, 85, 149
Robinson, Mr, *108*
Röntgen, Wilhelm, 74

Rose, Major Rampling, *105*
Royal Society, 30, 32, 36

Scatcherd, Felicia, 98, *99*
Schrenck-Notzing, Baron, 64–70, *66, 68, 71, 79*, 85, 149
science, 8, 15, 16, 20, 23, 30, 32–38, 42, 61, 64, 67, 70, 71, 74, 85, 101, 102, 104, 120, 143, 144
Scientific American, 74, 78, 104, 146, 147, 148
Scottish Society of Magicians, 98
séance cabinet, 18, 25, 32, 33, 34, 36, 41, 64, 66, 67, 69, 120
séances, 9, 19, 24, 25, 26, 32, 33, 34, 36, 37, 38, 41, 42, 47, 53, 64, 66, 67, 68, 69, 70, 71, 72, 73, 74, 75, 78, 79, 81, 82, 84, 85, 90, 92, 98, 100, 104, 112, 113, 116, 120, 123, 128, 135, 142, 143, 144
Shaw, Mrs, 51
Sidgwick, Eleanor, 144, 149
Smith, G. A.,
 Photographing a Ghost (*film*), 142
Society for Psychic Research (SPR), 37, 59, 69, 70, 72, 73, *73*, 74, 75, 78, *78*, 90, 101, 104, 109, 144
Society for the Study of Supernormal Pictures (SSSP), 8, 90, 94, 97, 102
Spencer, Major R. E. E., *96, 97, 97*, 100
spirit materialization, 26, 32, 33, 34, 38, 41, 42, 46, 50, 64, 69, 82
Spiritual Magazine, 24, 25
Spiritualism, 8, 9, 14, 15, 16, 19, 20, 22, 23, 24, 26, 30, 32, 33, 37, 41, 46, 47, 49, 51, 53, 59, 61, 71, 79, 90, 92, 94, 100, 101, 102, 109, 110, 111, 112, 117, 119, 125, 135, 142, 143, 144, 146, 147, 148, 149, 150
Spiritualist, 26, 32
Stanislava P., 67, *68*
Stead, Estelle, *122*, 123, 125, 128, 135
Stead, W. T., 46, 50, 123, 125, 128, 135, 149
 The Blue Island, 123
Sunday Pictorial, 94

Sydney, 41, 42
Syna (the spirit), 24

Taylor, J. Traill, 46, 50
Tebb, Mrs, 25
telegraph, 8, 20, 30, 33, 46, 61, 92, 93
telekinesis, 64, 74
telepathy, 37, 64, 143
television, 36, 142, 149
Theosophy, 49
Thomas, Rev. Charles Drayton, *130*
Titanic, 123
Titford, Mrs, 50, *50*
Travers-Smith, Mrs, 135

Varley, Cromwell Fleetwood, 20, 30, 33, 36, 37, 61
Vearncombe, M. J., *58*, 59, *59, 60, 61*
ventriloquism, 71

Wallace, Alfred Russell, 61, 144
Walter (the spirit), 74, 75, *76–77*
Warren, Mabel, 19, *19*
Warrick, F. W., 84, 119, 120, 123, 135, 139
Warsaw, 97
Waverley Magazine, 19, *19*
Whiteford, Robert, 51, *52*
Williams, Charles, 24
Winnipeg, 109
wireless radio, 8, 37, 61, 69, 74, 93, 125, 144
Wood, Miss, 24, 41
World War One, 90, 125
Wyllie, Edward, 50–53, *51, 52, 53, 54, 56, 57, 59*, 93

X-rays, 8, 37, 74

Yolande (the spirit), 38, *38*

159

Picture Credits